Dr. Mary Ann Culotta End Scholarship Fund

This limited edition is dedicated to the memory of my colleague and dear friend, Mary Ann Culotta. In many ways it could be reasoned that without Mary Ann's steadfast support, so many years ago, this book and perhaps some of my earlier books may have never been written. She was a very busy person, but never too busy to stop and catch up on the latest happenings. In fact, she took time to be an active advisor to me as a member of my doctoral committee. Her loyalty and belief in my efforts served to prevent a lot of what she considered unnecessary changes in my program. For that I will always be grateful.

Mary Ann's accomplishments were manifold. I shall endeavor to list a few, but most important in my mind was her genuine caring for others. She had the ability to see solutions with clarity and the fortitude to stand up and be counted when necessary. We need more like her. Mary Ann was an artist, and also a first rate, dedicated educator.

She served for 34 years with the Jefferson County Board of Education as an art teacher, art supervisor and Director of the Arts Education Program. One of her top priorities was bringing a sustainable arts program to children.

Dr. Mary Ann Culotta

Throughout her life she partnered and served on numerous Arts and Education Boards including the Virginia Samford Theater, Space One Eleven Art Gallery and the Joseph Bruno Montessori School. As a part of her legacy, she also taught Art and Art Education classes at her alma mater, Samford University. In the midst of her busy schedule, she was also dedicated to her faith. She was a long time member of Our Lady of Sorrows Catholic Church, where she also taught PSR 2 classes weekly during the school year. She was a devoted adorer at the Chapel of Divine Mercy, and cooked for The First Light Shelter ministries.

Mary Ann was also a world traveler and sought to learn more of the culture of others seeking to promote understanding and good will. All proceeds from the sale of this edition will go toward increasing the Dr. Mary Ann Culotta Endowment Scholarship Fund, thereby helping to continue her legacy by helping deserving Art Students with an emphasis on future Art Educators.

—Don Rankin

Don Rankin, Artist

Collector's Edition # 88 *of 300*

BACK ROADS & MEMORIES
The Art of Don Rankin

Foreword by Barbara J. Moore

Acclaim Press
MORLEY, MISSOURI

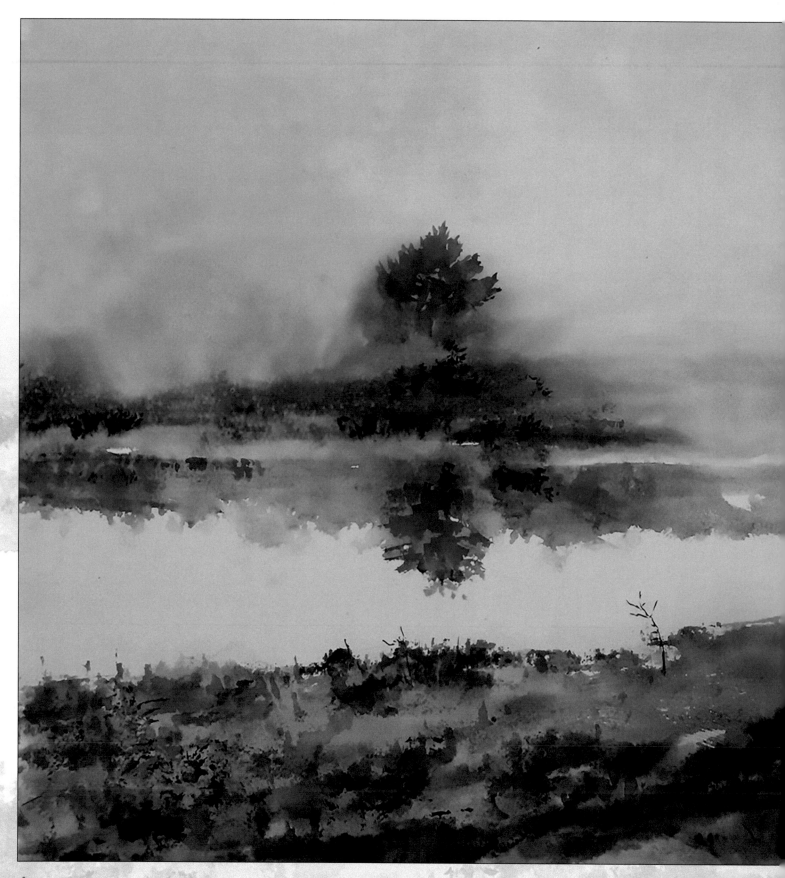

Misty Lake

Lake Cyrus, Watercolor on paper, 22" x 15" (55.88 x 38.10 cm)

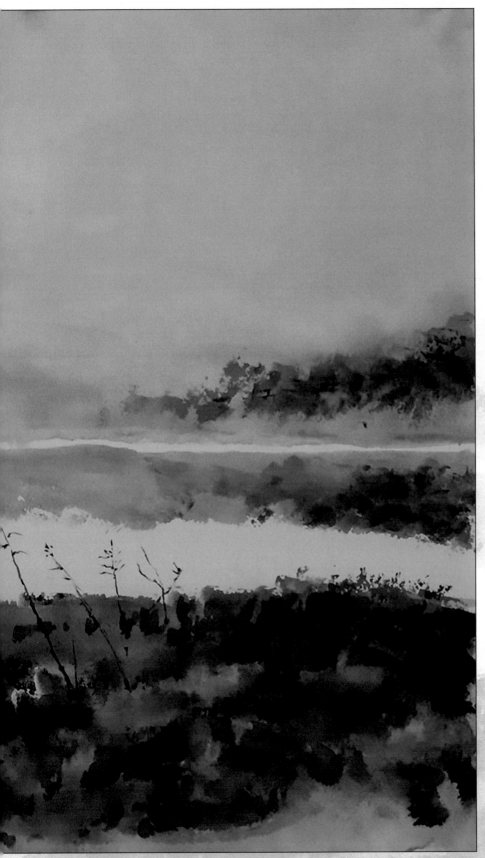

Acclaim Press
— *Your Next Great Book* —

P.O. Box 238
Morley, MO 63767
(573) 472-9800
www.acclaimpress.com

Book & Cover Design: Frene Melton

ISBN: 978-1-948901-36-9 | 1-948901-36-6
Library of Congress Control Number: 2019947566

First Printing: 2019
Printed in the United States of America.
10 9 8 7 6 5 4 3 2 1

*This publication was produced using available information.
The publisher regrets it cannot assume responsibility
for errors or omissions.*

Cover: *Old Friend*

Watercolor on paper, 14" x 19.5"
(35.56 x 49.53 cm)

I passed by this old oak on Hackberry Lane
for many years. I regarded it as an old friend.
It had such marvelous texture and cast
beautiful shadows. I had noted that its leaves
weren't as abundant, but I wasn't prepared for
the orange pylons and the chainsaw crew!

Contents

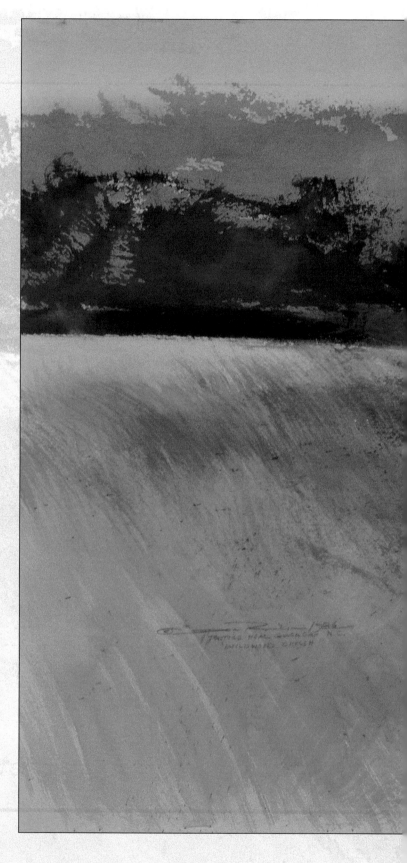

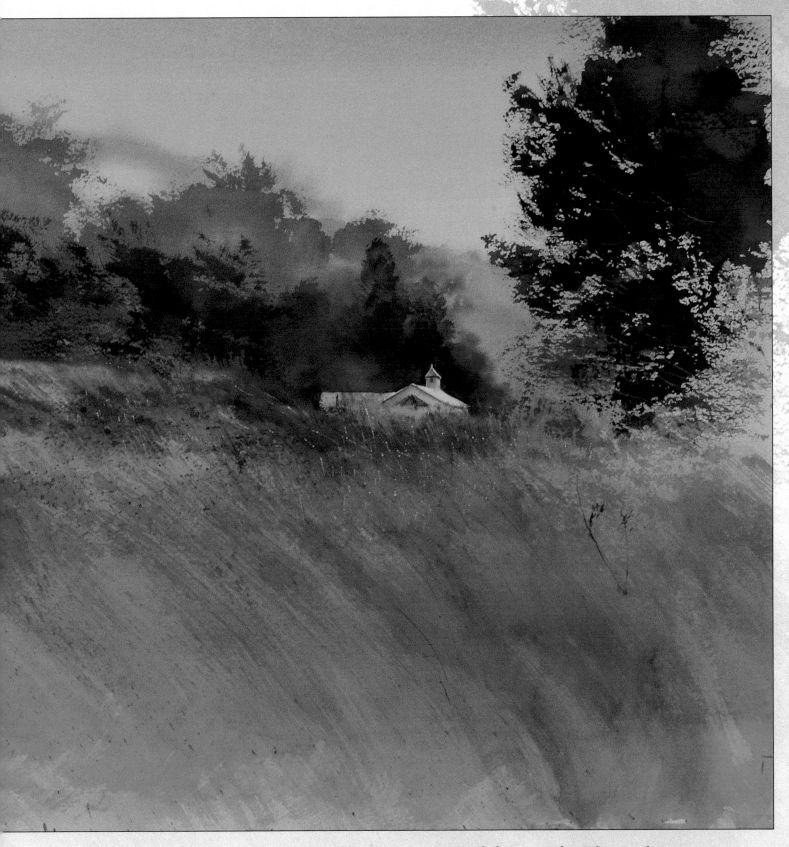

Wildwood Church

Watercolor on paper, 23" x 14" (58.42 x 35.56 cm)

Painted near Gooch Gap, North Carolina. Artist Collection.

Foreword

Named Art Director, 1976, to an established art gallery in the village of Chadds Ford, Pennsylvania, I have had the opportunity to meet and work with a variety of artists from elementary and high school grade talents, ranging from those not well known, to the established, and on to Andrew Wyeth, one of the most famous artists of the 20th century.

A visitor to the village, Don Rankin, was an early entry into my book of talents to explore. A Southerner who had the Brandywine interests and talents—but by choice didn't limit his work to that style—Don came with a watercolor palette of different color and range creating a wonderful glow to his subjects. He has produced volumes of work spanning five decades…simple, yet expressive and compelling compositions of land and water…light and shadow through a doorway or window spills through to touch a basket, cat or child, framing a part of his world.

Highly educated, extensively traveled, and well versed on national and international art worlds, Don Rankin continues to bring interest to his works through his teachings, books and paintings. Some of his books are available in foreign language editions. Visuals of his work on Instagram and Facebook and other online venues of watercolor technique tutorials are continuous.

Winner of many recognitions and awards, he was the recipient of the 2017 Marquis Who's Who Lifetime Achievement Award in Art and Art Education. Examples of Don Rankin's artworks and books can be found in many Private and Corporate Collections both in the U.S. and abroad.

Mastering Glazing Techniques in Watercolor, Volume I by Dr. Don Rankin, previously published by Watson Guptill Publications and revised and updated, is available through DonRankinFineArt.com.

I welcome you to view this volume of works, old and new, and enjoy another era of Don Rankin.

Barbara J. Moore
Barbara Moore Fine Art Gallery
Chadds Ford, Pennsylvania
(484) 776-5174

Dedication

Dedicated to Geneal Rankin

1944-2019

Bless the Lord, O my soul;
And all that is within me, bless His Holy name.
Bless Adonai, O my soul,
And forget not all His benefits:
Who forgiveth all thine iniquities;
Who healeth all thy diseases;
Who redeemed thy life from destruction;
Who crowneth thee with loving kindness
And tender mercies;
Who satisfieth thy desire with good things,
So that thy youth is renewed like the eagle.

– Psalm 103:1-5

My Story

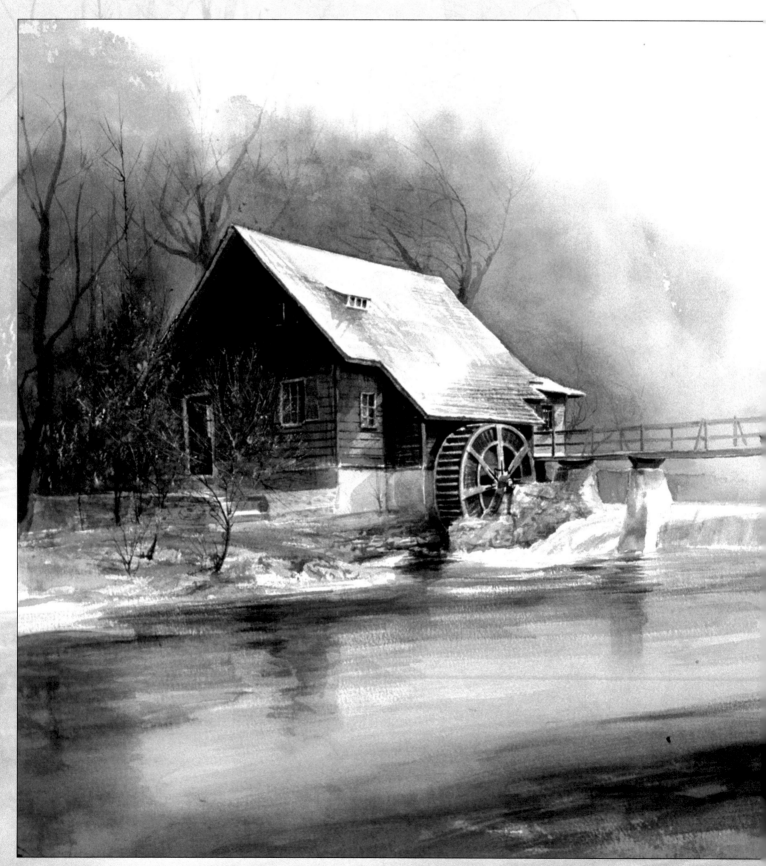

I am convinced that the works of today's avant-garde are the poisoned fruit of a spiritual decadence, with all the consequences that arise from a tragic loss of love for life.

—Pietro Annigoni

❖ ❖ ❖ ❖ ❖ ❖

One's art goes as far and as deep as one's love goes.

—Andrew Wyeth

Downstream
Watercolor on paper, 28" x 18" (71.12 x 45.72 cm)
Private Collection.

Developing My Skills

It seems as if I have been teaching art almost all of my life. In that time one thing has become crystal clear—I can teach the mechanics of art, but I can't teach passion! Passion is something that drives you to endure and to get back up when you get knocked down.

As you look through these pages, perhaps the love of my subjects will come through. Not every subject was triggered by the same thing, it is as if every work has its own story to tell. In short, a great part of my life is wound up in every attempt to capture that elusive "something."

Where did it all begin? Perhaps it helps to start from the beginning. My parents and other family members told me I started drawing before I could write my name. I can remember that my mother would give me a pencil and piece of paper whenever I was required to sit somewhere and be quiet. It worked rather well for a number of years, especially during church services.

I grew up in rural Alabama a few miles west of Birmingham. The neighborhood was quiet, and we kids played from dawn to dusk outside without harm or adult supervision. The woodlands were our home and we knew almost every crook and turn in the paths that meandered through the hills. For the first 16 years of my life, I probably spent more time in the woods and meadows than anywhere else. The county schools did not offer art classes at that time, but I was called upon to draw a number of things. Teachers would comment to my parents that I needed to receive a proper art education.

Winter Snow

Watercolor on hot press board, 22" x 14" (55.88 x 35.56 cm)

Private Collection.

Probably my first passion was drawing airplanes. My notebook was filled with all sorts of aircraft. Often I would share drawings with grammar school classmates. Most of us were of the generation that was born during World War II. Many of our parents and relatives had served in the armed forces. One of the local junkyards was crammed with the wreckage of Spitfires, Mustangs, Messerschmitts, Zeroes and other aircraft. Often while traveling by the junkyard a new batch of all sorts of wreckage with their insignia in clear view

Abandoned Farm

Watercolor on paper, 20" x 14" (50.80 x 35.56 cm)

Corporate Collection.

would be on display before they were melted down into ingots. At one time I could name all the aircraft, and I often produced school posters with all of the types displayed for all to see. My interests shifted as I grew older. However, I must admit that there is something awesome about hearing the engine of a Bearcat, Hellcat, P-51 or a Corsair belch into life. Honestly, I had little interest in jets but the sound of those old fighters, the SNJ trainers and Stearman biplanes brings back wonderful memories.

At the age of 13 I drew a picture I found in a magazine ad and mailed it to the advertiser. A few weeks later I got an exam book in the mail and followed the instructions. I passed the exam, which consisted of a number of drawing assignments as well as design problems. My father paid my tuition to the Famous Artists School in Westport, Connecticut. While it was correspondence, it was pretty demanding. The questionnaire had a number of questions. One in particular was very telling. It asked, "Can you take criticism?" I answered yes. Well, I got a lot of helpful, and at times strong, criticism. The school no longer exists, but I credit it with giving me a strong foundation that was polished later by others. I remember advice by none other than Norman Rockwell on how to develop a painting. How I regret now that it took me so long to learn to listen to such wisdom. I didn't want to listen; I wanted to paint. As a result of my haste, many of my pieces were utter failures. The first few years were studies in grey scale and pen and ink wash. Much later I would learn to connect grey scale to color. It gave me a strong foundation.

The Battle Begins

Insanity began to creep into the world of art many years ago. A popular opinion holds that in art, anything goes. At first I was pretty well insulated. The faculty members at Famous Artists School were all very capable draftsmen and could often draw in various styles. Their criticism of my work had often been harsh, but always given with a practical solution. However, my parents were insistent that I get a college degree, and a few years later I was enrolled in a college art program. It was like daylight and dark. The constant refrain was something

like, "You can't compete with a camera" or "All of that has been done before, you need to change your thinking!" The real truth was, although sincere in their belief, most of the faculty could not draw! One or two could, but the most vocal disciples of the "new" thinking were just not skilled. After meeting with an editor in Nashville who reviewed my college work, I was told that if I relied on that I would starve to death as an artist!

I Made a Decision

I recalled my training from before college, and in my junior year I left and went to study for the next four years with Bill Yeager. Before he would accept me, I had to show him my work. Thankfully, he agreed to enroll me. Bill introduced me into the real world of watercolor. His rationale was that I needed to master watercolor; up to that time I had been trained in oils. At first, my experience with watercolor was frightful. Everything I did was wrong. If you can name the mistake I made it, and made it dynamic! I was accustomed to pushing and pulling oil around. Watercolor was a wild, untamed beast.

After about eight months of serial disasters, we began to make friends. Today watercolor—transparent watercolor—is my main method of conveying my passion. I favor transparent watercolor for its clean, luminous washes. The medium allows for delicate passages as well as strong areas of color. Yes, in the beginning it was a wild stallion, but today I feel very comfortable with the medium. I need to clarify the term "transparent watercolor." The phrase should tell you that the paints are transparent in nature. To be very precise, one must understand that the transparency of watercolor is on a continuum. While all of the colors—except things like Chinese white—are transparent, some are more transparent than others. Paints like designer colors and gouache contain opaque pigments, adding Chinese white or any other opaque pigment changes the nature of the watercolor. Properly applied, transparent watercolor is very vibrant and crisp. If you lay certain colors in a proper sequence of layers you get magnificent vibrant color.

Simple washes over a black field help judge transparency. The most transparent disappear as they cross the field. The more opaque leave their mark.

About Bill

Bill Yeager was extremely gifted but didn't have much to say. He would often walk by my work station, stroke his chin whiskers, and maybe grunt or shake his head. At times I would spout so called art theory and he would look at me and very firmly say something like, "Shut up and paint!" On another occasion I began to tear a partially developed watercolor off my drawing board to throw in the trash. His response was, "What are you doing?" I replied that the piece was hopelessly lost and I was going to start over. Bill replied, "You don't know enough to say it's hopeless! You fight it to the bloody end!" I did. The result was pretty decent.

While Famous Artists School had been extremely important in my development, it was, after all, via correspondence. With Bill, it was a group of about fifteen students Monday through Friday from 8AM to 3PM. There would be a season of drawing from still life, landscape and live model. Then there would be a season of painting from our sketches. Almost daily we would get the opportunity to watch Bill work. On occasion he would lecture about some specific aspect of painting. However, the emphasis was on students drawing and painting. When students would reach a certain level of maturity, they would be allowed to exhibit selected matted pieces of work in the school gallery. Bill was the sole judge of what was selected and what was not. Later, he and I would

do a few joint exhibitions after I finished my studies. He moved the school to the bluff in the Bluff Park area and I became a part of the faculty. A number of my works were included in the gallery.

Looks Like Wyeth

From time to time viewers would comment that my work and some of Bill's work looked like the paintings of Andrew Wyeth. Early in my training, I didn't even know who they were talking about. The comment was two edged. For most it was a compliment; for others it was derision. I discussed this with Bill and I learned something interesting. Bill didn't talk a lot about his private life, but he opened up and I learned that he was a part of the Carnegie child prodigy program in Pennsylvania. During the summer they would transport him from around Pittsburgh down into the Brandywine Valley. He studied there under some of the more noted artists in the area. He also attended the Pittsburgh Art Institute. I had noticed that there were often striking similarities between Bill's brush strokes and especially the scale of some of his figures with those of Wyeth. I failed to ask him the names of some of his Brandywine teachers. He probably would have told me had I asked. I did learn that he was once a steel guitar player for Brenda Lee. He told me about putting her up on a stool so she could reach the microphone! As I said, Bill was not a man of many words, his work ethic was to let his paintings speak for him; they did and his work was very well received, commanding good prices for the '60s and '70s. Sadly, Bill passed away in Jupiter, Florida, but not before I had the chance to give him an autographed copy of my book, *Mastering Glazing Techniques in Watercolor.* He taught me a lot, especially about digging in and working with perseverance. He had a way of teaching you without you being aware of it.

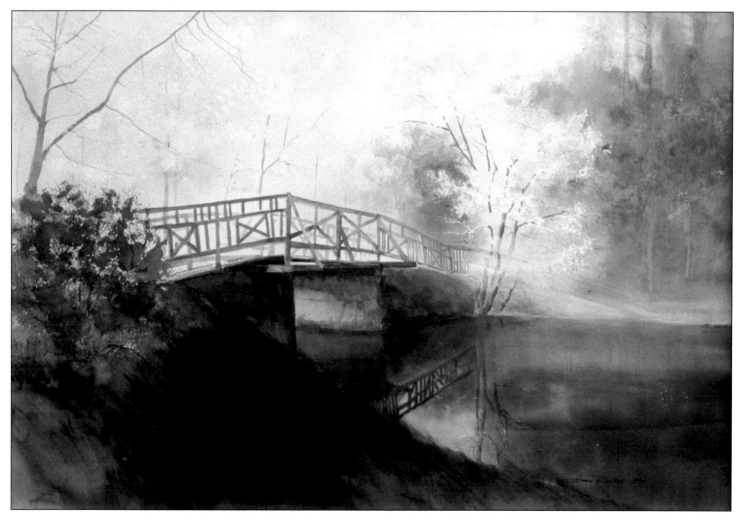

Paradise Bridge
Watercolor on paper, 36" x 20" (91.42 x 50.89 cm)
A beautiful old bridge that was knocked down to make way for progress. Private Collection.

Even today I get comments and comparisons about some of my work with Wyeth. I don't always see the similarity. I've given it some thought, for it is hard to cast your own shadow if you are standing too close to a giant oak. I have exhibited in the Chadds Ford Gallery, and now with Barbara Moore Fine Art since 1985. Barbara has over 40 years experience dealing with Wyeth's art. She knows the family and a whole host of artists in the valley.

I think any similarity may come from loving the land and really learning to draw. I have great admiration and respect for Wyeth's work, just as I have great admiration for the work of Pietro Annigoni. I can say I share Annigoni's philosophy about art. The bottom line is I am just me and I paint what I feel. On reflection, I also admire both artists for bucking the trend and winning! Long ago I refused to bend to the so-called "modern" thinking in art. At times the road has been rocky and I've taken my lumps, but to this day I can say I'm not swayed by the crowd. I began my painting career trying to record images of ways of life and places that were quickly being gobbled up by progress. I have often felt sadness that my children and grandchildren will never know the land as I did before massive stretches of asphalt and strip malls altered the earth. While these things may be necessary, I have often agonized as I watched beautiful secluded places devoured by bulldozers and dynamite.

Wilderness Treks

When I was younger, I assisted a Boy Scout troop that made it a policy to do one wilderness trip per month. We would often hike various trails, trek into the Sipsey Wilderness, and canoe the Okefenokee Swamps and Ocoee River, along with other areas. Later as my son grew out of scouting, I expanded my trips to places like the Boundary Waters and the Escalante System in Utah. While they were miles away from Alabama, I found that the wilderness recharged my batteries. So, my connection with the land and now especially with my childhood comes through in my work.

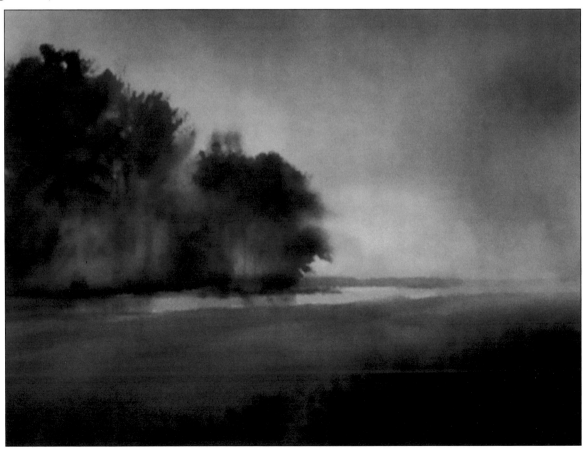

Day Break

Watercolor on paper, 14" x 11" (35.56 x 27.94 cm)

While camping in the Okefenokee Swamp it snowed for the first time in many years.
Dawn broke in a haze and the light revealed that most of the snow had melted.

I have always been fortunate that my work is popular and God has blessed me with the privilege of supporting my family with my brush. So any similarity with any other artist, living or dead, would come from my connection with the land that I know and remember so well.

The other obvious connection that I stated earlier was learning to draw. As a young artist I was influenced by many painters, including Albrecht Durer, Rembrandt, Michelangelo Caravaggio, Leonardo Da Vinci, John Singer Sargent, Frederick Remington, Winslow Homer, Salvador Dali and others. In my mind, aside from all being masters, they had one thing in common…they could DRAW. Drawing is a skill that needs to be nurtured. The old ways of drawing from still life and plaster casts are still very valuable methods in which every aspiring art student should be immersed and immersed deeply. Personally, I prefer to draw with ink and skip the mess of pencil and charcoal. However, in the beginning charcoal and pencil are wonderful tools.

Glazing Technique

In 1985, Watson-Guptill Publications published my book *Mastering Glazing Techniques in Watercolor.* It was an instant hit. In fact, a number of vendors were very upset, for they had extensive Christmas advertising for the book only to be informed by the publisher that they had sold out of the first run. Unhappy vendors waited for the next run. Unfortunately it was after Christmas, and a lot of their sales were lost. *Mastering Glazing Techniques in Watercolor* was presented as the first authoritative book on the subject of watercolor glazing techniques. It was greatly applauded by many painters and dismissed or ignored by some so-called experts.

Why Glazing?

While I was accustomed to using varnish-based glazes in oil and glazes in egg tempera, there wasn't much talk about glazing with watercolor. Many teachers of the time taught the very sound concept of put down a wash and leave it alone. The idea of allowing a passage to dry then applying another wash was not discussed very much.

The approach began to form while absorbing some ideas from two very prominent watercolor painters. The first, John Pike from Woodstock, New York, talked and wrote about tinting his paper with a very thin, almost imperceptible, wash of red, blue and yellow randomly mixed on the paper and allowed to dry. He surmised that this approach approximated the effect of diffused sunlight on the landscape. He was especially fond of using this method for snow scenes, claiming that it boosted the sparkle of the color. The most concrete clue came to me when I witnessed a bit of the effect in some of the works of Rex Brandt of Corona Del Mar, California. Those hints, plus my dissatisfaction with the appearance of some of the umbers and seinnas after they dried, gave rise to my experiments. I had worked for the *Birmingham News* and one of my learned skills was mixing color combinations in ink to produce an effect we called fake color. Fake color was color we produced via mixing without going into color process, which was very expensive in those days. A part of my job was to update the color formula chart the printers used that gave the ratio of certain inks necessary to create a specific color.

I reasoned that I could apply that technique to simple red, blue and yellow mixtures. Instead of using umbers, ochres and siennas, which were notorious for creating "muddy" passages, I created similar color by mixing primary colors of red, blue and yellow in varying proportions. The results were exciting, for the color mixture stayed vibrant even after it dried. Experiments with layers of yellow, then red and a bit of blue produced vibrant color. From time to time I still use the umbers and other earth colors.

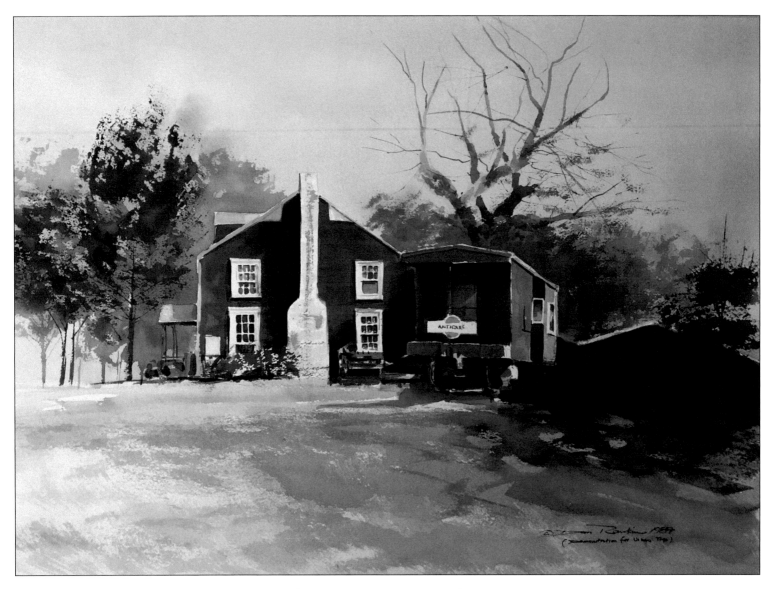

The Antique Shop

Watercolor on paper, 24" x 17.5" (60.96 x 44.45 cm)

Many years ago we had considered purchasing the old house to use as a location for Bill Yeager's art school. Today it is still a thriving antique shop.

Today the effects are much easier to obtain since we now have quinacridone colors, which are very transparent and often don't have the "body" that many of the more traditional paints have. I continue to experiment with layers of various color combinations and various brands to create all sorts of effects.

Why do I paint?

I've thought about that question from time to time. I often remind myself of the lyrics of one of my favorite songs:

All God's Critters have a place in the choir,
Some sing low and some sing higher;
Some sing out on a telephone wire,
Some just clap their hands, their paws or anything they've got.

Truth is God gives all of us gifts. When it comes to painting, the simple answer is I can't help myself. I tried to run away from it, but couldn't. I paint for me. My best painting time happens when I enter into another realm of consciousness. All sense of time ceases. There is no here and now. There is no future. It is just me at one with the painting, and I have learned to listen. It tells me what it needs in order to survive and prosper. When I ignore the course of the painting, failure is not far behind. There is an inner guidance, a "knowing," if you will. Rules and formulas fall by the wayside, and everything falls away except the paper, the brush and the paint. In my mindset the very Creator Himself takes over and directs my path. Of course, my touch with nature pales in comparison with His works. I am often reminded of His conversation with Job in Job 38:4-7. *"Where were you when I laid the foundations of the earth?"* So, I paint reverently always mindful of the Master Artist.

My quest for that certain something may be the glint of light off an object or the texture of tree bark or a wall. It may be the way a person cuts their eyes when they look at some one or how they hold their hands. The list could be endless. The most maddening thing happens when I am driving and a fleeting shape or color combination viewed out of the corner of my eye sparks my reaction. Often I struggle to recapture that fleeting moment. So my inspiration is more visceral, less intellectual. There are times when those images and/or shapes go through an internal struggle before they give birth on paper.

Virginia Storm

Watercolor on paper, 15" x 11" (38.10 x 27.94 cm)

Private Collection of David Rankin.

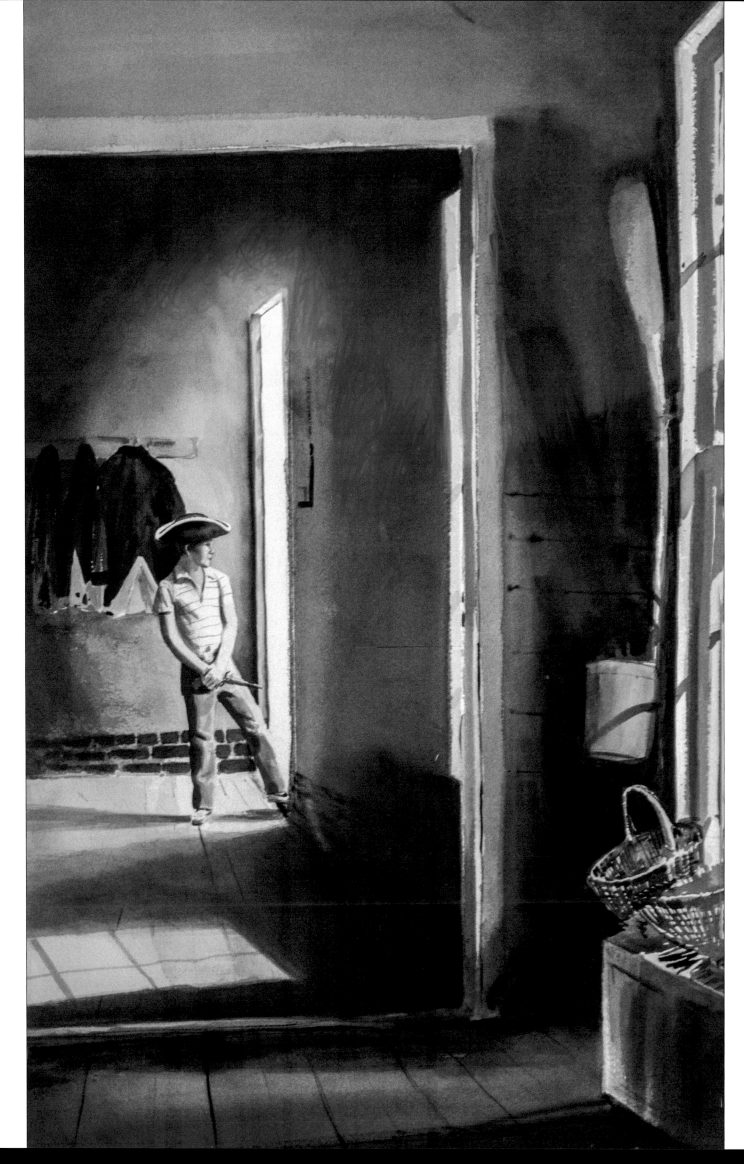

I almost always have a sketchbook at hand. Many of my sketches make no sense to others, but they really don't have to. Those attempts are there for me as I work through possibilities or attempt to coax an old memory to bring it to life on paper or gesso panel.

My sketches are like a time machine. Even years later I can go back to an old sketch book and see something I had drawn before. Instantly the sounds, the smells, the weather—everything—comes rushing back and I am transported to the spot.

In the past I have done a limited number of commissioned works. Some have been highly successful, yet at times I have felt a bit of a let down with some. Somehow a part of the spirit just isn't there. They may be technically correct, but that magical feeling isn't there. In my mind that is failure. As a result I don't accept commissions, unless I have a genuine feeling for the subject. These days I rarely take on commissions at all.

I don't go on wide ranging trips to paint "scenes." That is just not my way of doing things. Before my books were published, I used to enter many painting competitions and won my share of prizes. However, I have always avoided what I consider a trap. For me that trap is "painting for a judge." I paint what I feel and experience; a lot of it is in solitude. Quiet paintings are often drowned out in the clamor of this or that technique.

While awards can be very fulfilling and at times lucrative, achieving one is not always certain. Early in my career, I was faced with a choice. I could enter the juried exhibition or accept a payment often in the realm of five figures from a collector who wished to purchase my painting. It almost seemed as if they always wanted to buy the piece I was going to submit to a show. I took the money. I'll never apologize for that. Somehow that sale was often more gratifying. After all, a collector was willing to pay a significant sum for my work. I've even had it happen in exhibitions where prizes were awarded to other artists, but my entry was purchased by the group hosting the exhibition! Funny world.

David

Pen and ink, 7" x 5"
(17.78 x 12.70 cm)

Opposite page:

Day Dreaming

Watercolor on paper, 24.75" x 35" (63 x 89 cm)

My son was amusing himself as I explored and sketched in an
old building in Williamsburg, VA. Artist Collection.

Southern Watercolor Society

I am not opposed to juried exhibitions. They are a very important part of the art scene. I am also most interested in helping promote the level of watercolor as a painting venue. Far too many "experts" enjoy down playing the worth of watercolor. I have even had some, who should know better, state that watercolor is not painting! That is gross ignorance.

In order to combat that ignorance and help elevate the talent of so many watercolor painters living in the South, I became one of the co-founders of the Southern Watercolor Society in 1975. I remember the remarks of our first judge who expressed surprise at the level of sophisticated work that he found among the entries. Prior to our formation, there had been no concentrated focus on the efforts of our region. We started in Memphis, Tennessee when a group of about twenty-six artists gathered. John Wilkison, our first president, Connie Hendrix, a very talented watercolor painter and our first Secretary, and I are still alive out of those who helped found the society. I am very proud to be a part of the history of the organization. I am delighted that our child is alive, well and highly respected for presenting some of the finest examples of watercolor being produced today. Many wonderful people have put their time, talent and heart into nurturing and sustaining the Southern. I still have pleasant memories of all of those I have come to know through a mutual love of watercolor. Make no mistake, there are many highly talented watercolor painters and all of them deserve respect.

As for me, it seems that my primary goal is the same now as it was when I was young. Simply put, I want to produce the best paintings I can. Someday I might even get it right!

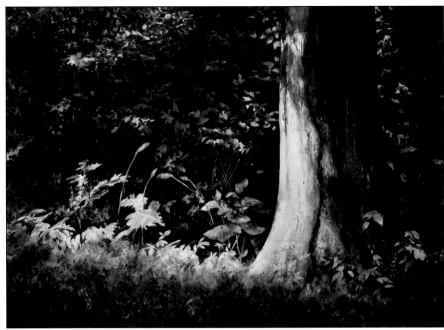

Weeds
John Wilkison, artist

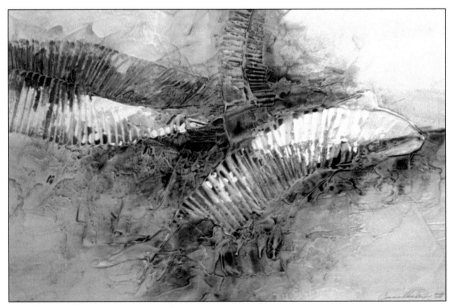

Fossils
Connie Hendrix, artist

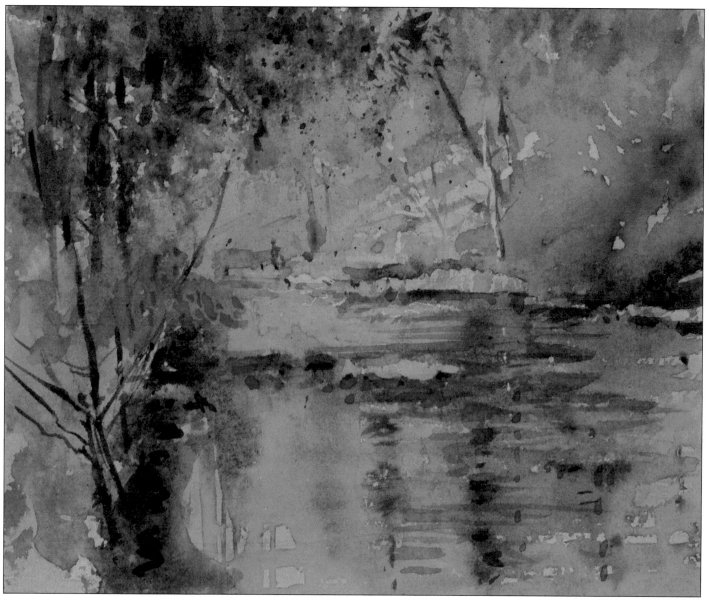

Marley's Place

Watercolor on paper, 6" x 5" (15.24 x 12.70 cm)

Paradise Creek runs behind my old studio. Marley, our golden and Oscar, our terrier, would often break out and go to the water. This was Marley's favorite swimming spot. She would come home soaked and exhausted while Oscar was dry. No amount of scolding could dissuade her. She would just look at me resting up for the next time the two would break out.

Let There Be Light

Every good composition is above all a work of abstraction. All good painters know this. But the painter cannot dispense with subject all together without his work suffering impoverishment.

—Diego Rivera

❖ ❖ ❖ ❖ ❖ ❖

Painting is just another way of keeping a diary.

—Pablo Picasso

Notan Tree Watercolor

Let There Be Light! (Genesis 1:3)

The Hebrew word Bereshith (Genesis) is often translated as Beginning and/or Creation. A deeper study will reveal more about that word combination. Life as we know it would not exist on this planet without light. At the same time light has an opposing force we call darkness. As a painter I am intrigued with both in all of the ranges of light and dark.

Working on a flat sheet or plane, the challenge is to create a sense of depth and volume or three dimension on a flat plane. We do this by manipulating line as well as shadow. Color alone won't do the trick unless one understands value. Very basically, every color has a corresponding grey scale. For example, many reds have the same corresponding value as black. One can use color without understanding value and wind up with a flat image. It's okay if you like that approach. However, it is vital for success that you understand the "why" of the flat effect.

My first four years of formal art training required working with graphite, charcoal and pen and ink, and finally ink wash. The object was to understand the importance of the pattern of shapes and their relative lightness or darkness to one another. By learning to manipulate these elements, a sense of volume is created. Pablo Picasso was credited with saying that art was a lie that makes one see the truth. I took his comment to mean we are manipulating elements to create an illusion that is not reality even though it may give that appearance.

If an artist's goal is to achieve a sense of reality in their work, then they must understand the importance of value and its relation to color.

For a little more than 25 years I studied classical Japanese martial arts as well as other disciplines. During that time I was introduced to a concept called Notan. Notan is the play or interaction of light and dark. Every successful representational painting is based upon the interplay of light and dark. Working with small sketches, preferably with no more than three values, one can map out the composition of a painting. These sketches should only contain the larger forms or shapes not detail. One is seeking find a powerful and/or pleasing relationship between the lights and the darks. The possibilities are unlimited.

Looking back at my life as a young art student I have never forgotten my first encounter with a Sumi-e painter. I watched in rapt attention as she lovingly ground her ink stick and quietly loaded her brush. With a few strokes of the brush this marvelous bird appeared. It looked as if it would

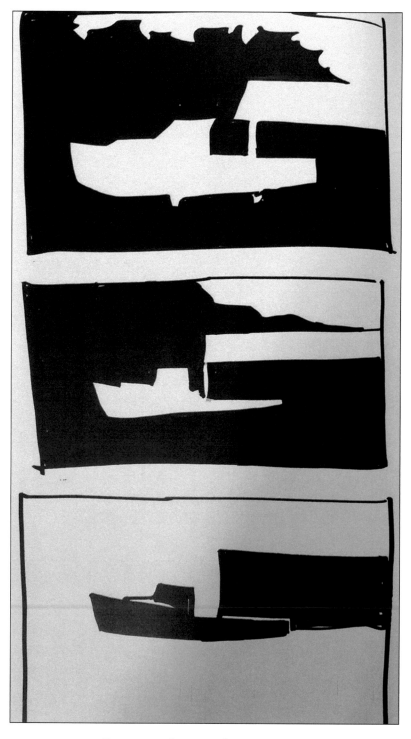

Boat Yard Notan

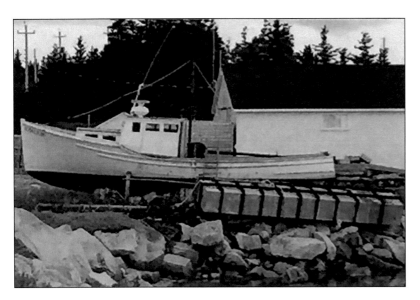

Boat Yard

take flight at any moment. I was humbled, for at that time I had many years of drawing and painting but not without effort. She had made it all seem so effortless. I asked her how did she do it. Her answer was very simple and yet profound. Basically she said, "As I prepare my ink, I meditate on the subject. When I can feel it with my mind, it drops off the end of my brush." Maybe a more contemporary way of saying it is to become one with your subject. Technical prowess is a wonderful thing, but if there is no communion between the painter and the subject, the result will be dead on arrival.

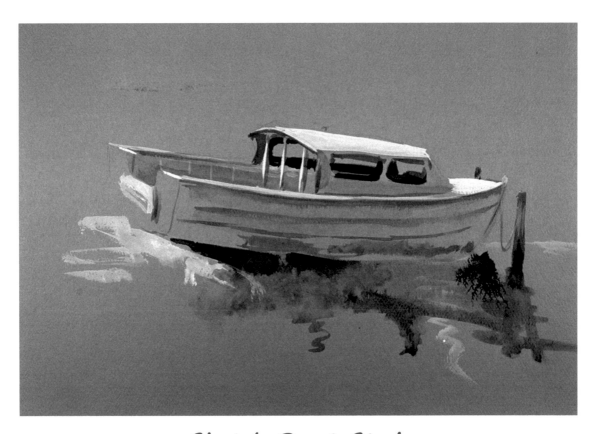

Sketch Boat Study

Ink on toned paper, 9"x 6" (22.86 x 15.24 cm)

Notan: Finding the Pattern

Notan is a principle of seeing patterns in black and white and/or shades of gray. Color is a wonderful thing, but many students fail to grasp that all colors have a relative gray scale. In years gone by we would have students purchase a piece of indigo glass. They would view the landscape or still life through the indigo lens and see dark and some light patterns. The idea was to unlock the secret of the "puzzle" pieces that go to make up a pleasing composition. Today, indigo glass is often difficult to obtain and we get a good result from using a red lens of some sort. Again, the idea is to unlock patterns that are right before your eyes. Once a student is initiated the lens is no longer necessary, for one can readily discern the pattern.

I am going to post a few examples; many are two value—that is black and white— and some are shades of gray. As you learn to see, you can make the patterns as complex or as simple as you like. Most of these examples are fairly simple.

For Beginning Students

In my design classes I used to have students get two pieces of 8" x 10" (20.32 x 25.4 cm) paper; one sheet to be white and the other black or another dark color. The objective was to either cut or tear the darker or lighter sheet into shapes and then arrange the pieces on the contrasting full sheet. They would place the shapes on the field and move them around to achieve either an image or a design. The idea was to be fluid in thinking and to really see what happens when one shifts contrasting shapes around on a lighter or darker field.

The pattern may not be a perfect rendition, but hopefully you can see the basic shapes. Don't forget the subtle cloud shapes in the sky. This is a very simple arrangement.

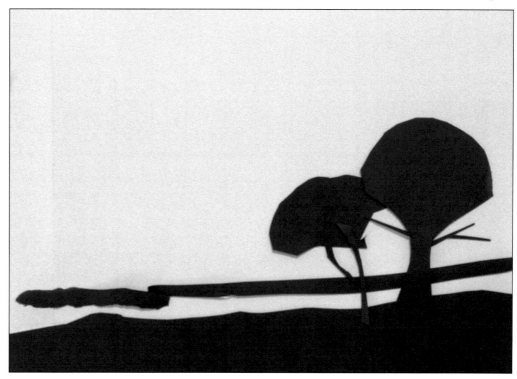

Cut paper study

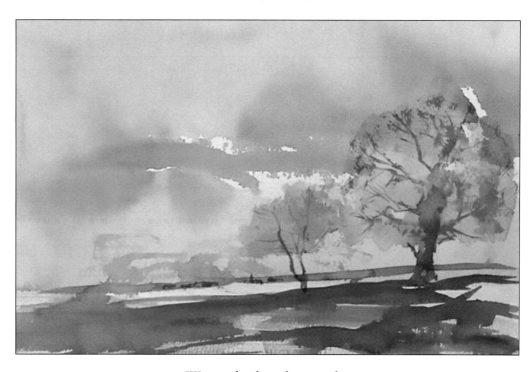

Watercolor based on study

Working with Photos

We certainly have a lot of possibilities. I am illustrating only two possible solutions—one as a negative light subject on darker field and one as a positive image. What solutions can you find?

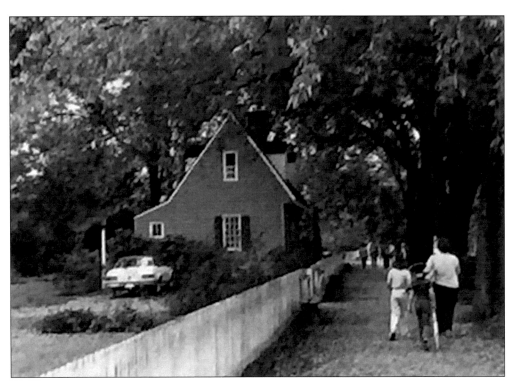

Original photo

Photo study using a light subject against a darker field

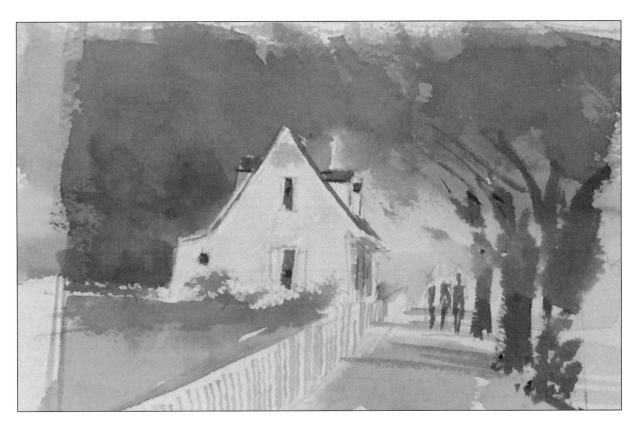

Watercolor solution based upon the negative image

Photo study using a dark images
against a lighter field

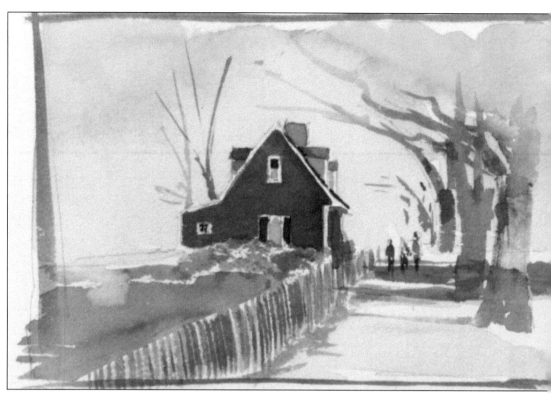

Watercolor study based upon positive image

Negative Shapes

Black marker on paper,
approx. 6" x 8" (15.24 x 20.32 cm)

Sometimes what you don't draw is more
important. Demo for student.

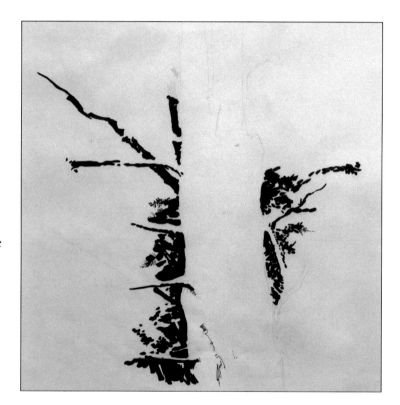

Working with Toned Paper

Perhaps some of you are familiar with reductive drawing. One takes a full sheet of paper and covers it with
charcoal. Then with a kneaded rubber eraser, one begins to draw by removing the dark charcoal from selected
areas. While very instructive, it is also quite messy. Another, cleaner solution is to work with toned paper.

Toned Paper Concept

This is a wonderful way to "see" values. Consider that the grey of the paper is automatically the middle tone value. Darks are applied for shadows, while opaque white or white chalk is applied for highlights. While some will discount this technique as being something for beginners, take a look in any reputable Art History book and see how many masters used this approach often with chalk or quill pen or brush.

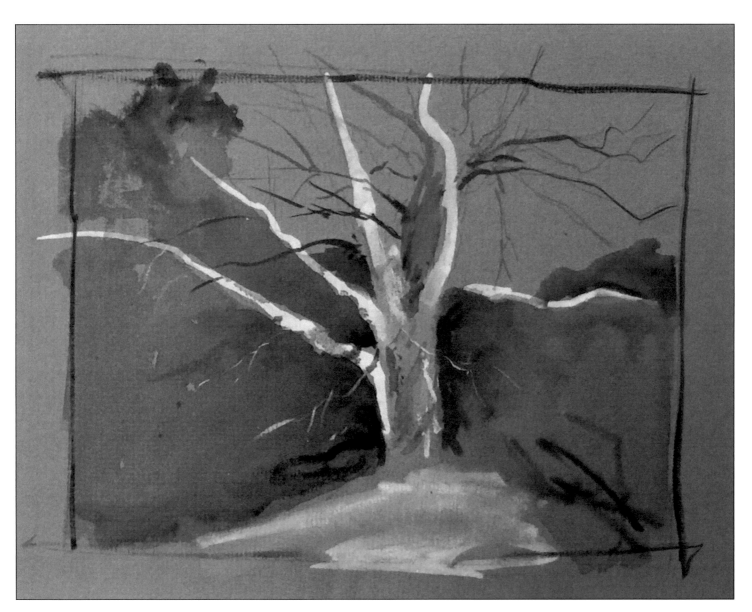

Newtown ink and wash study on tone paper, 8" x 10" (20.32 x 25.40 cm)
See the finished piece "Path to Newtown" on page 94.

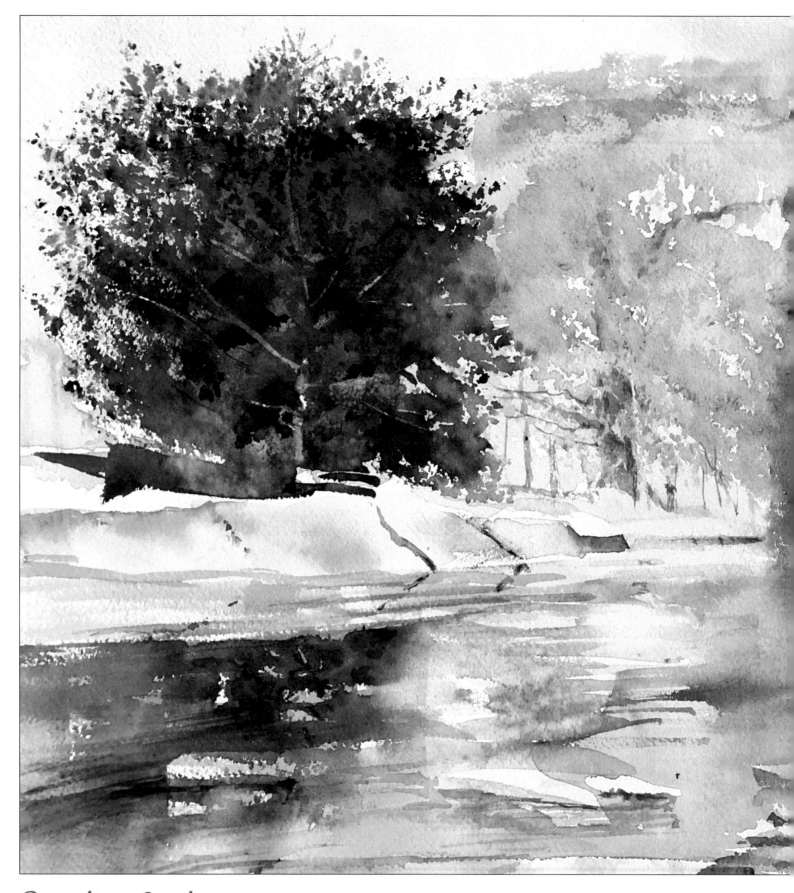

Paradise Creek

Watercolor on paper, 16" x 12" (42 x 32 cm)

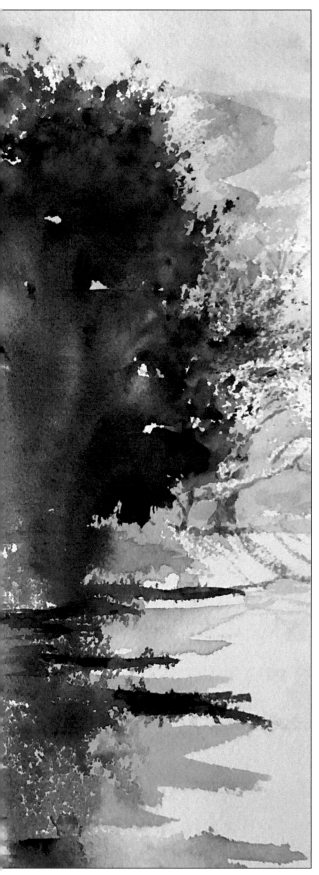

New Technology

Ok, so this is a modern era. So, can this approach be updated? If you own an iPad or an iPhone, an approximation of the notan process can be very simple. Take your photo in color and save it. Then go to edit mode and convert to B&W or Noir under the color scale. The resulting pattern will reveal a monochrome pattern. I will offer the following example. The watercolor was painted in a plein aire session. Then to demonstrate the concept of notan I took photos, saved the image of the color rendition, then went into edit mode to see what the black and white image would reveal about the painting.

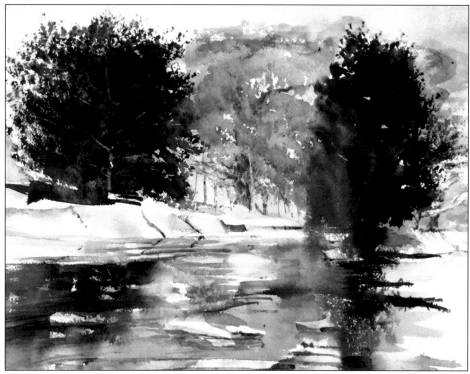

Black and white version on iPhone

Try Examining These Photos

Consider this homework. Put a piece of tracing paper over one or all of these photos and see if you can isolate the darkest darks from the lights. See if a pattern emerges. Then think about how you can enhance that pattern by either moving, enlarging and/or diminishing the size of some of the elements. The objective is to produce pleasing patterns. Give it a try. These are my personal photos, so no worries about any infringement.

This is a brief glimpse into the concept of notan. It is a skill that every successful artist uses in one way or another. Like any skill, the more you use it, the better you will come to understand it. Work with it, for it will reveal many possibilities.

Sketching

I believe that sketching is the backbone of competent representational art. In fact, for me, my sketches are the very lifeblood of my work. Unfortunately when I was younger I didn't always work that way and the results were less than pleasing.

From the very beginning of my art education I was immersed in drawing. I enjoyed that since drawing had always been a part of my life. Even before I could spell my name I was drawing. The education I received helped me to become more accurate and experience fewer catastrophes. It also helped me to begin to understand the power of the grey scale.

In formal art school I began with a pencil and eventually graduated to pen and ink. To this day pen and ink is still one of my favorite approaches to drawing. While it is unforgiving, it still holds many advantages. One of the primary advantages for me is that dry ink doesn't smear like pencil. The downside might be that blending soft passages can be a little more problematic.

I use the power of the sketchbook to solve design problems and to discover and modify shapes. In this book you will see a variety of sketches; executed with everything from pencil to brushstrokes. In many cases I produce multiple sketches of the same subject until I get it just right. This is especially critical when I am developing an egg tempera.

The Importance of Sketching

Sketching is vital. I sketch indoors as well as outdoors. In fact, sketchbooks are stacked in my studio and laying about in other areas of the house. This is a bit haphazard, since recent sketches often find themselves sitting near very old ideas. My books would probably drive an archivist crazy. However, when I need a book I don't always have time to find the most current one. Any book with a clean sheet of paper is fair game. That's why I have sketches on strips of paper, napkins and every other kind of paper you can imagine. In spite of that, there is a bit of order to my disorder. The more you sketch the better you get. All of my works begin with a sketch of some sort. Outdoors, I very quickly learned that the brilliant light of the day would wreak havoc on my eyes as it bounced off a white sheet of paper. To avoid those terrible spots before my eyes along with throbbing headaches, I switched to toned paper. Toned paper is wonderful not only for saving eyes but it also serves as a middle tone value. A tried and true method for learning to "see" is to learn to master seeing three values—a highlight, mid-tone value and shadow. The toned paper automatically becomes the mid-range value, allowing one to focus on seeing the highlight shape and the shadow shape. This is another application of notan. After mastering simple visual challenges, one can add additional values if necessary. Building a strong three-value foundation will ensure a greater chance of success. As one teacher said, "If you can learn to see three values, you can paint anything!"

One day Joe Miller and I were having a conversation about seeing values. I told him about the old days and the use of an indigo glass to help students "see" shapes in value while sketching and painting. I suggested that we might re-create that old device. Ever the entrepreneur, Joe immediately suggested that I draw up my idea and give to it him. He would sell them and we would share in the profits. We did just that and today that little value finder is available at Cheap Joe's Art Stuff. He has sold a lot of my value finders.

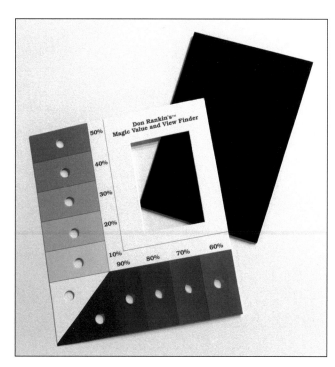

Don Rankin's Magic Value Finder, available at Cheap Joe's Art Stuff, Boone, North Carolina

A Series of Sketches for the Old Mill

The old mill on Mountain Brook Parkway, in Mountain Brook, AL has been an attraction since 1927. It is now listed as an historical landmark. My first encounter was as a freshman in college taking a drawing class. It was a love /hate relationship! I loved the site but hated that I couldn't do it justice. Those first attempts were painful as I tried to hold down a huge newspaper sketch pad and use a black marker. Later, I would visit often and as a teacher I took many of my students to the site.

Mr. O'Neal, the owner at that time, and I had an agreement. I would not permit my students to walk across the bridge and everyone had to stay on the road side of the creek, His reasoning was sound. He lived in an attractive nuisance. He recounted stories of awakening in the mornings seeing faces peering in his windows or hearing the sounds of people tramping around outside at all hours of the day and night.

Over the years the old place began to reveal some of its secrets. For example, some of the most dramatic light occurs in late autumn around 3:00-4:00 PM. At that time the sunlight comes barreling down the creek illuminating portions of the house and bridge in brilliant warm light. That's not all of the special qualities. Keen observation reveals even more hidden secrets. I was always on the prowl for a different angle to get more than just a "tourist shot" of the place. Some of the sketches shown here helped me gain more familiarity with the subject.

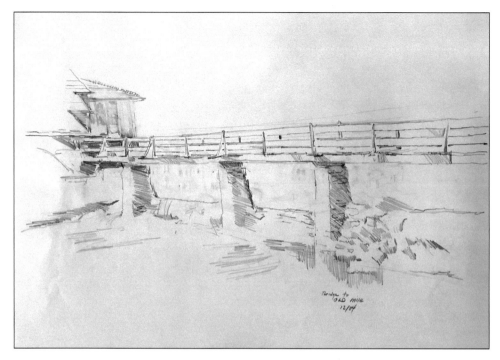

Old Mill Bridge

Pencil study, 14" x 11" (35.56 x 27.94 cm)

The drawing helps me to understand more about the subject.

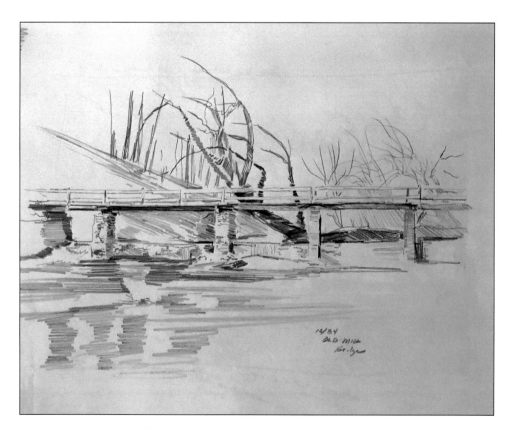

Old Mill Bridge with Trees

Pencil study, 14" x 11" (35.56 x 27.94 cm)

Just another angle to consider as I searched for the right spot.

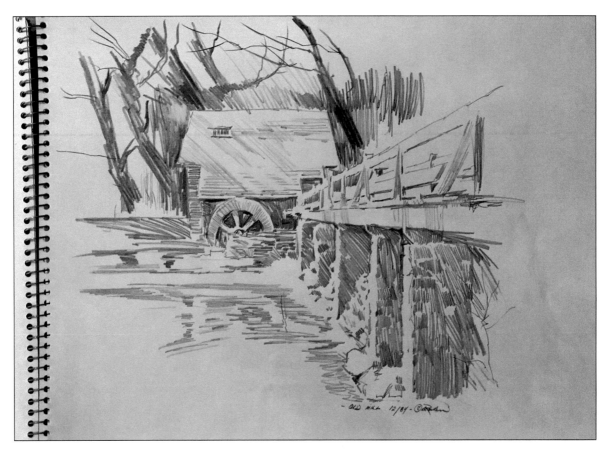

Old Mill

Pencil study, 14" x 11" (35.56 x 27.94 cm)

The sweep of the bridge and the texture of the rock pillars called for a closer investigation.

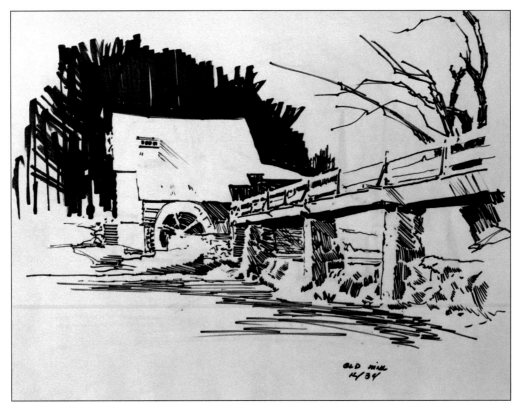

Old Mill with Bridge

Black marker, 14" x 11" (35.56 x 27.94 cm)

This wound up being a preliminary for Early Summer.

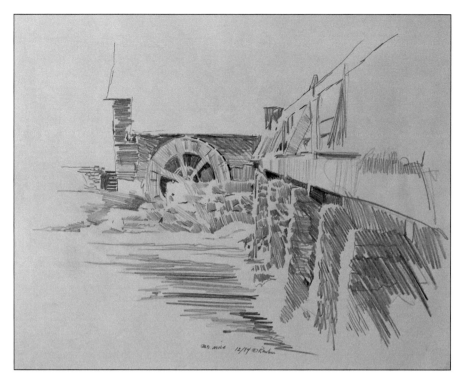

Old Mill

Pencil study, 14" x 11" (35.56 x 27.94 cm)

The drawing helps me to understand more about the subject.

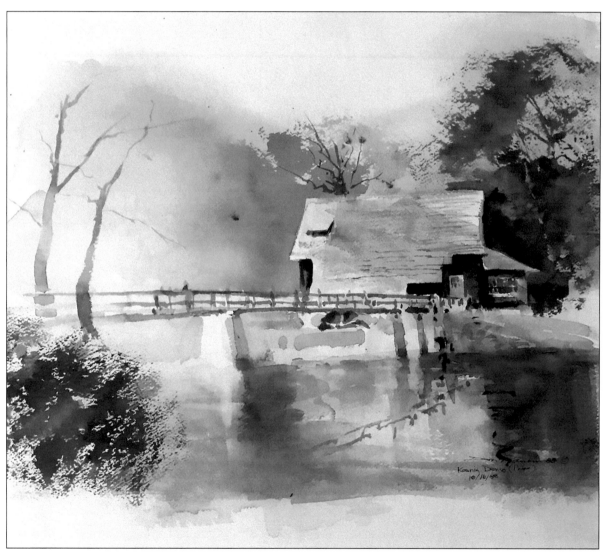

Old Mill

Watercolor study on paper, 14" x 12" (35.56 x 30.48 cm)

After all of the other drawings I decided to find another angle that was less familiar. Working through the underbrush I found the spot. Small, quick on site studies are invaluable for helping me develop the studio version.

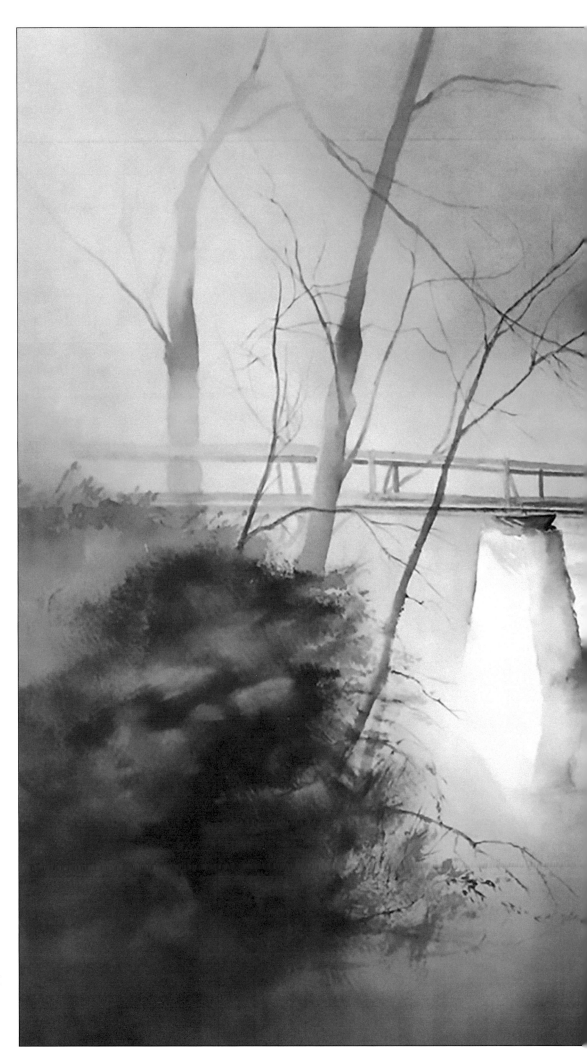

The Old Mill

Watercolor on paper, 27' x 18"
(68.58 x 45.72 cm)

A Mountain Brook landmark
that confounded me as a young
art student. The light is often
tricky yet intriguing. Frank
Lewis Estate.

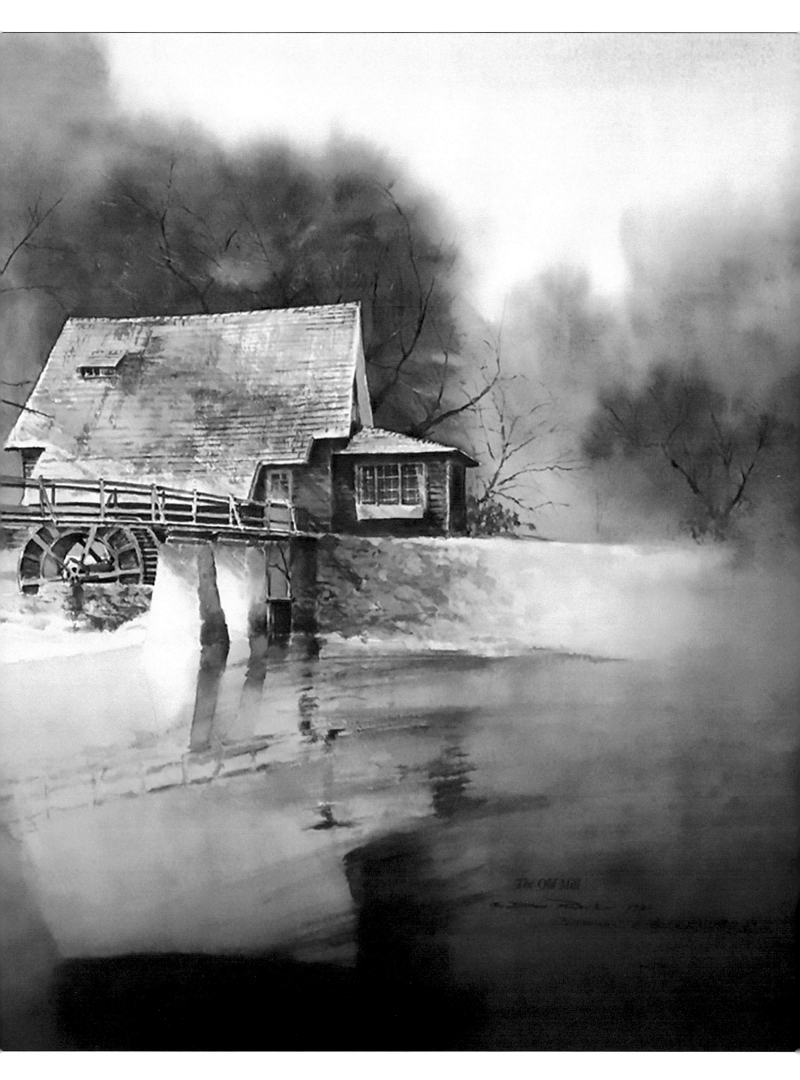

The Old Mill

West Homewood Park

In 1969 we had been married five years. My wife, Geneal, often joked that there were church mice who had bigger bank accounts than we. We were a family of three, our dog named Domino, a black spaniel, with one white dot on his chest, and us. Often our entertainment was to go to what is now West Homewood Park. At that time it consisted mainly of one road and a culvert bridge that spanned a stream. We would walk, run the dog and always carried towels to dry him off after he played in the water. Great memories.

Recently I found one of the sketchbooks from those days. I had forgotten all about it. Some of the entries are terrible but some even showed promise. One hurried sketch was of my wife standing near a tree. Not sure why I abandoned it but I think it was because I had missed the likeness. I used that old faded pencil drawing to re-create and refine her image. Not totally satisfied but am working on it. The magic of the moment was the light and the color. Hopefully the final painting captures the essence if the moment.

That is what my sketches do for me. They are capsules of a bit of a special moment. A sketch from fifty years ago has brought a special magic moment back to life. My sketches often transport me back in time. I feel the "place," I hear the sounds, the smells; the moment comes back to life. The trick is to capture that moment!

Domino

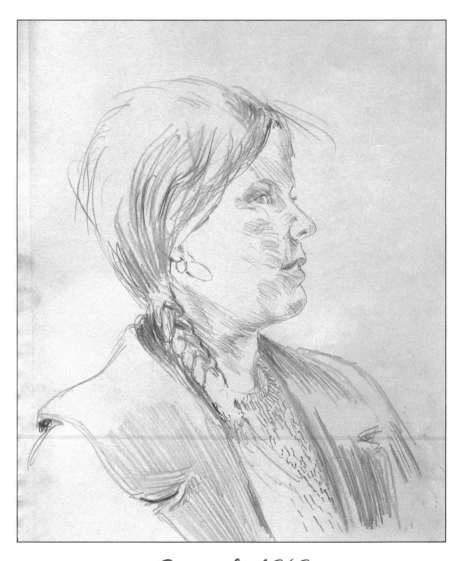

Geneal, 1969

Pencil on paper, 14" x 16" (35.56 x 40.64 cm)

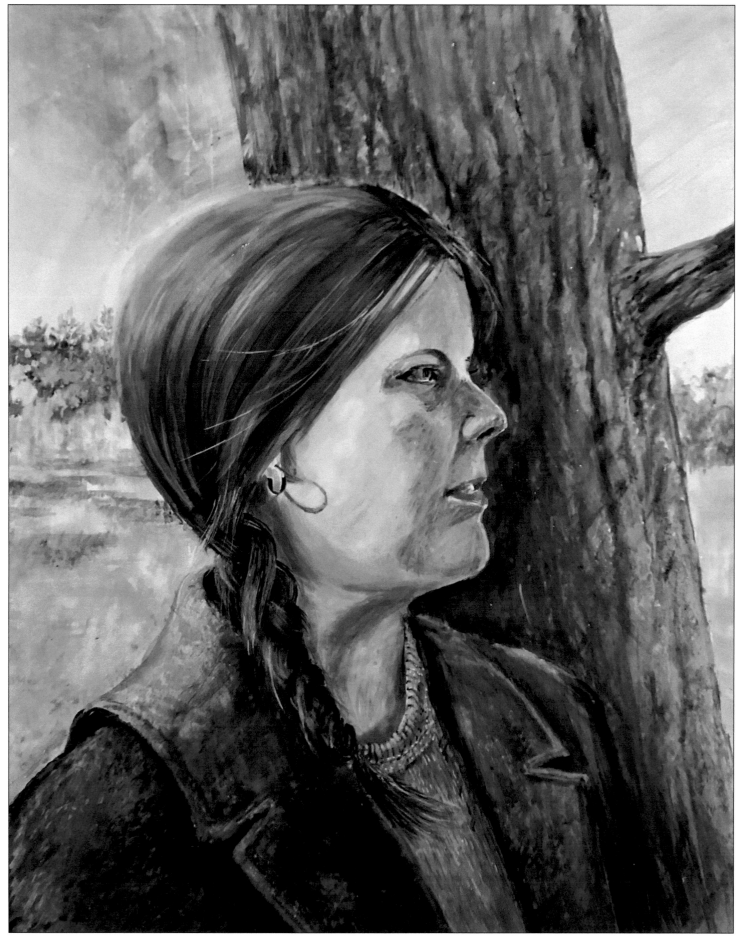

Geneal, 1970

Egg tempera, 11.5" x 14.5" (29.21 x 36.83 cm)

In January 2019, Geneal passed away after a debilitating illness. While going through items in the attic I found an old, forgotten sketchbook from the late 1969-1970 era. The faded pencil sketches brought back memories that resulted in this painting of a time when we were both young.

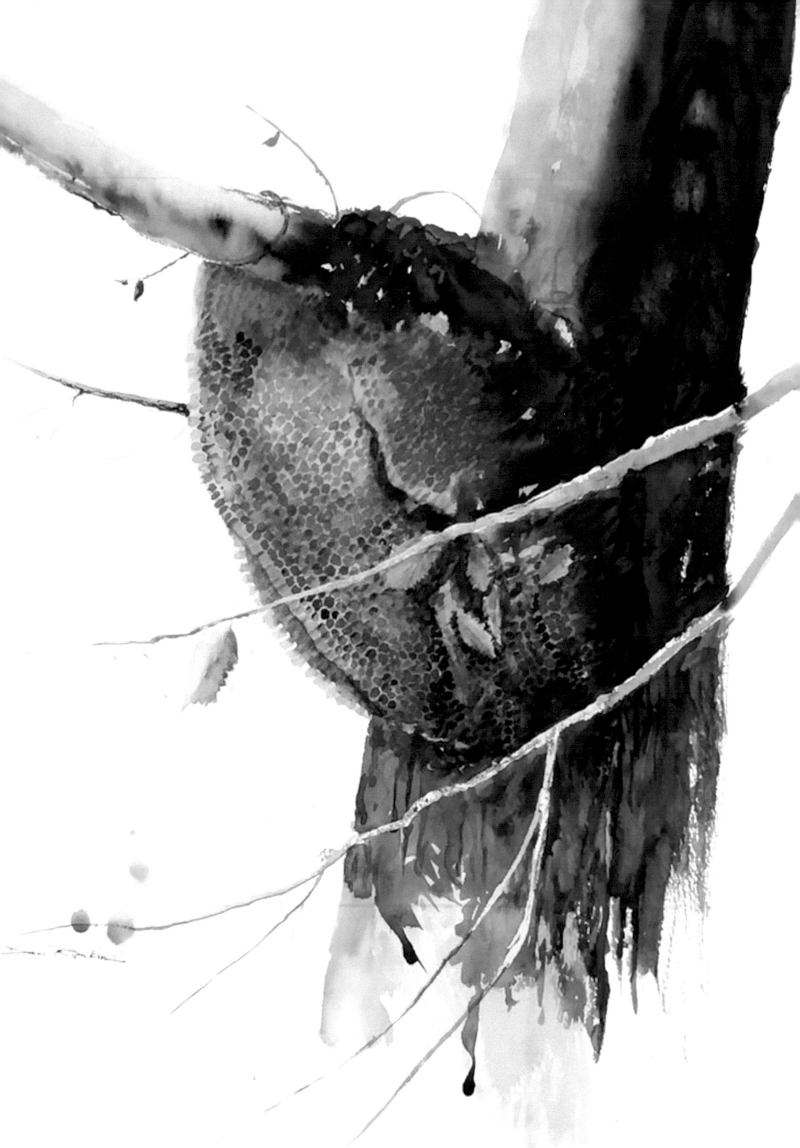

The Paper Makers

Watercolor on museum rag board, 33" x 23" (83.82 x 58.42 cm)

A word of caution to budding naturalists. Be careful what you bring indoors! It was dead of winter and on one of our forays to the park I found this perfectly preserved nest that appeared frozen. Intrigued, I brought it home and placed on the window sill next to my drawing board in the studio. After a few days of sketching and painting my new found treasure I could hear some faint nibbling sounds. I disregarded it until all of these young wasps began to emerge from the nest. I was the first thing they saw and not one of them ever attempted to sting me. When the weather warmed, I gently opened my window and placed the nest on the roof. They all flew away.

Opposite page:

Winter

Watercolor on paper, 20" x 30" (50.80 x 76.20 cm)

Inspired and painted from an old sketch book.

Nixburg Church

Nixburg Church started out as a part of a commission. The ink sketches indicate some of my options as I visited this antebellum church. I was told that some of the watercolors from that excursion were gifted to the Alabama Historical Commission.

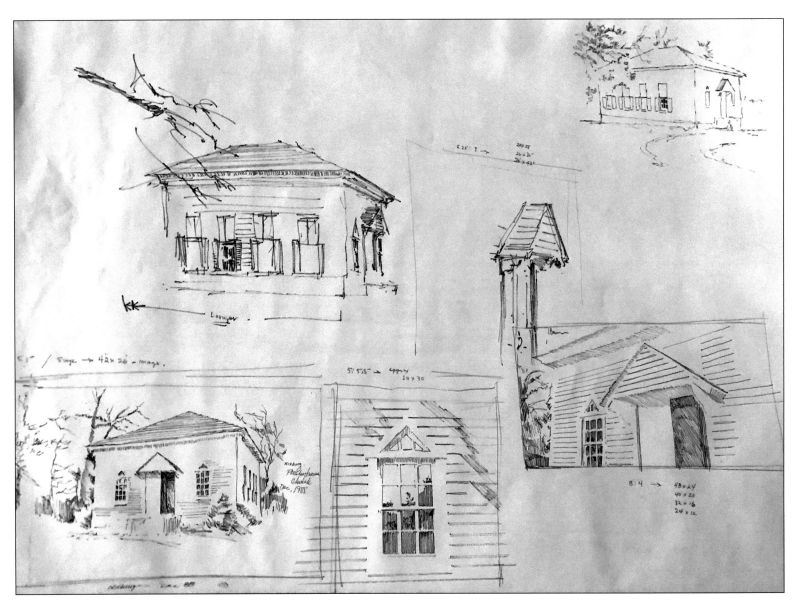

Nixburg Sketches
Pen and ink on one sheet, approx. 20" x 16" (50.8 x 40.64 cm)

Opposite page:

Nixburg Church

Watercolor on paper, 33" x 21" (83.82 x 53.34 cm)

A winter reflection in the window of an old antebellum church in Nixburg, AL. Artist Collection.

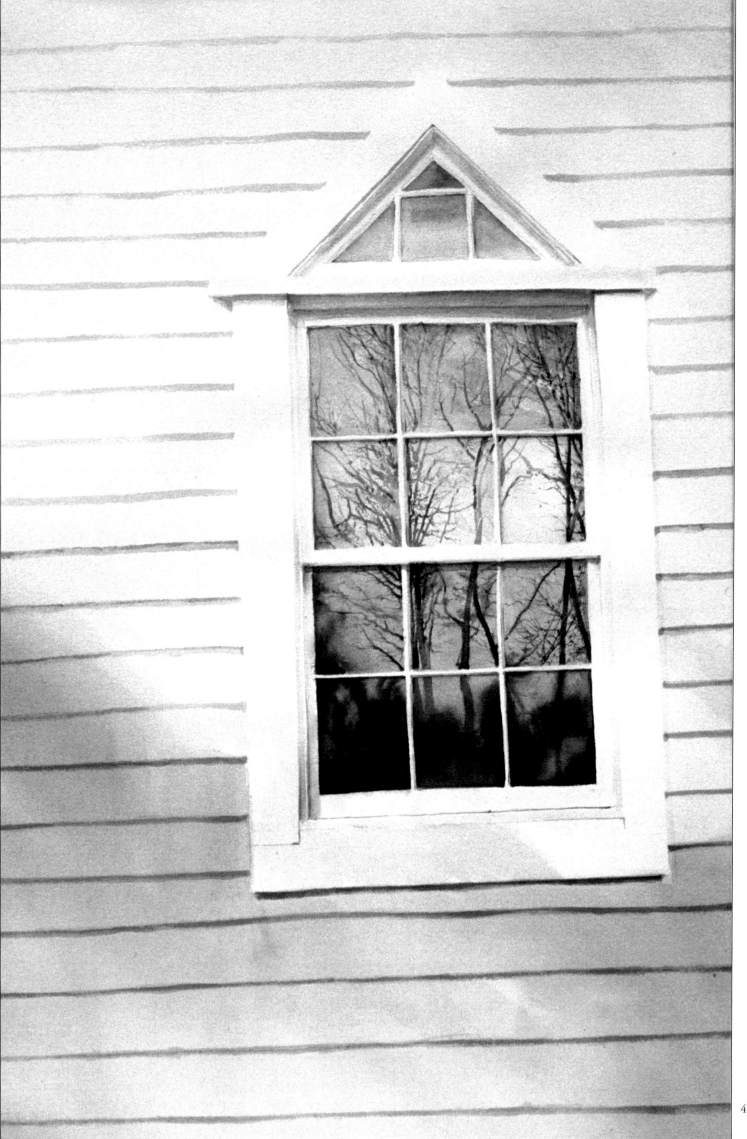

Pilgrim Hearth

This was a preliminary sketch I made one morning inside the old Pilgrim Congregational Church in Mountain Brook, AL. The church no longer stands but my sketches still bear witness to its existence.

Pilgrim Hearth Sketch

Pen and marker duotone, approx. size 9" x 8" (22.86 x 20.32 cm)

Pilgrim Hearth

Watercolor on paper, 29" x 15"
(73.66 x 38.10 cm)
Private Collection.

Pilgrim Congregational Church

Black marker on paper,
approx. 18" x 11"
(45.72 x 27.94 cm)

For some reason I sketched the
outside of the church and the trees
that surrounded it. Part of the old
site is now being developed into
garden homes.

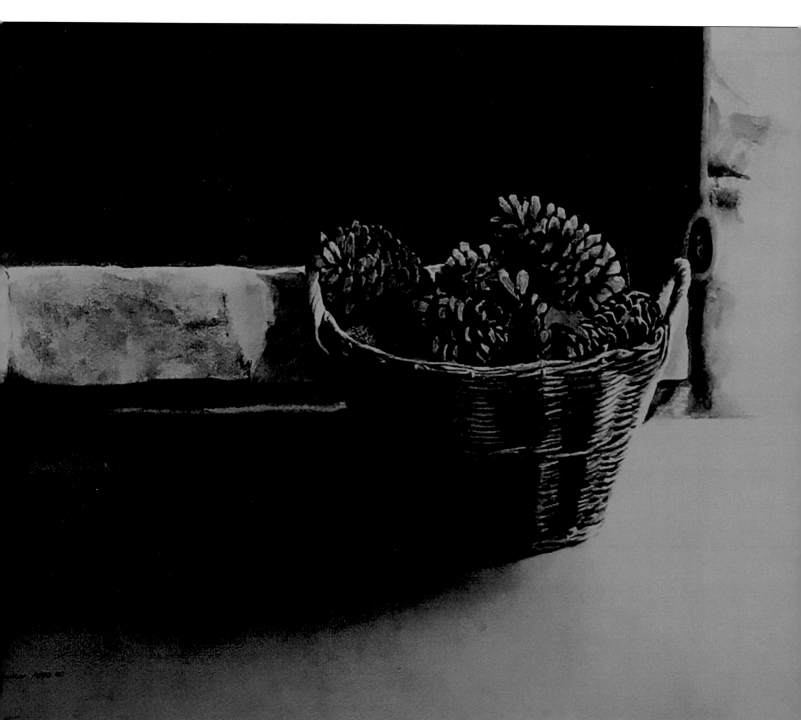

Bon Ami Mines

A number of years ago Murray Wentworth and Franklin Jones, two New England painters, and I were painting plein aire (on site) near a little town known as Gooch Gap, NC. The weather had gotten rather hot and I was concerned that Murray was about to have a heat stroke. We went into the old Bon Ami Mines to cool off. The cavern was nice and cool so we set up shop looking out the entrance. We painted for several hours until the heat subsided and then made our way back to our cabins. I had my sketchbook and fortunately one piece of watercolor paper left. I used the sketchbook for color preliminaries and painted the landscape with waterfall from the entrance of the mine.

Rock and Turf Study
Watercolor on sketch pad, approx. 28" x 18" (71.12 x 45.72cm)

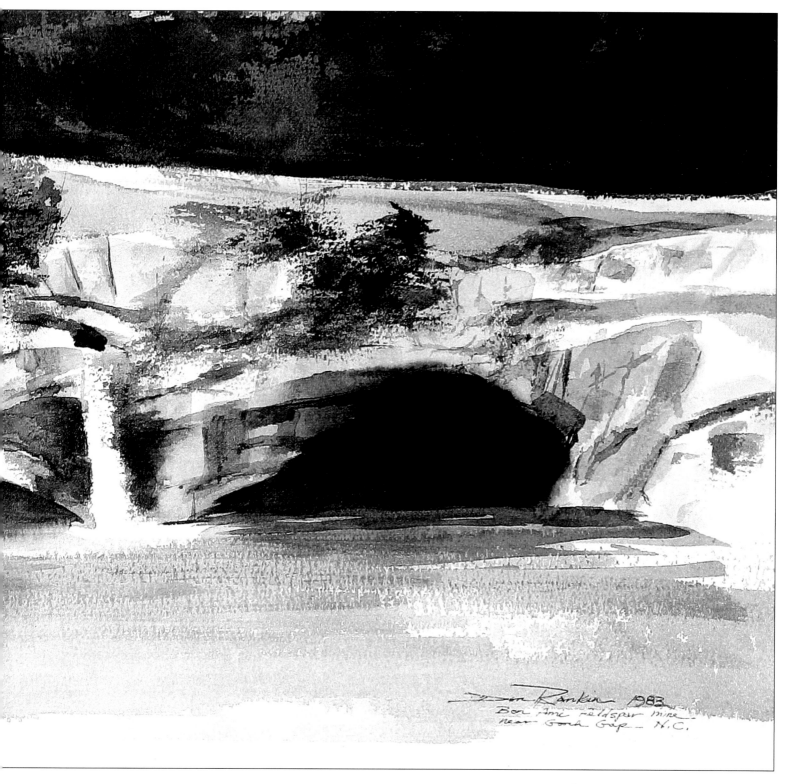

Bon Ami Mines

Watercolor on paper, 18" x 12" (45.72 x 30.48 cm)

Artist Collection.

Samford University Sketches and Watercolors

During my tenure as an Assistant Professor of Art at Samford University I made numerous sketches of the campus. At some point in their development I required all of my students to work outdoors. No matter cold or light drizzle, except for lightning or high winds, we worked outside, especially in advanced drawing and watercolor. I wanted them to gain experience with the ever changing light. Some of my finished paintings were used as Commencement Covers and for other memorabilia. Some of them are featured here.

Divinity Center Sketch
Pen and ink quick study, 10" x 8" (25.40 x 20.32 cm)

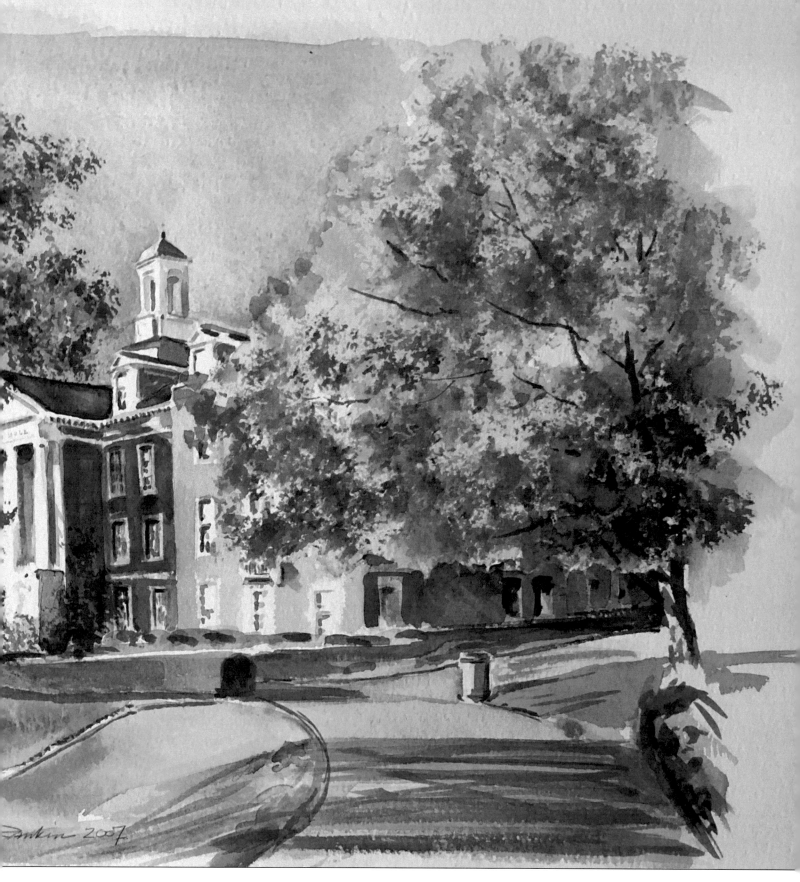

Fall Colors

Watercolor on paper, 15" x 12" (38.10 x 30.48 cm)

Many years ago this colorful tree stood near the Administration Building.
Long since cut down, it provided a wonderful subject for a demonstration.

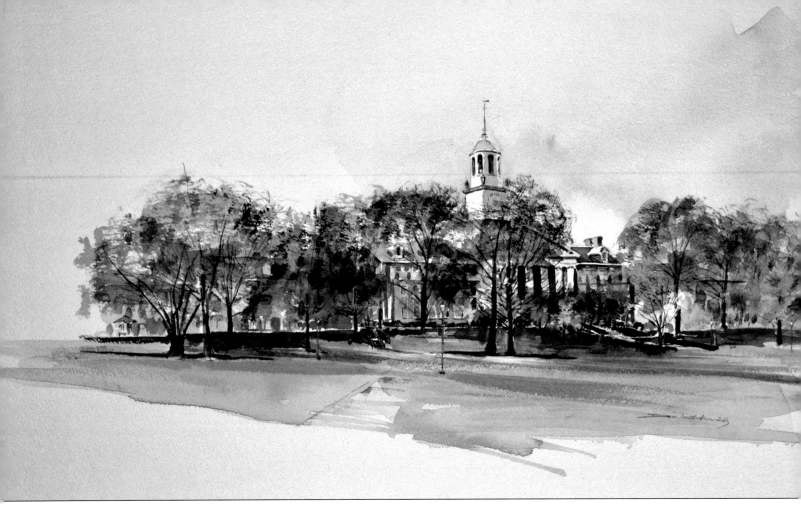

Harwell G. Davis Library

Watercolor on paper, 28" x 17" (71.12 x 43.18 cm)

The Davis Library was the first painting selected for use by the university.

The Wright Center

Watercolor on paper, 20" x 18" (50.8 x 45.72 cm)

This watercolor was used for a Commencement Cover and on other printings by the University. The Wright Center is very familiar to most visitors who come onto campus. Many events are hosted there. At one time the School of the Arts studios were a part of the overall building.

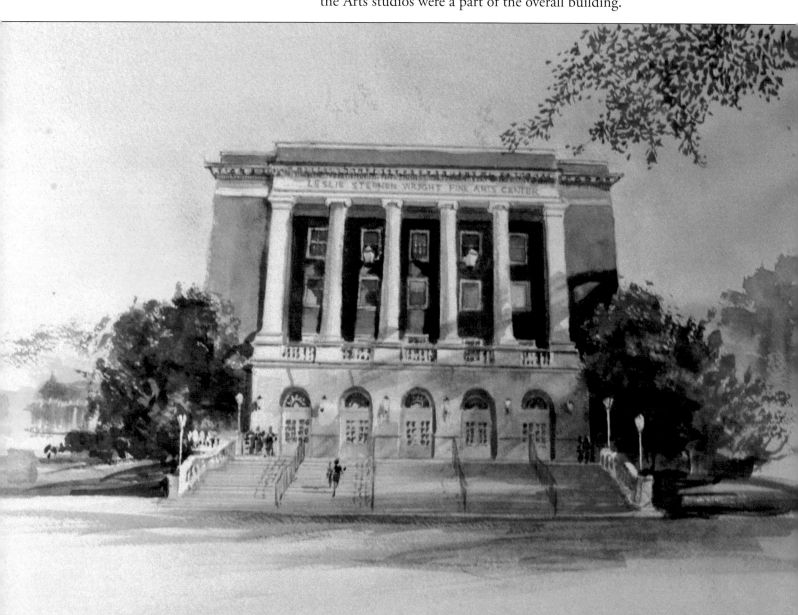

The Tunnel

Watercolor on paper, 30" x 22"
(76.20 x 55.88 cm)

Students dubbed this stretch of campus
"The Tunnel" for during the spring and
summer the foliage creates a canopy of
shade that goes down the sidewalk past
several buildings. I captured the scene on a
bitterly cold, but clear, February day when
only the hardiest ventured out.

Painting Outdoors

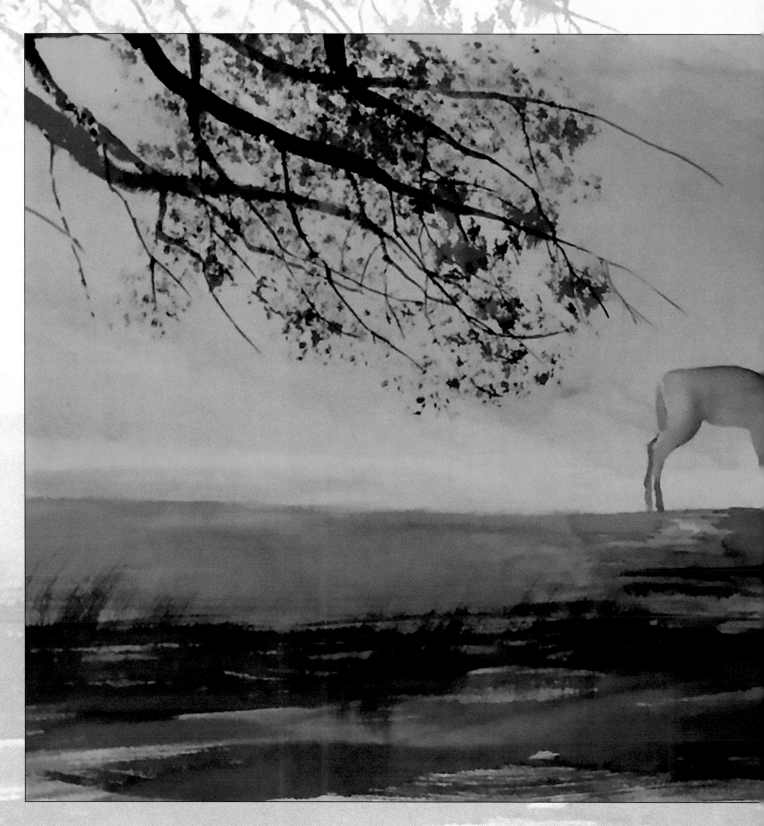

The creative habit is like a drug. The particular obsession changes, but the excitement, the thrill of your creation, lasts.

—**Henry Moore**

❖ ❖ ❖ ❖ ❖ ❖ ❖

Painting from nature is not copying the object; it is realizing one's sensations.

—**Paul Klee**

Dawn
Watercolor on paper, 25" x 13"
(63.50 x 33.02 cm)

Painting Outdoors

All of my works have their beginning as a result of an encounter. Many of them are developed in the studio from field sketches, while others are started and totally finished in the field. There is something about painting outdoors that is unsurpassed. The total immersion in ever changing light and fickle breezes, as well as all sorts of biting and stinging visitors, not to mention unexpected human visitors, can add spice to your work. For a lot of folks it is too overwhelming. However, in my mind the rewards outweigh any momentary inconvenience.

Most of my outdoor work is close to home. However, there were times when I painted in other parts of the country either while traveling or doing painting workshops. My experiences with outdoor work falls into two categories — planned and unplanned. If it is planned I have some painting or sketching equipment with me. If it is unplanned then any piece of paper is fair game! These days I rarely go anywhere without a sketchbook. Admittedly, some of my sketchbook contents make no sense to anyone but me. But then, it doesn't have to. It is my laboratory of sorts where I work out all kinds of ideas dealing with shapes, values, etc. One thing remains constant. My sketches act as a time machine transporting me back to the place and the moment I began to sketch. I smell the smells, hear the sounds and interpret the colors with almost total recall. However, most often, my interpretation is not an exact photo representation. It is my distillation of the scene; my reality.

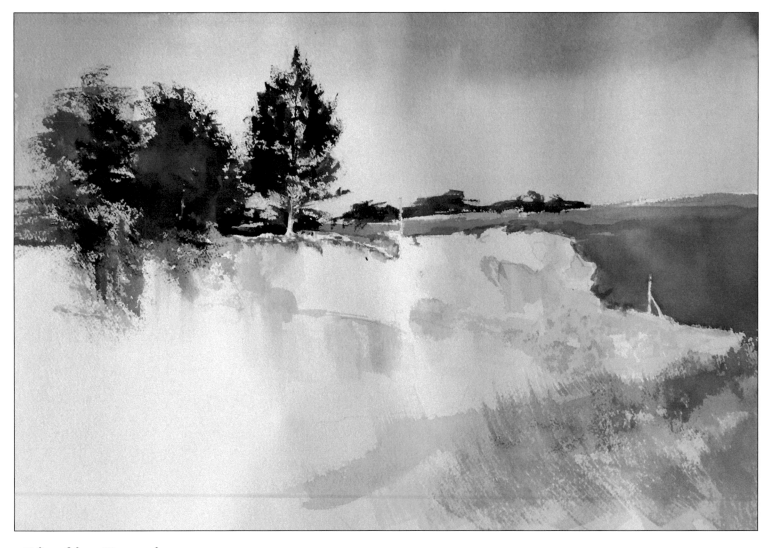

Chalk Bank

On site sketch plein aire, Watercolor on paper, 20" x 14" (50.80 x 35.56 cm)

Opposite page:

Chalk Bank 3

On site sketch plein aire.
Watercolor on paper, 14" x 20"
(35.56 x 50.80 cm)

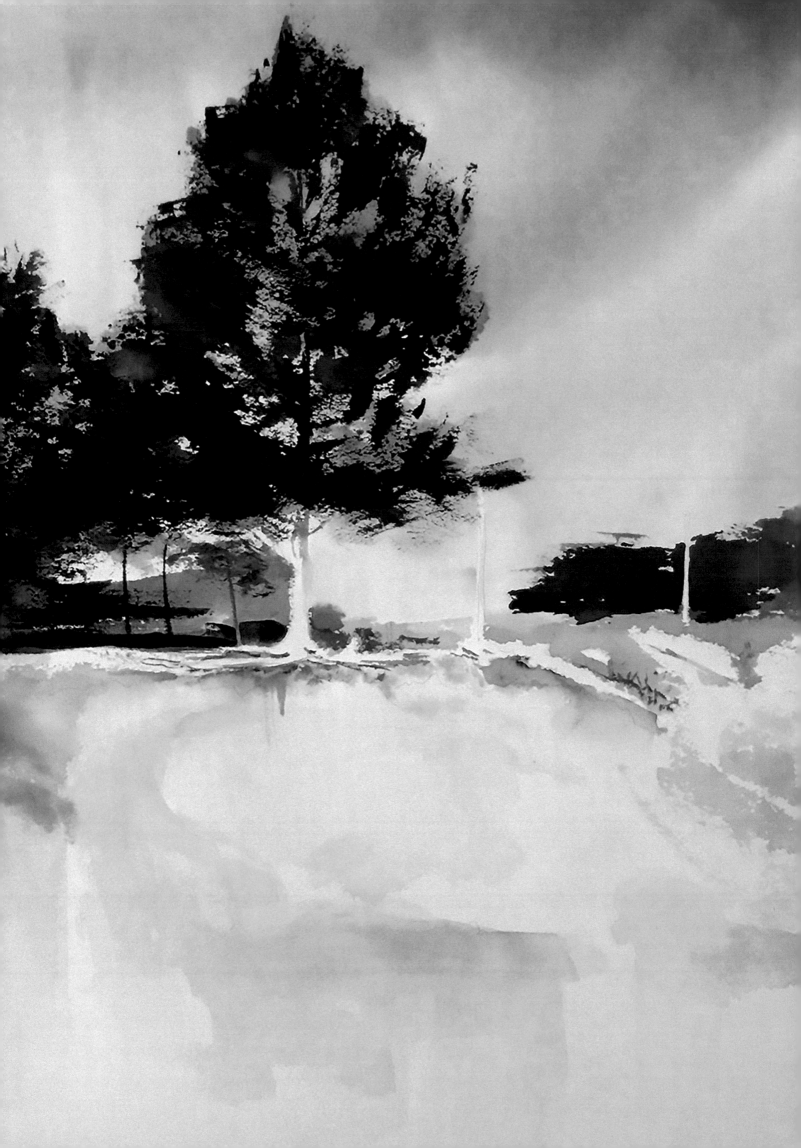

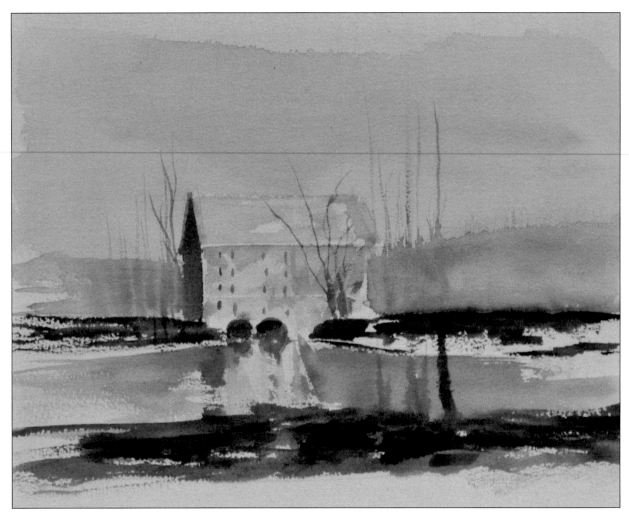

Brandywine, March

Watercolor on paper, 10" x 8" (25.40 x 20.32 cm)

Misty Landscape

Watercolor on paper, 11" x 5.5" (27.94 x 13.97 cm)

Artist Collection.

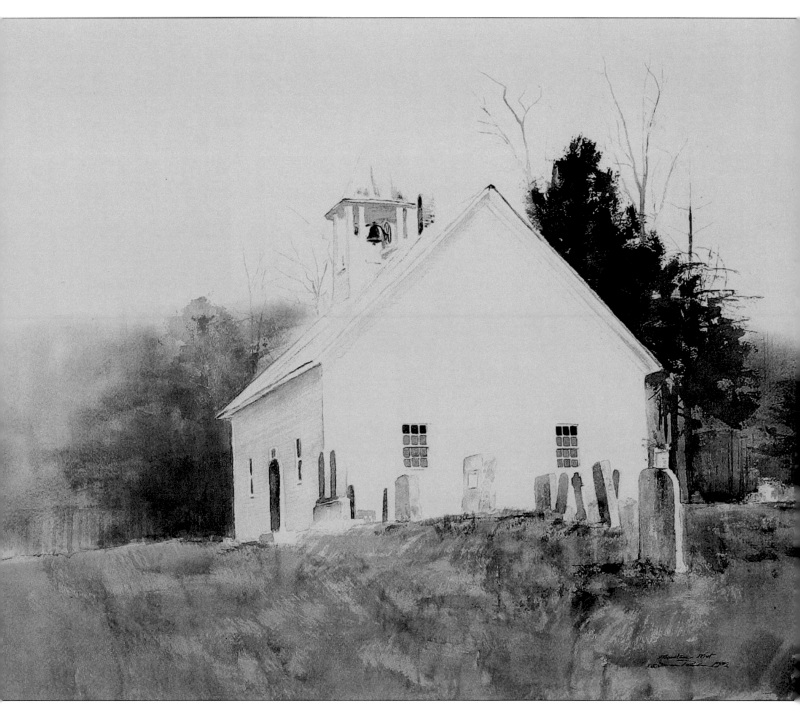

Mountain Mist

Watercolor on paper, 27" x 23" (68.58 x 58.42 cm)

Private Collection.

Range River
4 PM 64° End of Low Lake

Boundary Waters

Sketchbook, 12" x 9" (30.48 x 22.86 cm)

SATURDAY morning
lecture in blueberry patch.

The Lecture Spot

Sketchbook, 12" x 9" (30.48 x 22.86 cm)

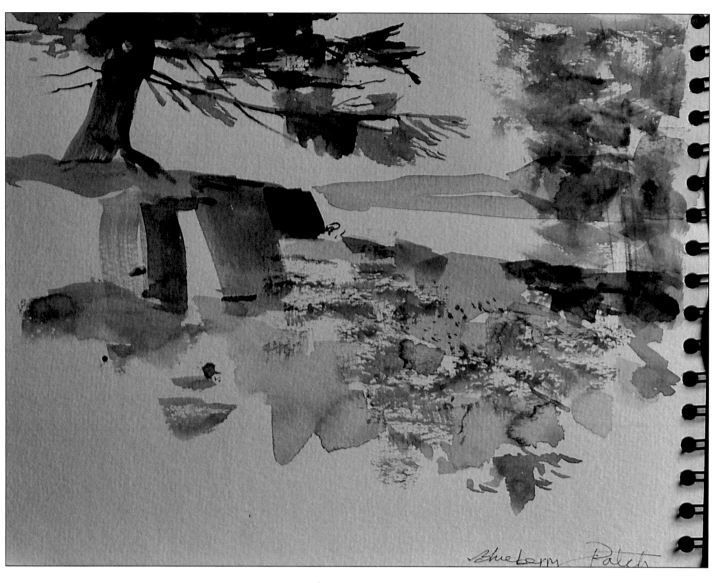

Boundary Waters 2
Sketchbook, 12" x 9" (30.48 x 22.86 cm)

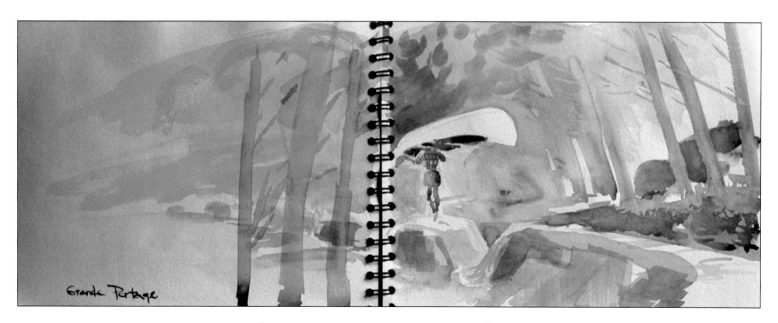

Boundary Waters Grande Portage
Sketchbook, 24" x 9" (60.96 x 22.86 cm)

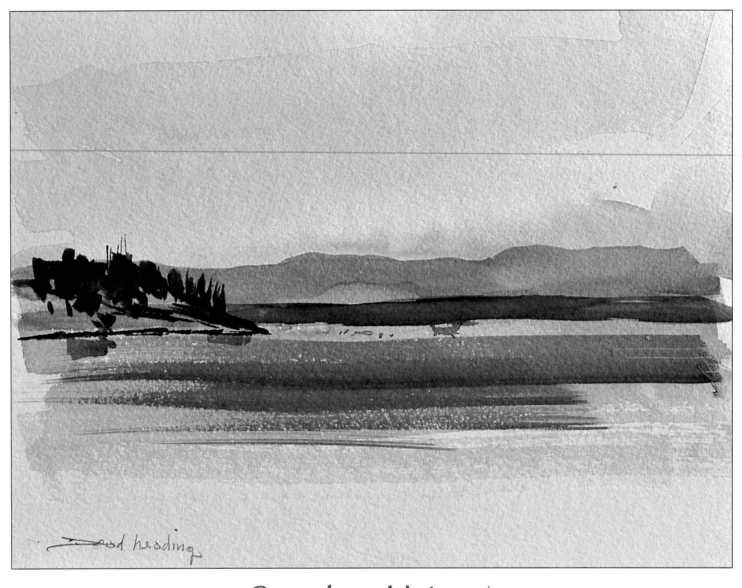

Boundary Waters 4
Sketchbook, 12" x 9" (30.48 x 22.86 cm)

Boundary Waters 6
Sketchbook, 24" x 9" (60.96 x 22.86 cm)

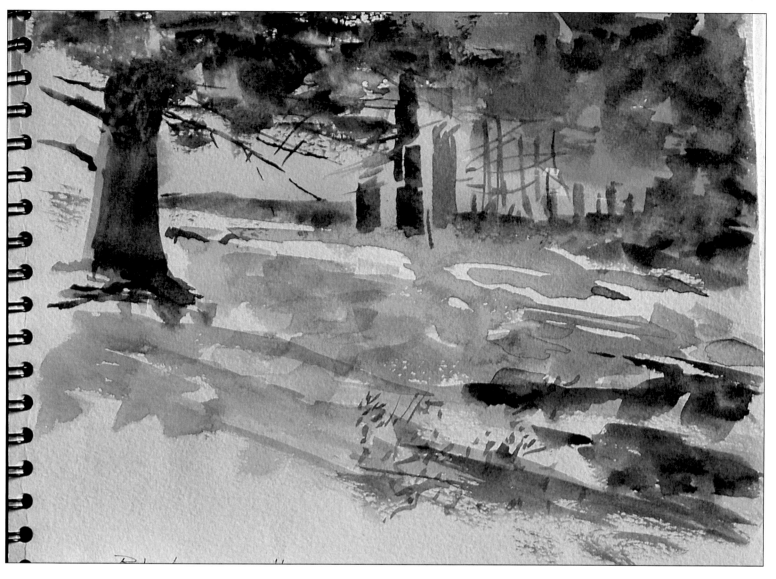

Blueberry Field

Sketchbook, 12" x 9" (30.48 x 22.86 cm)

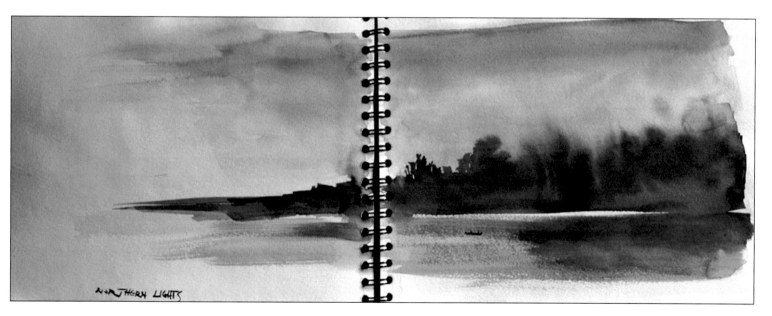

Northern Lights

Sketchbook, 24" x 9" (60.96 x 22.86 cm)

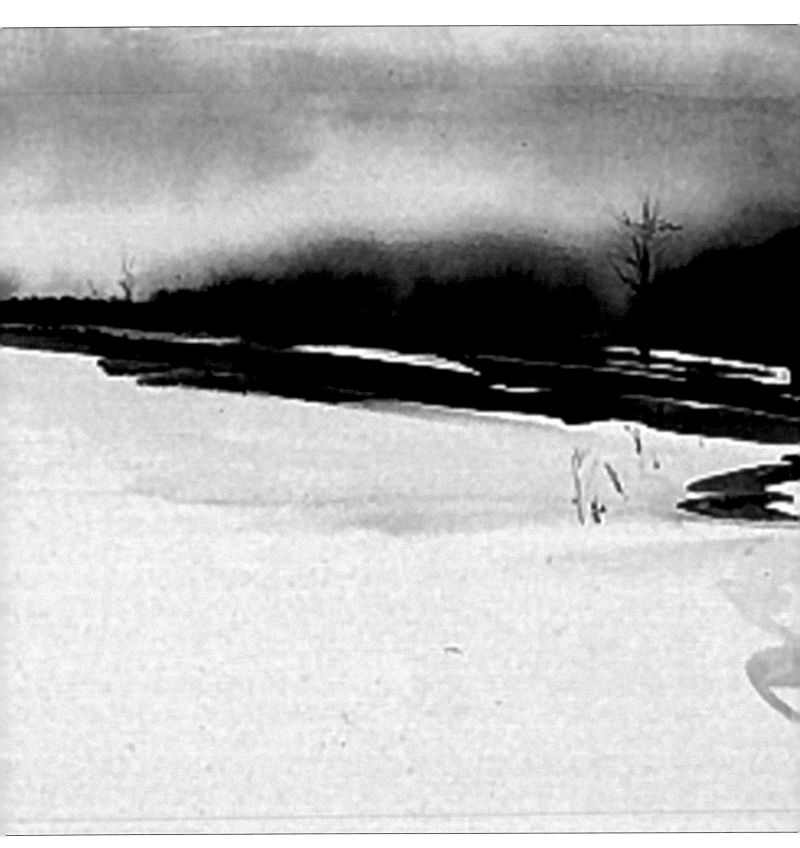

Melting Off

Watercolor on hot-pressed watercolor board, 16" x 7" (40.64 x 17.78 cm)

Corporate Collection (Originally purchased by SONAT, Inc.).

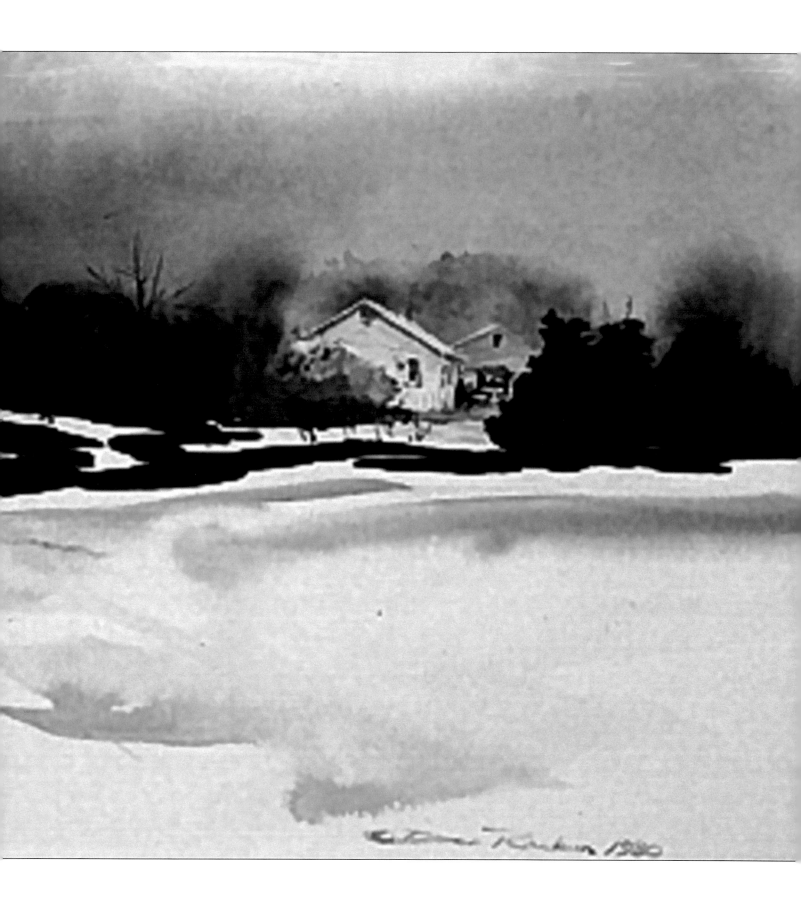

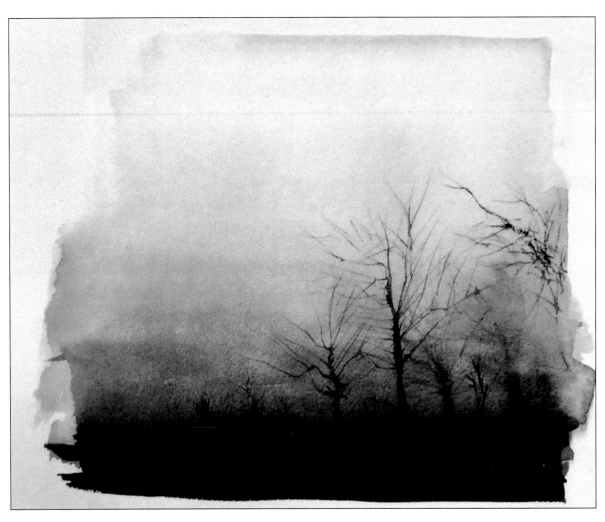

Night Fall

Watercolor on paper, 9" x 8.5" (23 x 22 cm)

Private Collection.

St. Clair Barn

Watercolor on paper, 20" x 14 " (50.80 x 35.56 cm)

Artist Collection.

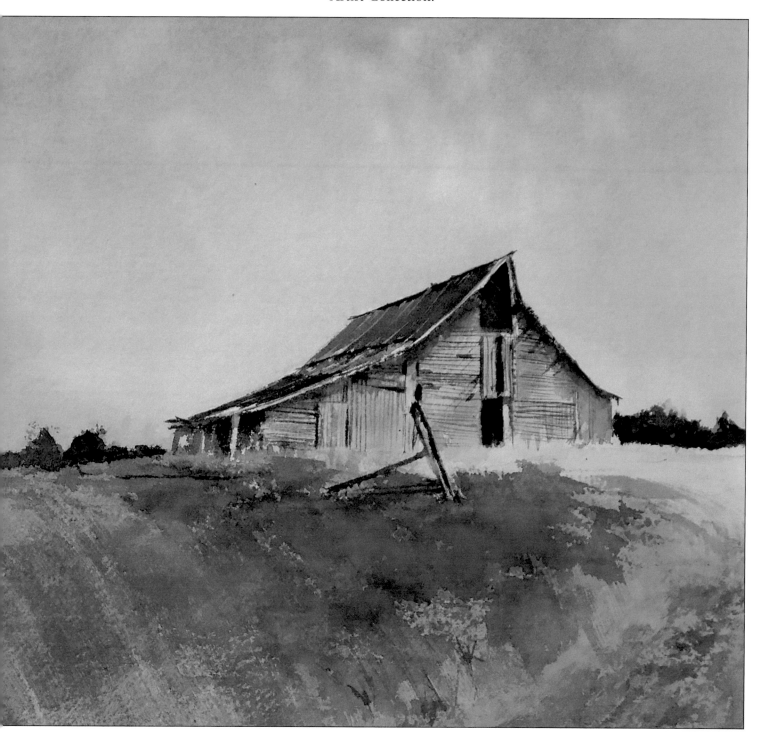

Cades Cove Sketch

Marker on paper, approx. 14" x 11" (35.56 x 27.94 cm)

Onsite marker sketch for a series of watercolors of the Primitive Baptist Church
in Cades Cove, Tennessee.

Cades Cove

Plein aire sketch, Watercolor on paper, 20" x 14" (50.50 x 35.56 cm)

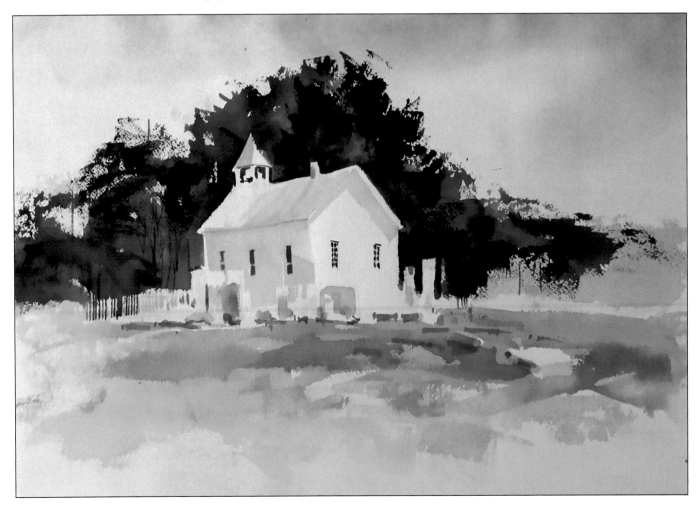

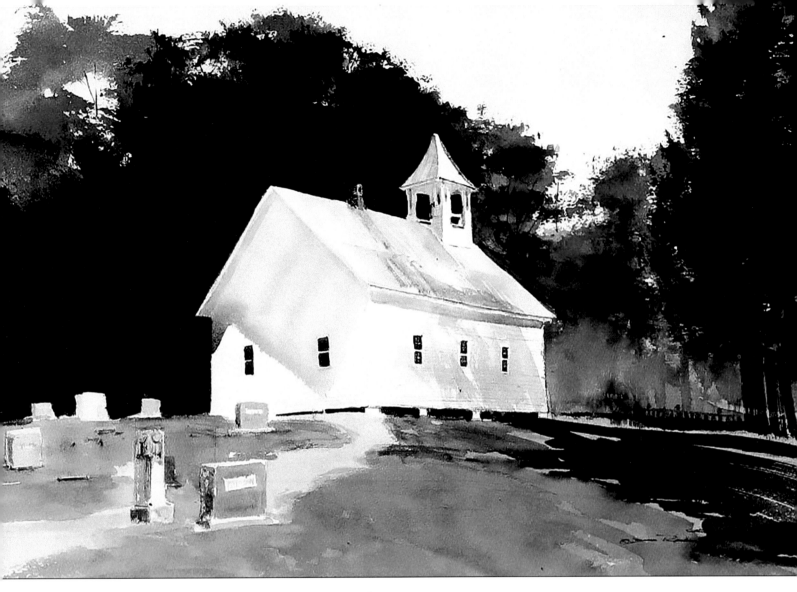

Cades Cove
Watercolor on paper, 24" x 10.5" (60.96 x 26.67 cm)

Artist Collection.

Cades Cove Study

Marker on paper, 8" x 5" (20.32 x 12.70 cm)

Following spread:
View from my Deck
Watercolor on paper, 9" x 6.5"

(22.86 x 16.51 cm)

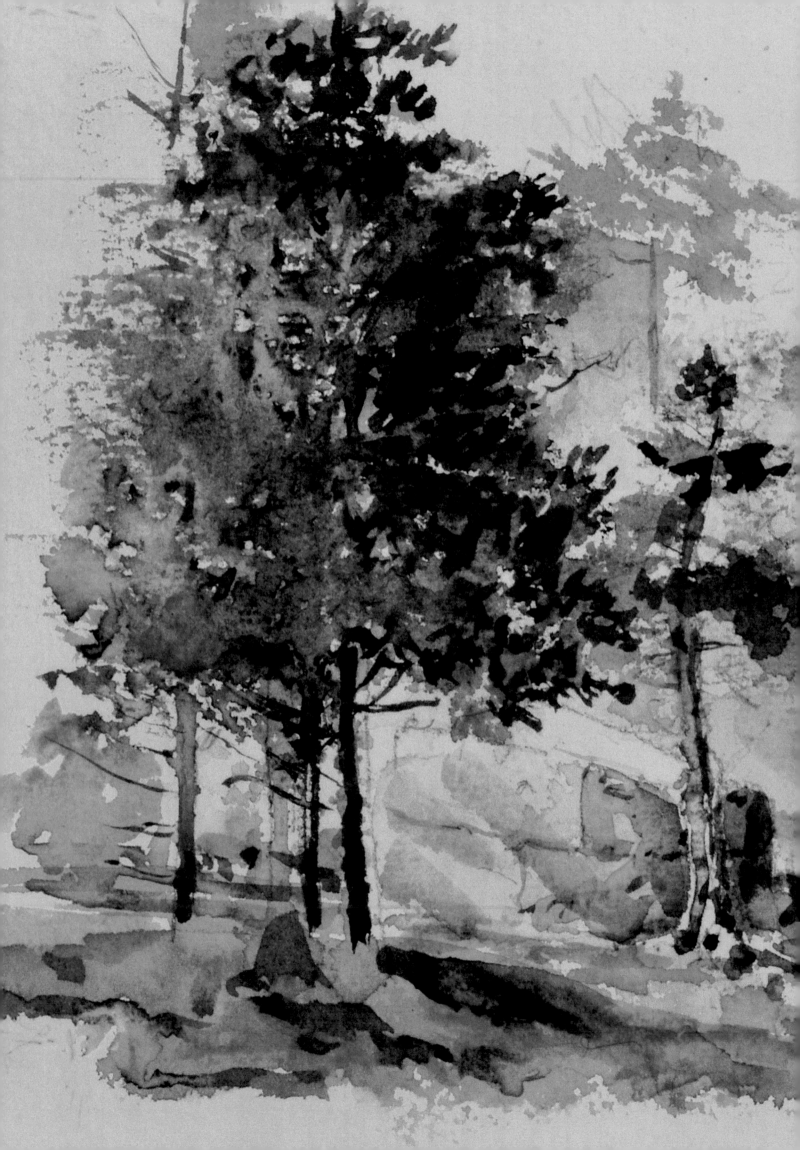

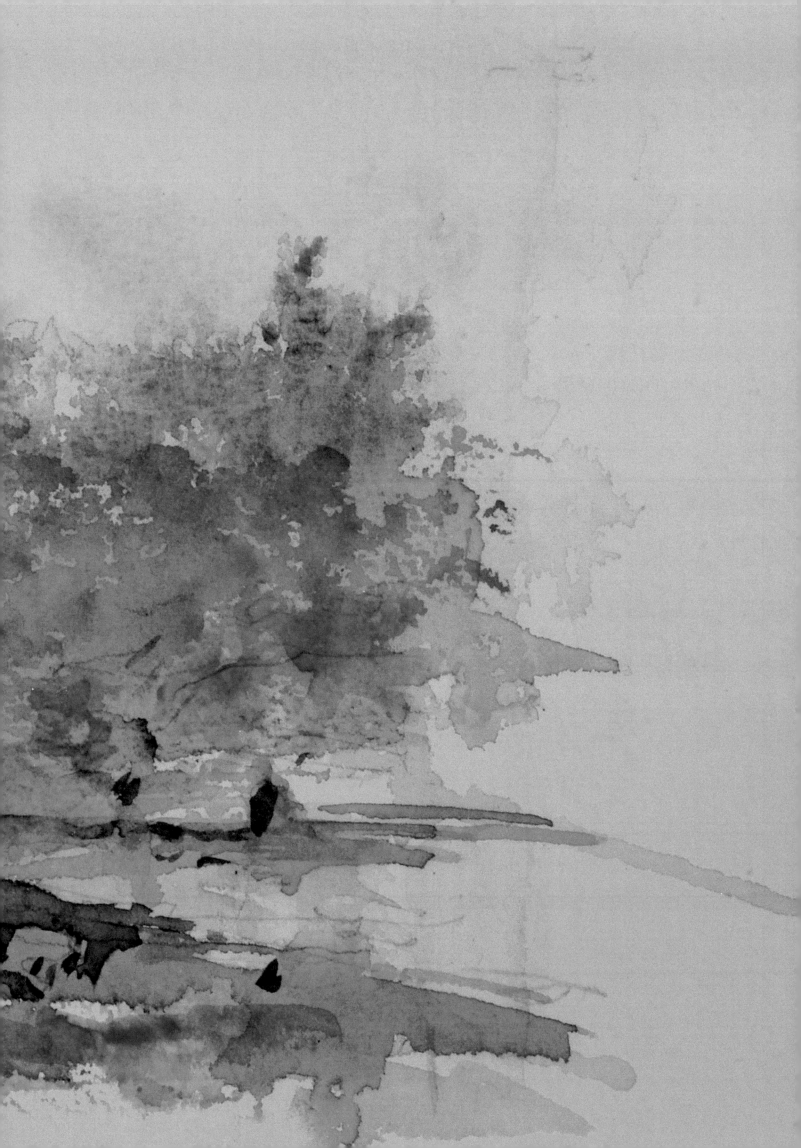

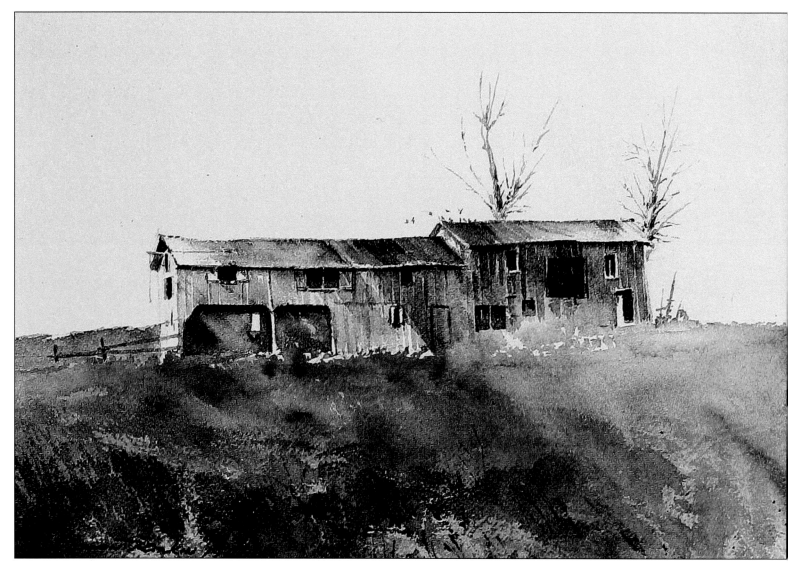

Early Winter Morn

Watercolor on paper, 12" x 9" (30.48 x 22.86 cm)

Corporate Collection (Originally purchased by SONAT, Inc.).

Blue Ridge
Plein aire demo, Watercolor on paper, 14" x 8.5" (35.56 x 21.59 cm)

Blue Ridge Farm
Plein aire demo, Watercolor on paper, 20" x 14" (50.80 x 35.56 cm)

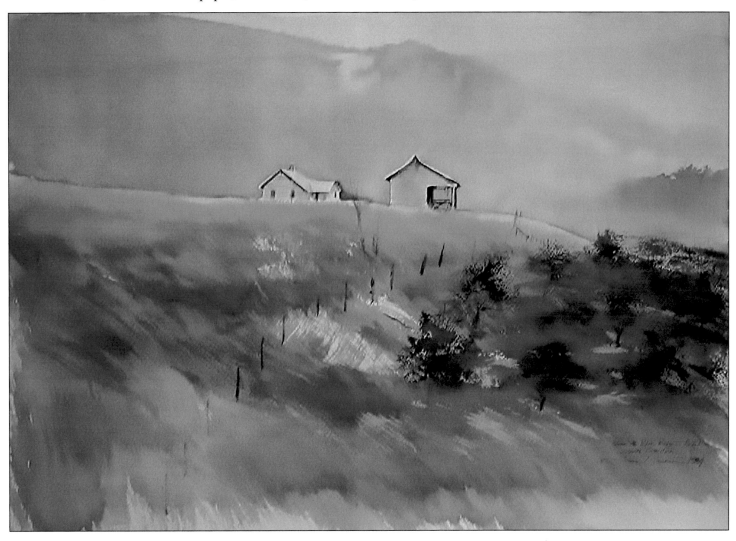

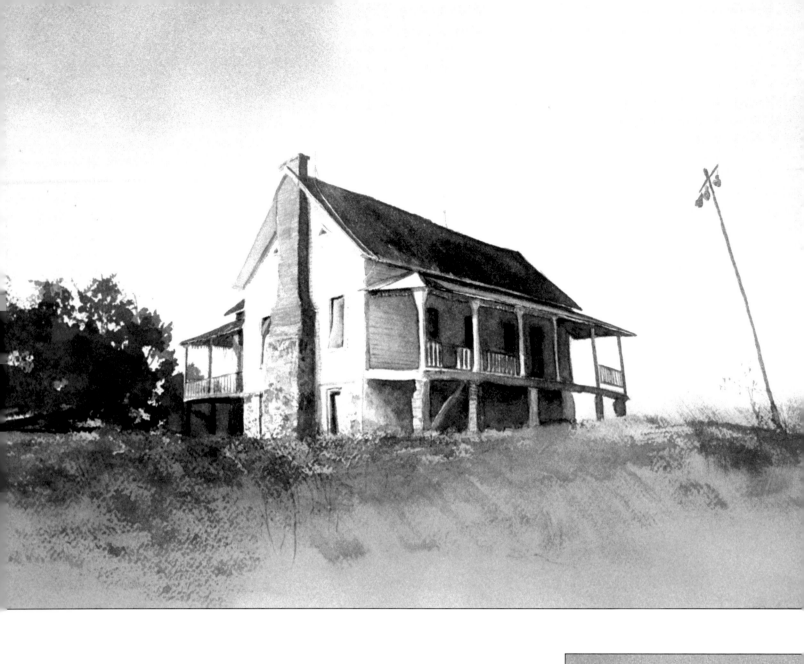

March

Watercolor on paper, 32.5" x 18.25" (83 x 48 cm)
Private Collection.

Up on Lightning Hill

Watercolor on paper, 18" x 10" (45.72 x 25.40 cm)

Traveling lightning rod salesmen used to make their rounds
through some of the communities. You could always tell they
had passed through when you saw many houses with multiple
rods on their roofs. Corporate Collection (Originally purchased
by SONAT, Inc.).

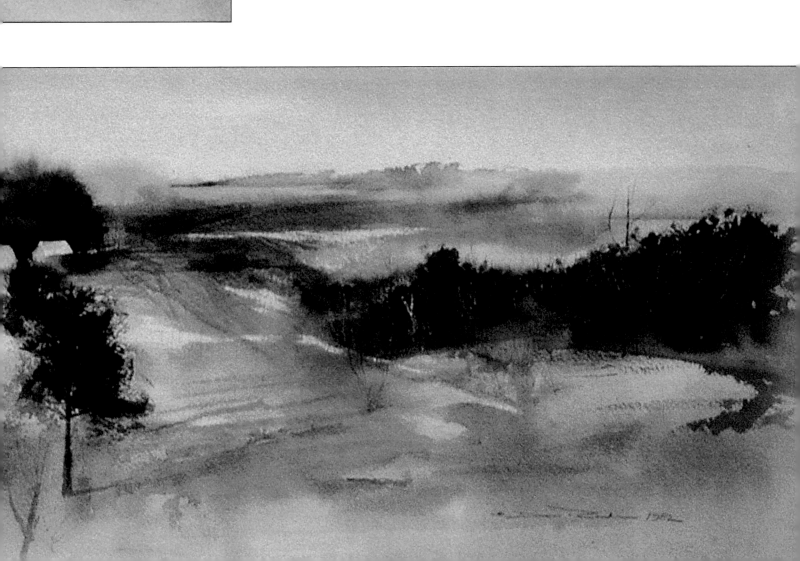

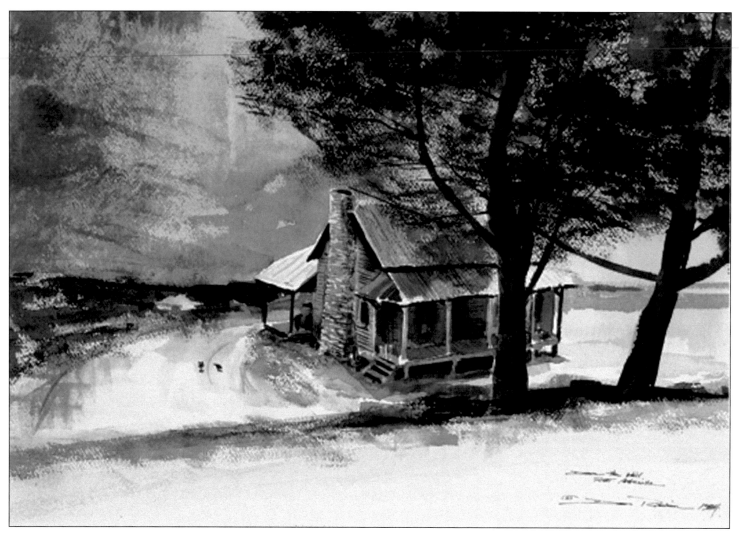

Down the Hill

Watercolor on paper, 14" x 11" (35.56 x 27.94 cm)

Corporate Collection (Originally purchased by SONAT, Inc.).

Opposite page:

Lake's Edge

Watercolor on paper, 21" x 13"
(33.02 x 53.34 cm)

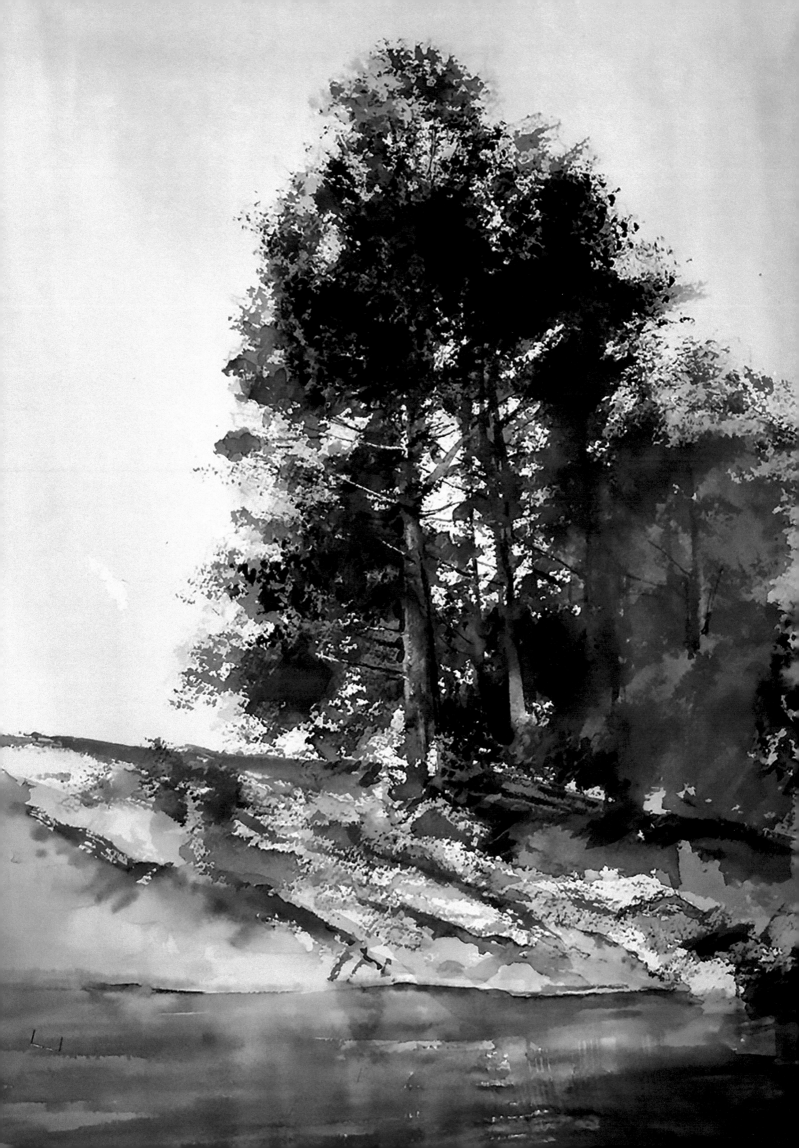

A Story Behind Every Painting

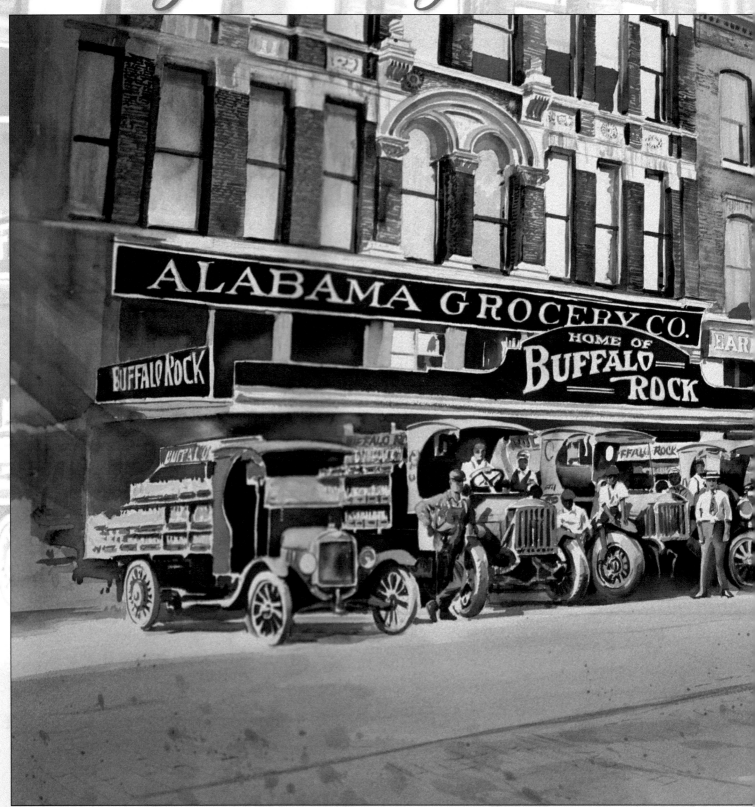

Courage doesn't always roar—sometimes courage is the quiet voice at the end of the day saying (whispering) "I will try again tomorrow."

—Mary Anne Radmacher

Old Buffalo Rock

Watercolor on paper, 37" x 29" (90.68 x 73.66 cm)

I produced a few large paintings for the Buffalo Rock beverage company. One of the pieces was derived from the company's archives and provides a glimpse of old Birmingham. Corporate Collection Buffalo Rock.

A Story Behind Every Painting (Behold I Make All Things New)

I really love wandering through the woods or along a deserted shore with no preconceived plan or motive. There is a story behind every painting but the question arises do you write about all of them? While it is not practical, there are some pieces that just need to be examined a bit. Some pieces fall into similar categories, so I'll try to group them while others perhaps stand alone. I prefer to allow the paintings to speak for themselves.

I had been injured in an automobile accident. While making a left turn, a driver hit the rear end of my car at a fairly high rate of speed. Both cars were totaled. After weeks of pain and physical therapy it looked as if I would be on a cane for the rest of my life. The lawyers in the case had been less than faithful and things were looking pretty grim.

About 250 feet from my old studio door was one of my favorite painting spots. We had had abundant rain and I wanted to see the edge of the creek where the water ran over the rocks. I set out with my cane, wondering if I would ever be able to hike my special spots again. The flowing of the water was touching a portion of the ground that was covered with the remaining dead leaves of winter. Midst all the decay, new life was sprouting, peeking its head from beneath. The never ending cycle prompted me to paint.

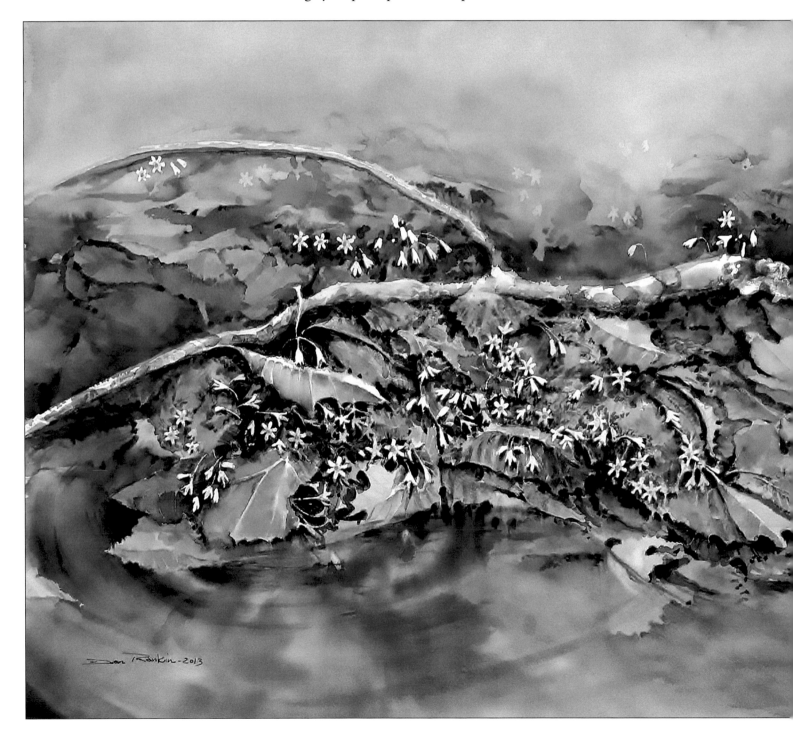

The Rest of the Story

After a while rehab and physical therapy was terminated and the lawyer failed miserably. He didn't even have the decency to face me with the less than stellar news. Then a wonderful thing happened. Prior to the accident I had survived four major heart attacks. I recently learned that the doctors had prepared my wife that it was not likely that I would survive very long due to the damage. In fact, for several years I was instructed to not be more than forty-five minutes away from the hospital heart unit. So travel, even short trips, was out of the question.

In August 2013, I was sitting in a Torah study at Beth Hallel, a messianic congregation, when Rabbi Solomon was teaching. Suddenly he stopped his teaching and explained that he was stopping for a reason. He said that he felt the need to pray for those with serious illness. When he asked for a confirmation I was the first to raise my hand. I got up and went toward the bema, leaving my cane behind. Realizing that I had left it I was determined to continue walking thinking that if I fell I would get back up and keep on going. He asked me what I needed and my mind was racing for I had several issues. I blurted out, "My heart!" As he raised his hand to touch me with oil, I felt the most magnificent rushing of energy a lot like a mighty wind. Two men caught me as I fell to the floor laughing with bliss. Words can't adequately describe the moment.

After about fifteen minutes, I gained my composure and stood up steadying myself with the railing. I walked back to my spot, retrieved my Bible and the cane. I carried the cane in my left hand, brought it home and to this day I have never needed or used it. I came home and cried for hours. For you skeptics the story goes even farther. My cardiologist's nurse had called on the Thursday before instructing me to meet the doctor at 10:30 AM in the local hospital. She didn't say why, just emphatically said, "Be there!" We went and the doctor did his examination. He sat and looked a bit puzzled and asked me did I know why he had urged me to meet him. I said, "No." He responded, well your monitor indicated that you had been in A-fib all of last week but your heart rhythm is perfect! I looked at my wife and at the doctor and said, "Let me tell you!" I related the whole wonderful event while he patiently listened. He said, "Okay that's wonderful but lets be scientific. Wear a heart monitor halter for the next 48 hours. If there are no repeats we will not talk about any new medications."

I agreed, assuring him that no new meds would be necessary. That was five years ago. Today I take no heart meds of any kind and my cardiologist still marvels. At my last check up he said that if I did not have a pacemaker/defibrillator in my chest he would consider my heart to be perfect!

Everyday I thank God that the lawyer failed in his efforts for if he had succeeded I would most likely have been charged with fraud! God is good and I gladly accept my healing over any man's money!

Water's Edge
Watercolor on paper, 30" x 18" (76.20 x 45.72 cm)

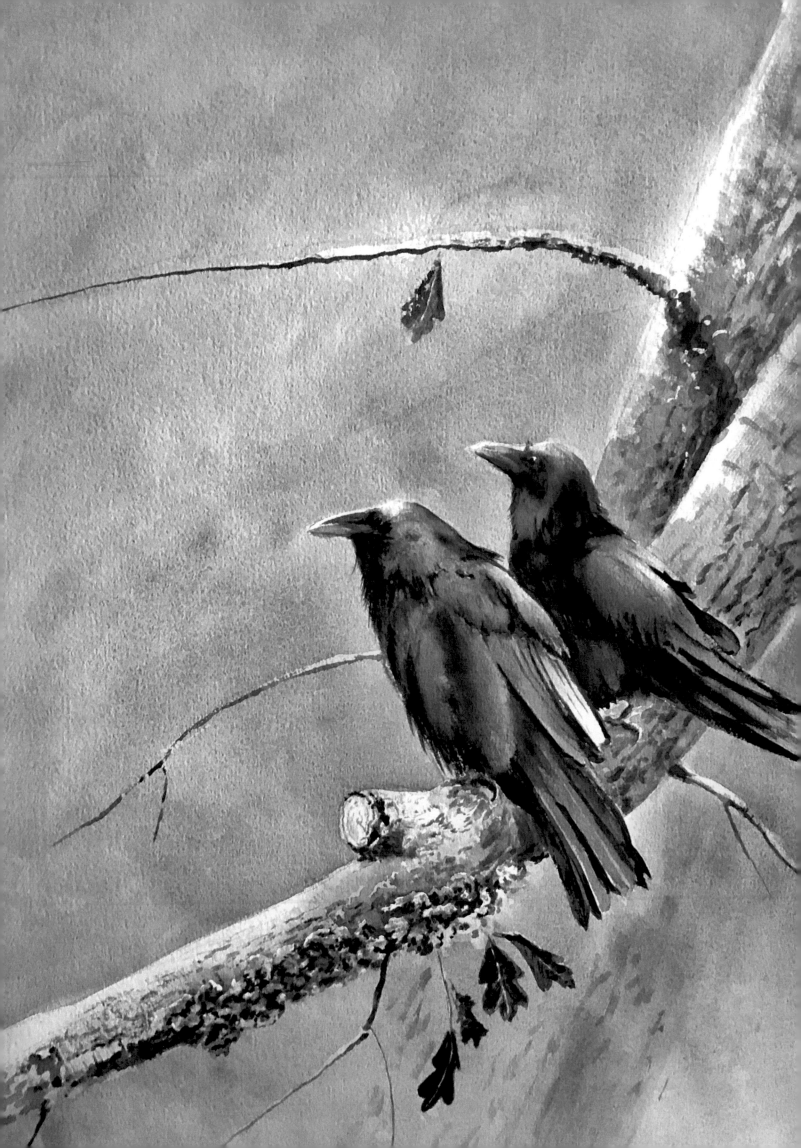

Birds of a Feather

Watercolor on paper, 22" x 30" (55.88 x 76.20 cm)

In the early morning mist on the Cumberland Plateau, two ravens quietly wait as the fog lifts.

I have always had a special relationship with ravens and crows. When I used to make wilderness treks the ravens would come and stay nearby. It was not uncommon for them to bring me gifts of one sort or another. Although they never brought me food; more than once I was reminded of the story of God sending the ravens to feed the prophet Elijah as he hid out east of the Jordan river. In 1994 I had to recover from major heart surgery and three ravens camped out on our deck at the back of the house. When I would go out the front door for my mandatory recovery walks, the birds would take to the air. One flew by my side, one went ahead and one flew directly behind. When I was finished they would return to the deck and await my next walk. When I recovered, they left as quietly as they had appeared. My late wife was unnerved by my companions but I counted them as friends. Some of my extended as well as adopted family on the Six Nations of the Grand River Reserve in Canada considered my companions to be perfectly natural.

Prior to the events of 9/11 I made the Grand Portage from Ely, Minnesota into Canada via canoe. When I would be some distance from my traveling companions the birds would come to be near. At times they would be vocal at times they would be silent, waiting, watching

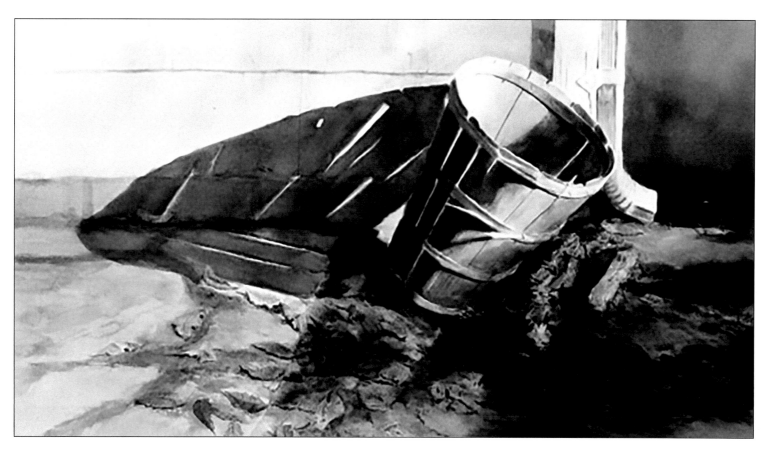

Autumn Light

Watercolor on paper, 22" x 30" (55.80 x 76.20 cm)

This was a discarded hamper that had contained fresh ears of corn. It was placed at the rear of our old house. I couldn't help but notice it at different times of the day. For most people this would be a very uninspiring subject. However, toward the afternoon the sunlight found its way into the interior of the hamper. An ordinary humdrum object became something fascinating! Corporate Collection (Originally acquired by Sonat, Inc.).

Shoal Creek

Rarely have I done commissions. The following group of paintings reflect a few of those times. Mr. Hall Thompson approached me about painting the Shoal Creek Golf Course. Our arrangement was simple. I had access to the grounds and was given use of a golf cart. I rode over the course for several days sketching and painting. After I had completed my work Mr. Thompson picked the pieces he wanted to purchase and I kept the rest. Some of the other pieces wound up in either private or corporate collections. Unfortunately not all were available to be photographed.

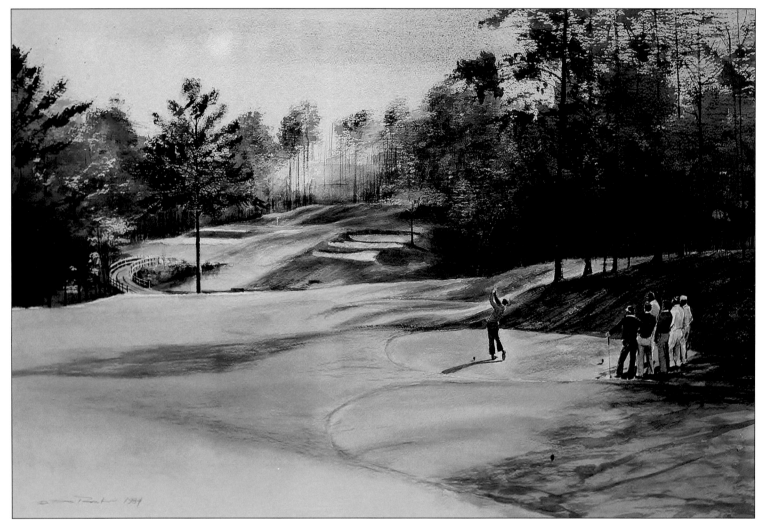

Foursome on Thirteen, Shoal Creek
Watercolor on paper, 18" x 24" (46 x 61 cm)
Shoal Creek Collection.

Opposite page:
Hole Number Five, Shoal Creek
Watercolor on paper, 40" x 24" (102 x 61 cm)
Shoal Creek Collection.

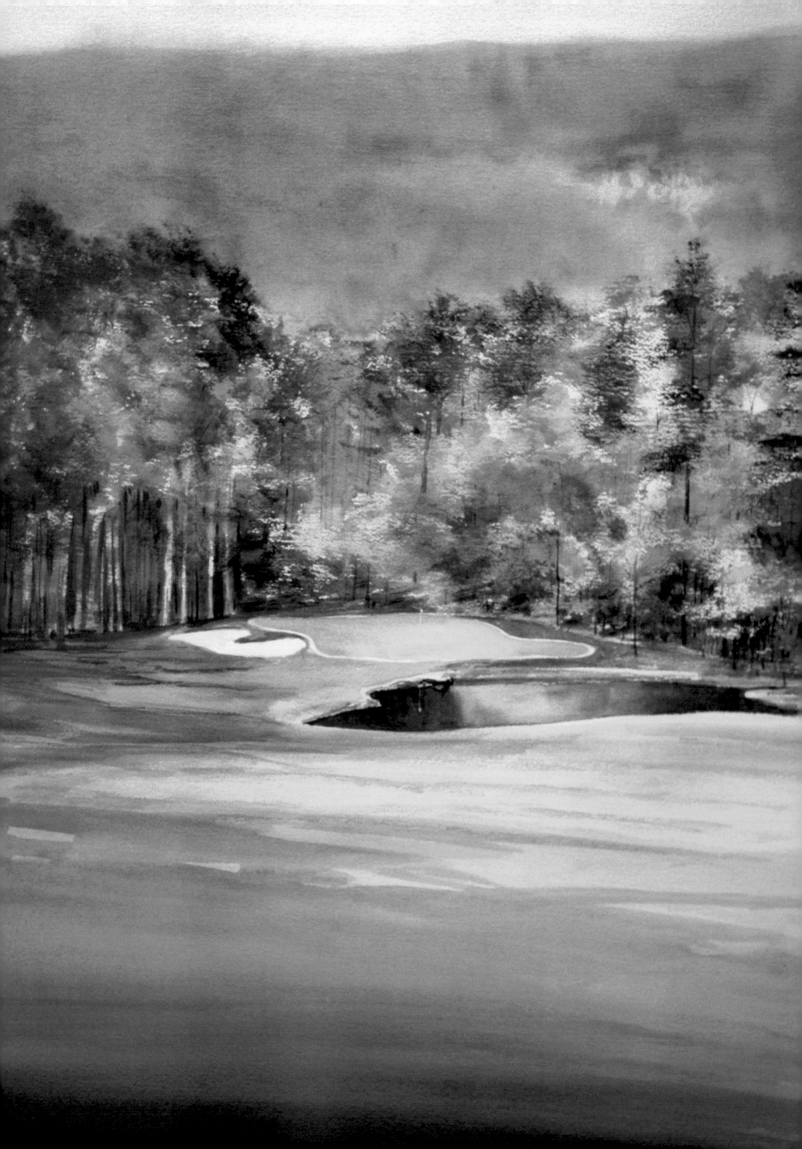

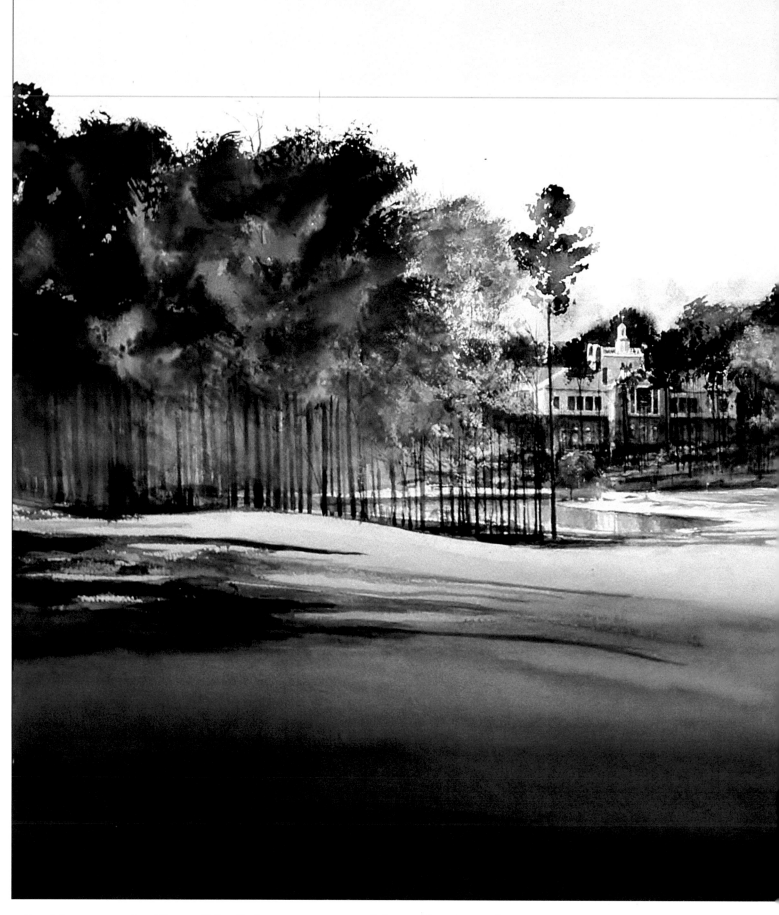

A View of the Clubhouse at Shoal Creek

Watercolor on paper, 24" x 40" (61 x 102 cm)

Shoal Creek Collection.

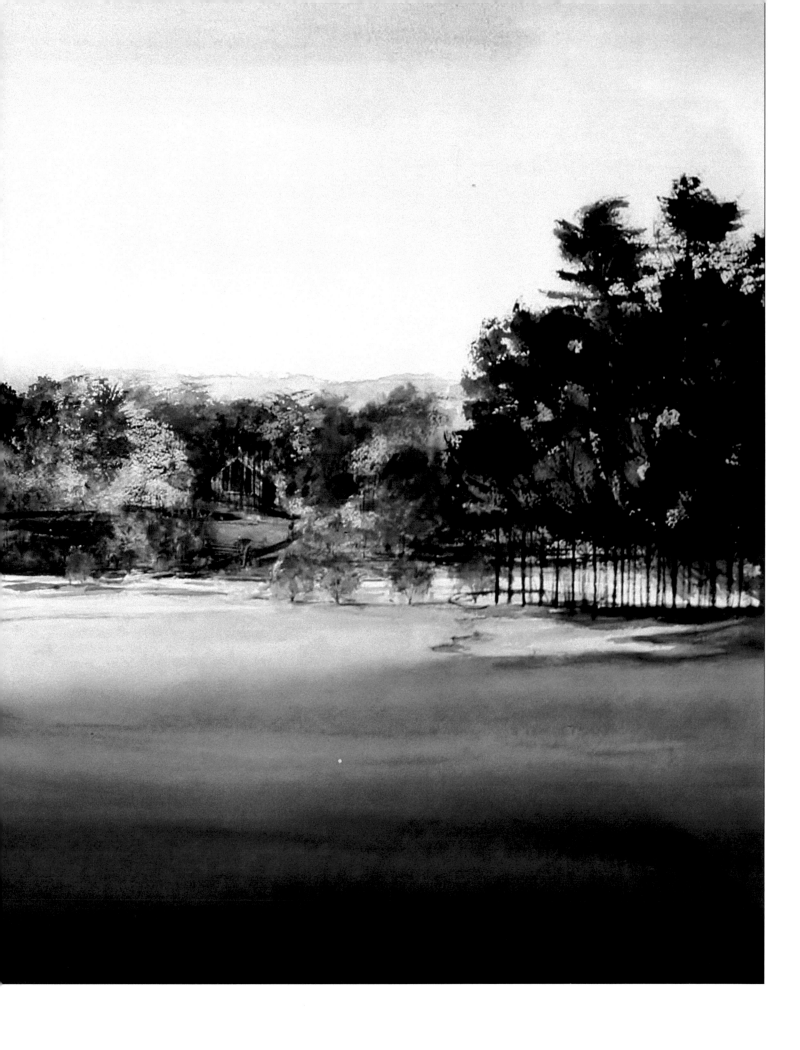

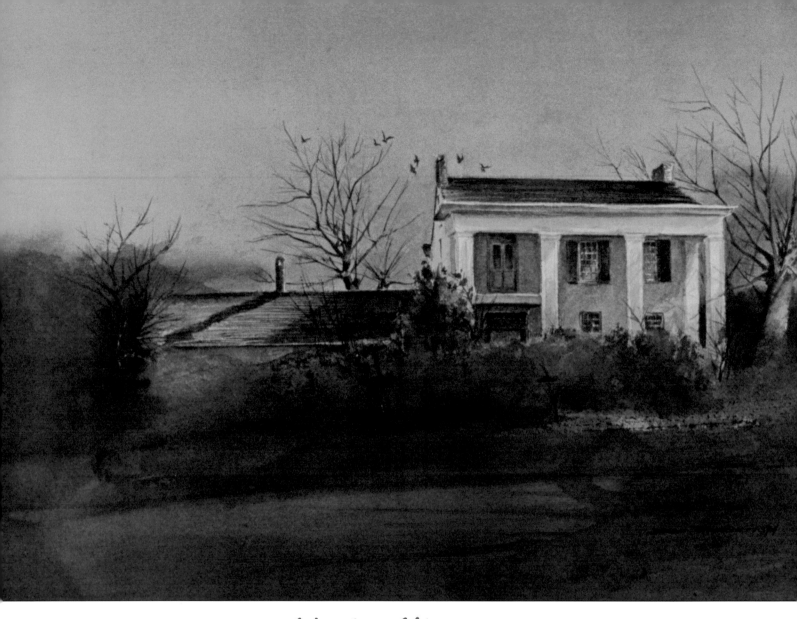

Winter Afternoon
Watercolor on paper, 21" x 13" (53 x 33cm)

In many ways *Winter Afternoon* was a major turning point, even though at the time I had no idea it would turn out that way. I was the Art Director of an important advertising agency. The First National Bank of Tuskaloosa, yes it was spelled with a "k" as a part of an old land grant, was a major client. I was approached by the agency owners about painting a series of watercolors for this client. I was a bit apprehensive, since I had had situations in the past where an employer expected me to do this sort of work as a part of work product with no additional compensation. In this case, all of those concerns were not justified and we made an excellent arrangement.

I was given the tour of possible sites to paint in Tuscaloosa. The idea was to create watercolors that would be used as covers for the bank's annual report. We searched all day and I was mildly motivated. So, we decided to call it a day and my guide was taking me back to my car. Suddenly we passed this old dilapidated house with bushes growing up around the front. The moment I saw it I yelled, "STOP!" One of the bank officials, Gerald Busby, was driving and he stopped. I began to talk about the house and got out, starting to sketch, and also took some photos. Gerald was reluctant and kept shaking his head saying, "Well, I don't know." We made a deal that I would paint the picture and he could show it to the bank president. If they didn't like it, no problem, but I HAD to paint that house! I competed the painting and was ushered into the office of Mr.

Frank Moody, the bank president. Mr. Moody looked at the watercolor and began to ask me questions. Finally, he pointed to some birds I had painted as they flew from the side of the house.

He asked me why I painted them in there. I responded that it just seemed like they needed to be there. He looked at me with one of those very strong gazes…it seemed like an eternity. Then he began to tell me that when he was a boy he had lived in that house and had kept pigeons and the area where I had painted the birds was their roosting place!

Suddenly I realized why Gerald had been so hesitant. Until that moment I did not know that the house had been Frank Moody's home.

Winter Afternoon made the cover and stirred a great deal of interest in the community while winning one national and several regional design awards. Mr. Jack Warner, a prominent businessman and art collector, got involved and the house was restored and became an historical landmark open to the public. In addition, the bank arranged for limited edition reproductions to be made of all of the series of paintings. They gave them away to customers who would appreciate them. Very soon they became a hot commodity among interested parties who began to sell their prints when the supply ran out.

Later, in 1980, the painting would grace the pages of *American Artist magazine's Watercolor Page* and gain the attention of a large Pennsylvania Publisher. Never under estimate the power of an image!

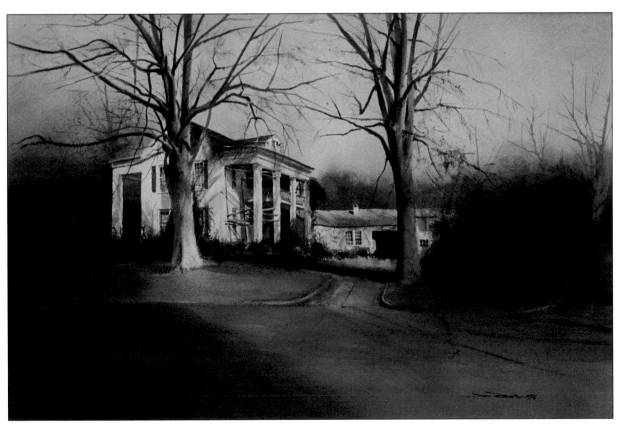

Winter Afternoon II

Watercolor on paper, 29" x 19" (73.66 x 48.26 cm)

Private Collection. The old house was often called the "Janus House" because the front and back of the house was identical. I was drawn by the late winter light that was breaking through the trees and surrounding structures.

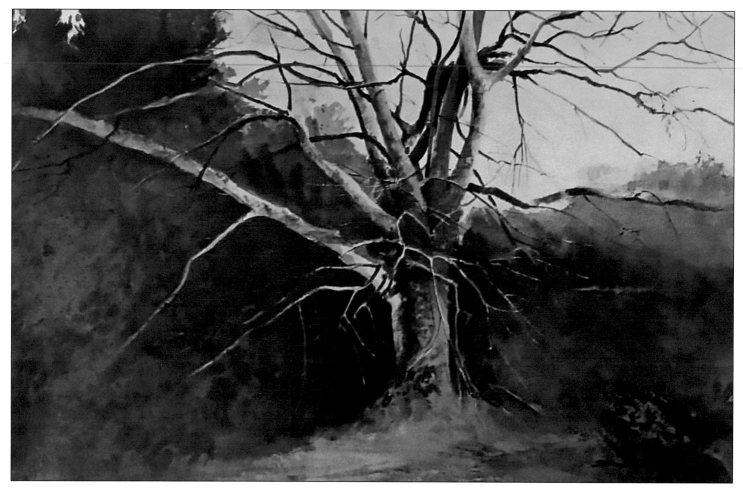

Path to Newtown

Watercolor on paper, 20" x 13" (50.80 x 33.02 cm)

Path to Newtown was the second watercolor in the series of four watercolors for the First National Bank of Tuskaloosa. Newtown was the name of the original settlement that became the city of Tuscaloosa. The story goes that the town was founded by the first white settler, Mr. Thomas York, in May 1816. Early on the name "Falls of Tuscaloosa" was applied to the location. Many people know that the name Tuscaloosa belonged to an Indian leader in the area who was said to be a giant so large that his feet touched the ground when he attempted to ride a horse.

When the 1819 charter was issued, only the name "Tuscaloosa" was used to designate this new municipality. The path is now marked by a pair of beech trees that stand like silent sentinels marking a path that was blazed by the first settlers in the early 1800's.

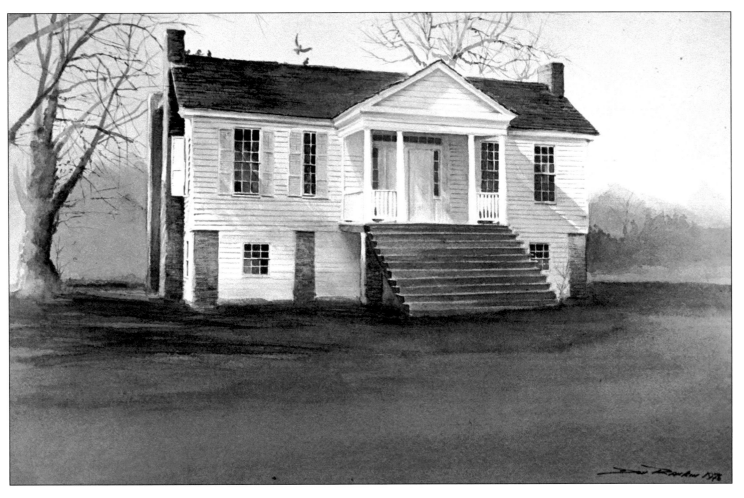

The Strickland House

Watercolor on paper, 21" x 13" (53 x 33 cm)

This was the third in the series of paintings and is listed as the oldest wooden framed structure still standing in Tuscaloosa. At the time of the painting it was called the Strickland House. However, the house was built around 1820 for Moses McGuire, the first probate judge of Tuscaloosa County. It served as the manse for the First Presbyterian Church and was occupied by the Reverend Robert B. White from 1844-1866. In 1866 Milton Strickland, a Civil War veteran, purchased the house for his family. In 1970 the Tuscaloosa Preservation Society moved the house to Capitol Park. Today it serves as a virtual museum of the Tuscaloosa area.

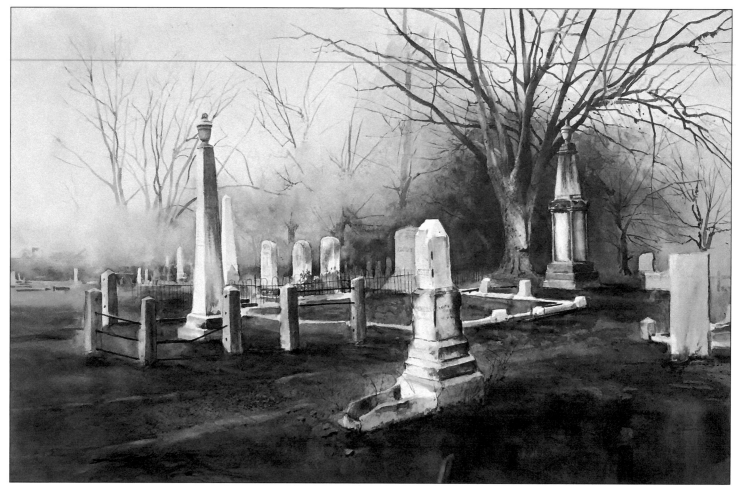

Greenwood

Watercolor on paper, 21" x 13" (53 x 33 cm)

Somehow the cemetery was a fitting end for the series. Creating a painting with the full focus on a cemetery was a new experience. This is one of the oldest cemeteries in Tuscaloosa County. Records indicate that it was laid out shortly after the first survey of the city in 1821. A number of the more prominent citizens are laid to rest in Greenwood. Among some of the most noted are Dr. John Drish, a famous doctor and landowner, as well as Mr. Solomon Perteat, a prominent free black craftsman who lived in Tuscaloosa prior to the Civil War.

Arlington

Watercolor on paper, 28" x 20" (71.12 x 50.80 cm)

Corporate Collection of Noland Company (said to be gifted to the Virginia Museum of Fine Art, Arlington, VA).

This painting was commissioned by the Noland Company for their annual Christmas card. The cards were sent out nationally as a part of their program of selecting an artist to paint a significant landmark in a selected city.

A Place Remembered

Watercolor on paper, 42" x 28" (106.68 x 71.12 cm)

Private Collection.

For several months I would pass by this house either in my car or on my bicycle. There was something special that compelled me to sketch the house. I couldn't get it out of my mind. So, I did just that and then got occupied with other paintings and allowed the idea to go on the back burner.

Later, I was working as an art director for a fairly large advertising agency when one day a stranger was knocking at my office door. He introduced himself and immediately told me that God had told him to come see me. He told me of his desire for me to paint his father's house. He even told me how much God had told

him to pay! I listened and agreed to look at the house. I went to the address and it was the house I had already sketched! He had told me that his father was terminally ill with a form of cancer and he wanted to do this last thing to honor his Dad. I painted the watercolor; we had it framed and presented it to his father at a mid-day family meal. The painting was well received and his father rallied and lived quite a while longer. It was more like a Divine appointment than a commission.

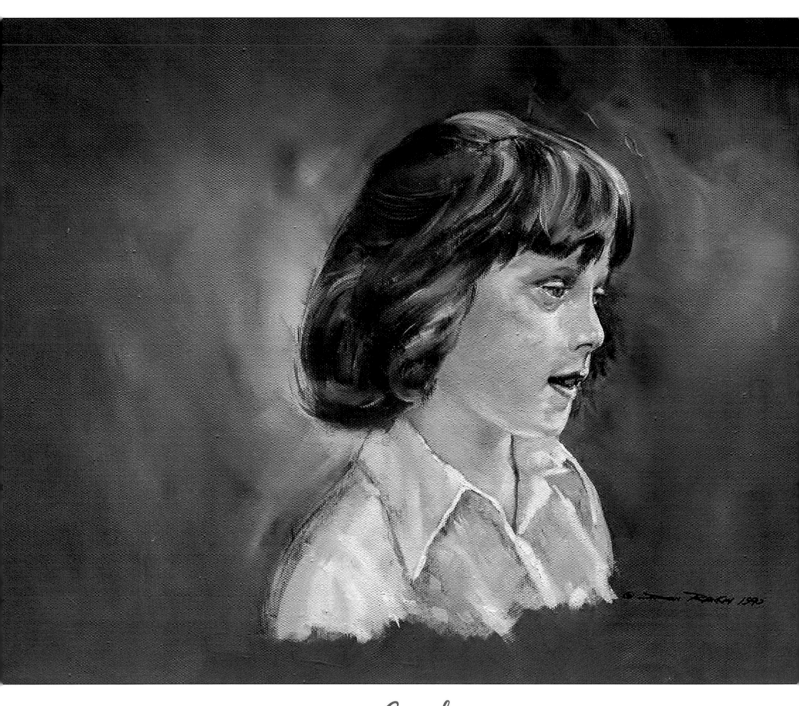

Carol

Oil, 12" x 9" (30.48 x 22.86 cm)

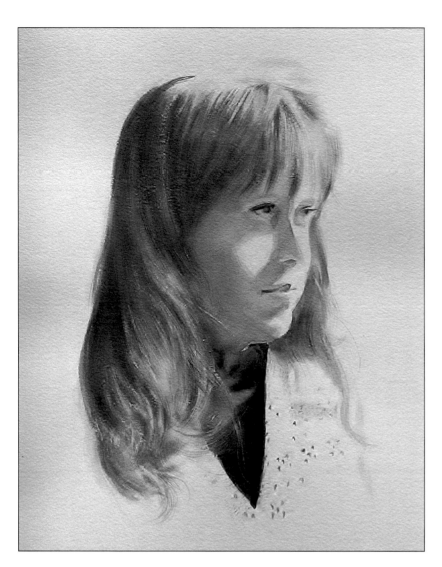

Carol

Watercolor on paper, 14" x 20" (35.56 x 50.80 cm)

Collection of Geneal Rankin.

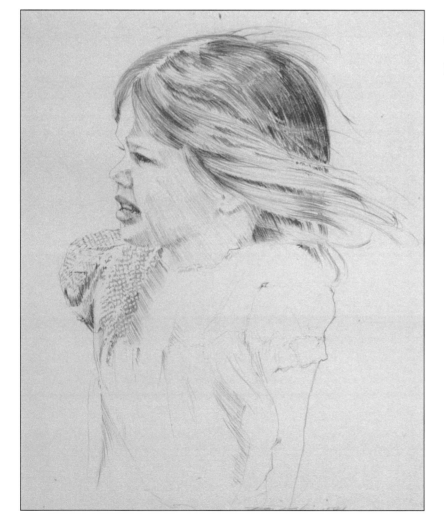

Carol

Ink sketch

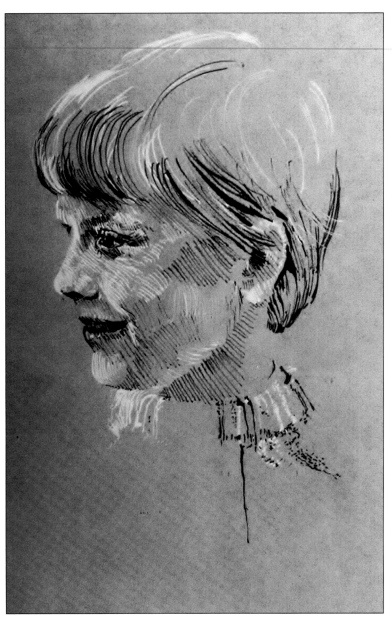

David

Quill pen sketch on grey paper

David

Ink sketch

David

Pencil sketch

David

Oil, 9" x 12" (22.86 x 30.48 cm)

David

Pencil sketch

Opposite page:

David

Watercolor on paper, 26" x 20.5" (66 x 53 cm)

I took my son with me on a sketching trip that wound up being a business discussion with an art buyer. After a while I caught a glimpse from the corner of my eye as David was quietly, patiently waiting for me to fulfill my promise. Collection of Geneal Rankin.

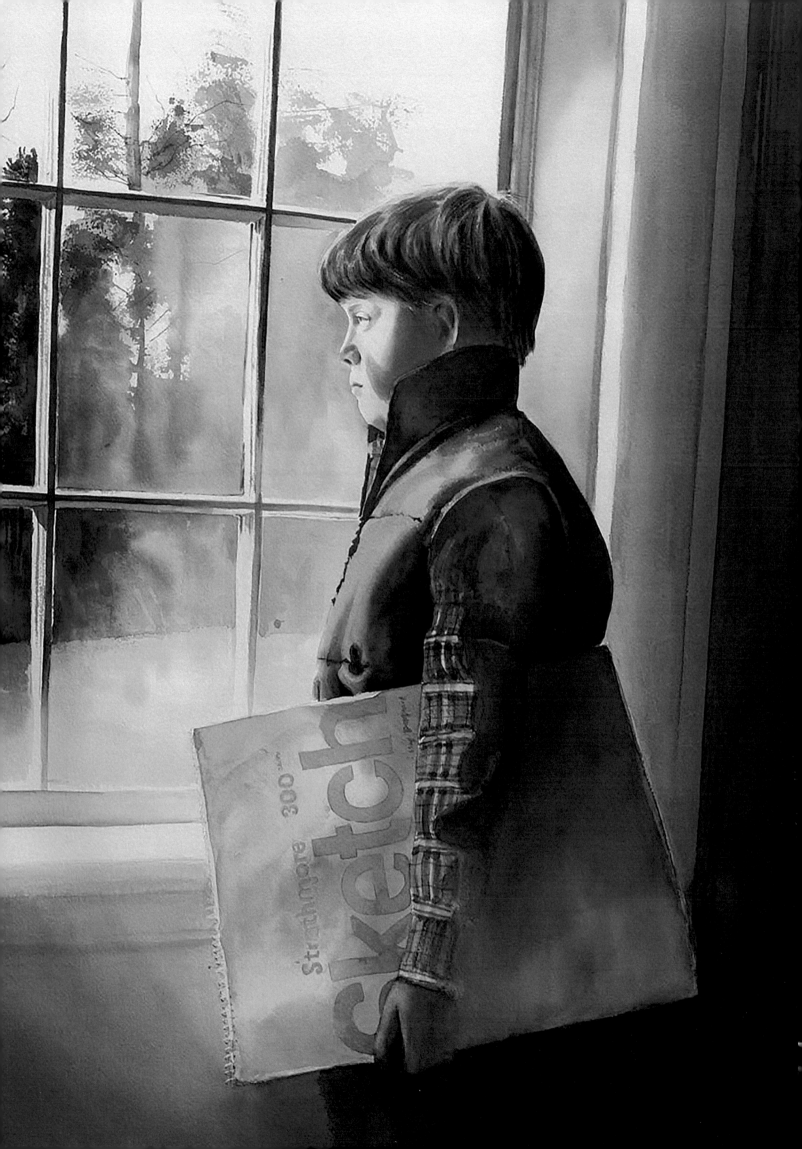

New England and the Maritimes

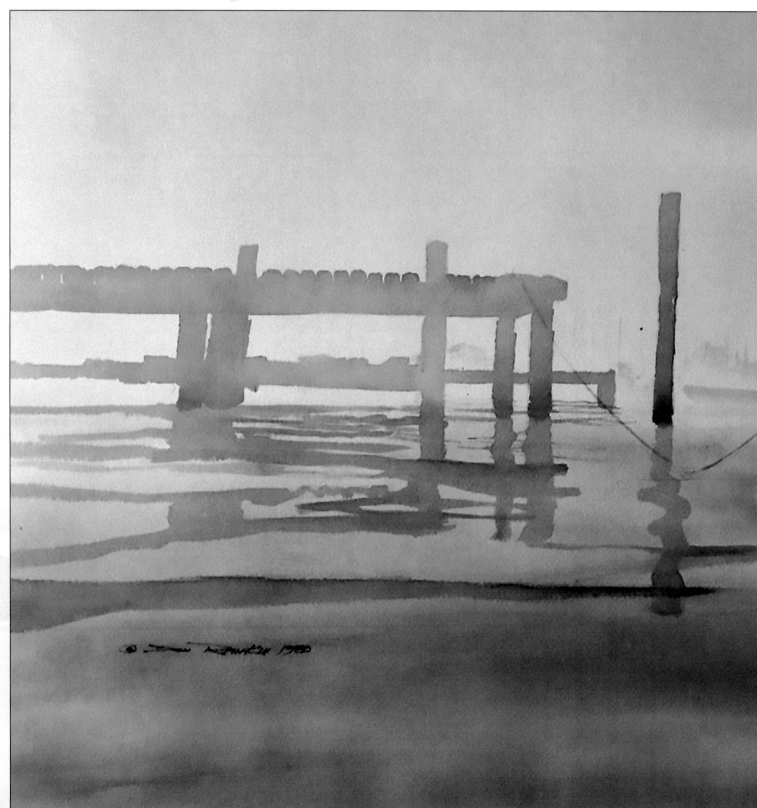

Lots of people think they deserve success as some sort of a right: But here's the truth… Success is something you need to earn through effort.

—Eric Worre

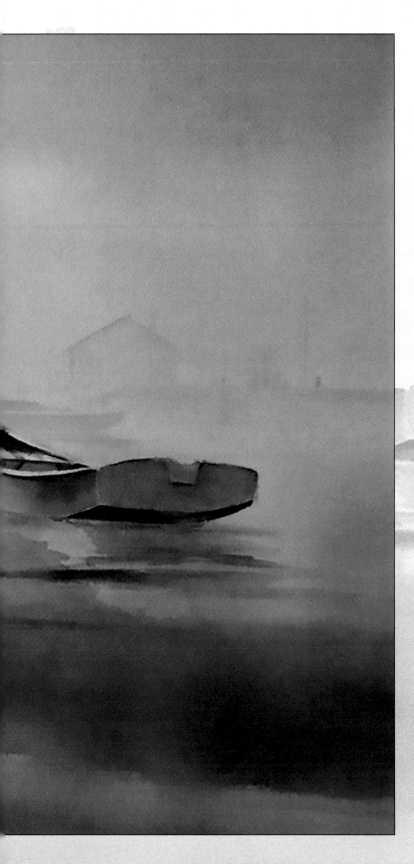

Foggy Day
Watercolor on paper, 22" x 15.5" (55.88 x 39.37 cm)

New England and the Maritimes

When my children were young, we frequently made trips into Pennsylvania and parts of New England to visit with friends. We would often take long walks through the countryside and on the beaches. Later I would find myself writing a few of my books with material gathered in New England and the Maritimes. I recall a slight resistance to leaving Maine in order to travel into Nova Scotia one spring. I found myself returning in the fall to Nova Scotia for more sketches. I still have another lifetime of material.

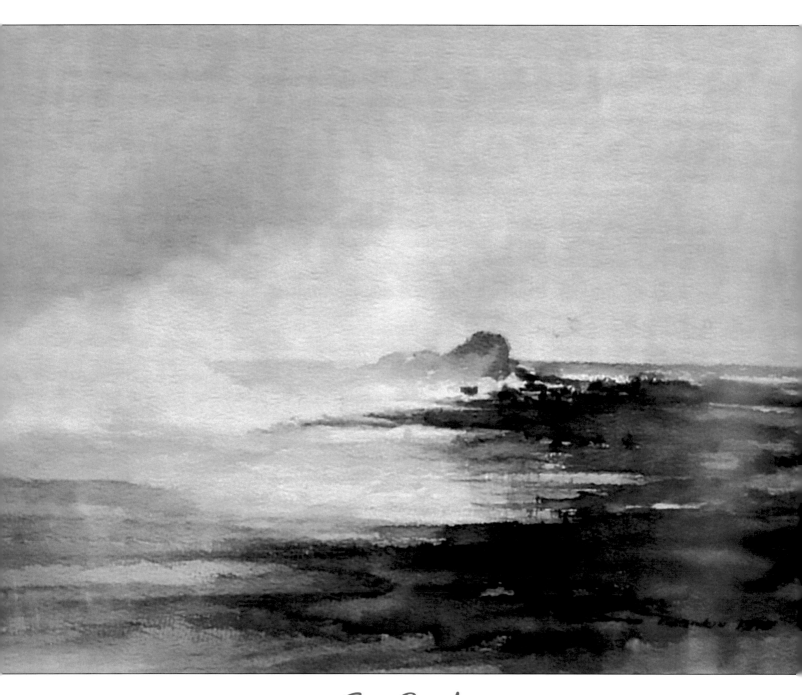

Fog Bank
Watercolor on paper, 14' x 11" (36 x 28 cm)

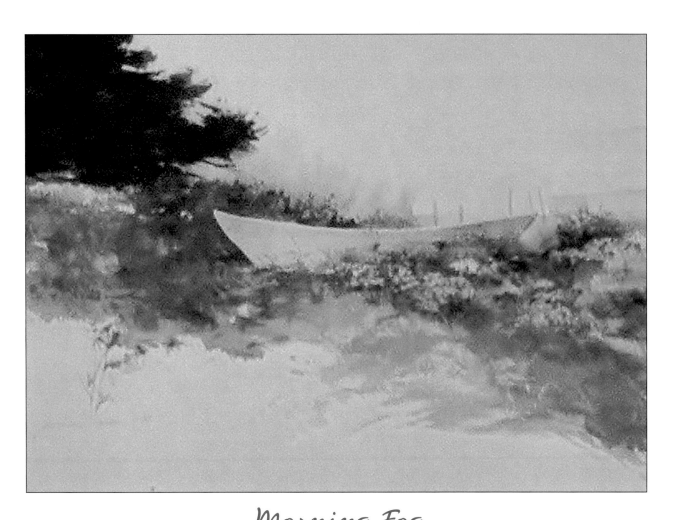

Morning Fog

Watercolor on paper, 20" x 14" (50.80 x 35.56 cm)

Private Collection.

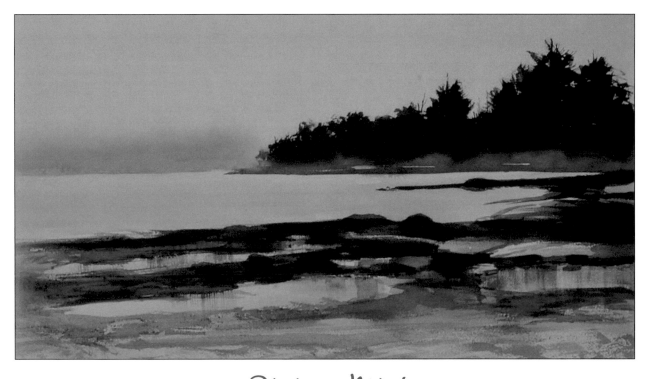

Rising Mist

Watercolor on paper, 34.5" x 22.5" (87.63 x 57.15 cm)

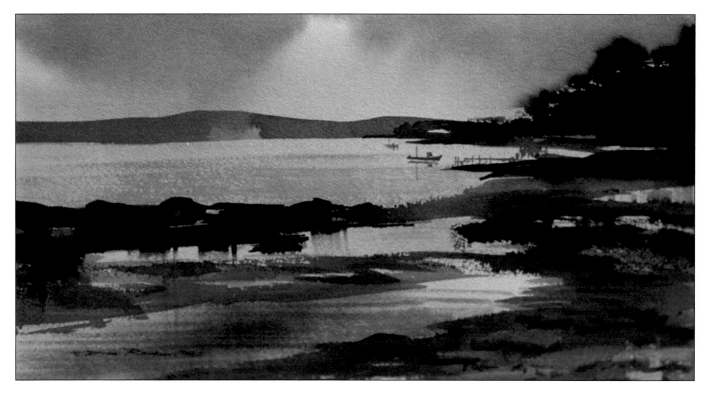

Twilight

Watercolor on paper, 21.5" x 15.5" (54.61 x 39.37 cm)

The beauty of the light on Bras d'Or Lake, Nova Scotia at sunset is hard to describe. No wonder it was dubbed "The Arms of Gold." Artist Collection.

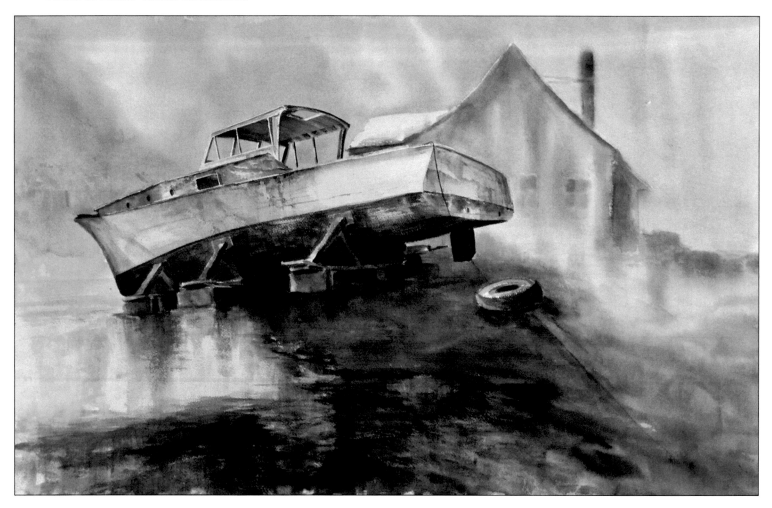

Fog

Watercolor on paper, 40" x 30" (124.46 x 76.2 cm)

Nantucket Light

Watercolor on paper, 26" x 24" (66.04 x 60.96 cm)

We had made an excursion to Nantucket for a day trip. I was trying to convince my wife that we should spend the winter on the island. She wouldn't hear of it. While wandering through one of the alleys of the main street I found this treasure bathed in sunlight and strong shadow. Corporate Collection.

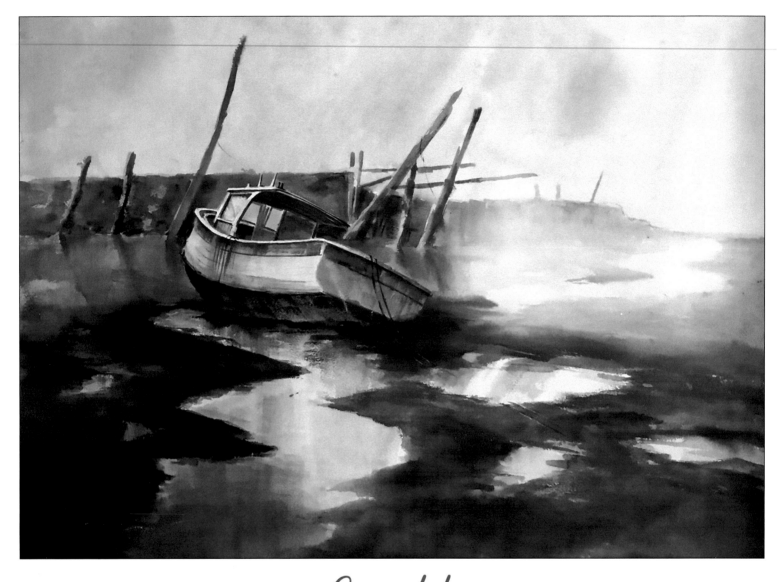

Grounded

Watercolor on paper, 40" x 30' (101.6 x 76.2 cm)

Previous spread:

Salt Marsh

Watercolor on paper, 30" x 20" (76.2 x 50.80 cm)

Opposite page:

Foggy Peggy

Watercolor on paper, 30" x 20" (76.2 x 50.80 cm)

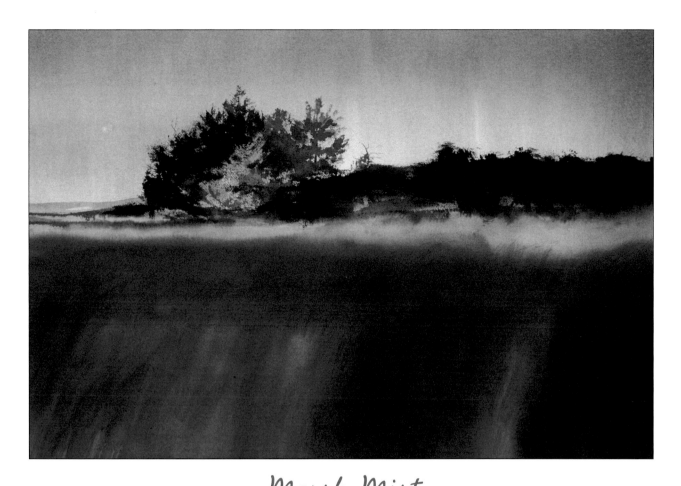

Marsh Mist

Watercolor on paper, 42 x 26" (106.68 x 66.04 cm)

Twilight in the Maritimes can create some beautiful effects. Private Collection.

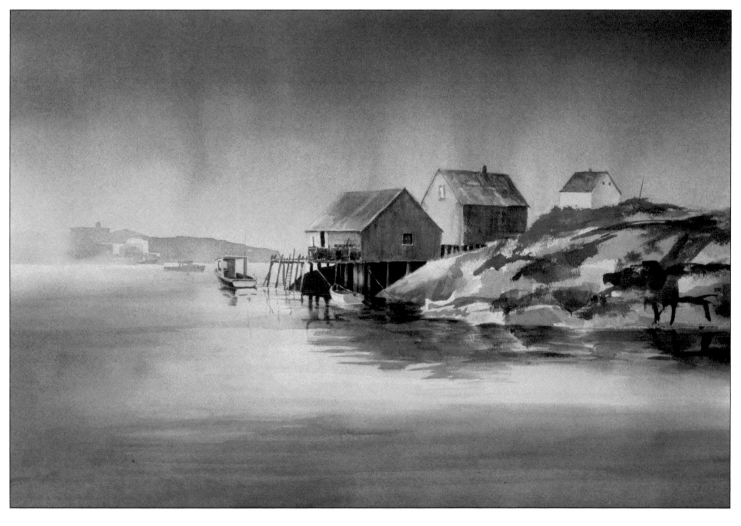

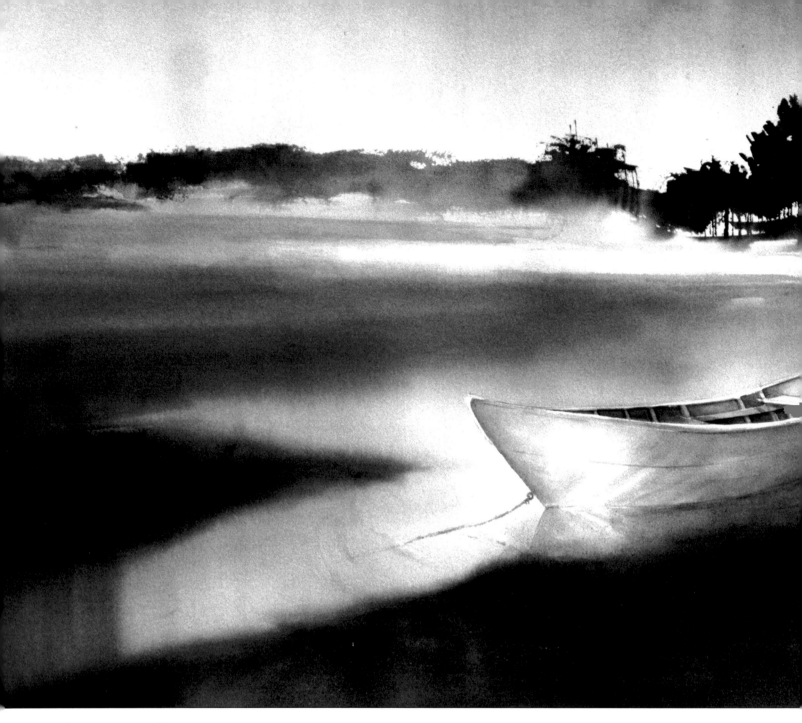

Low Tide

Watercolor on paper, 42" x 26" (107 x 66 cm)

Private Collection.

Skiff
Watercolor on paper, 15" x 6" (38.1 x 15.24 cm)
Private Collection.

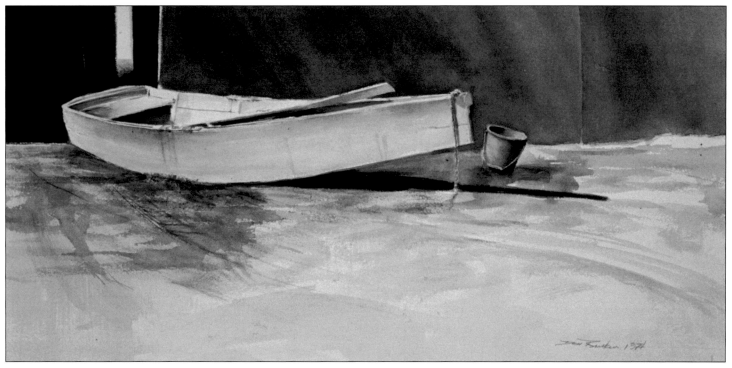

Crab Shells

Watercolor on paper, 28" x 14" (71.12 x 35.56 cm)

Corporate Collection.

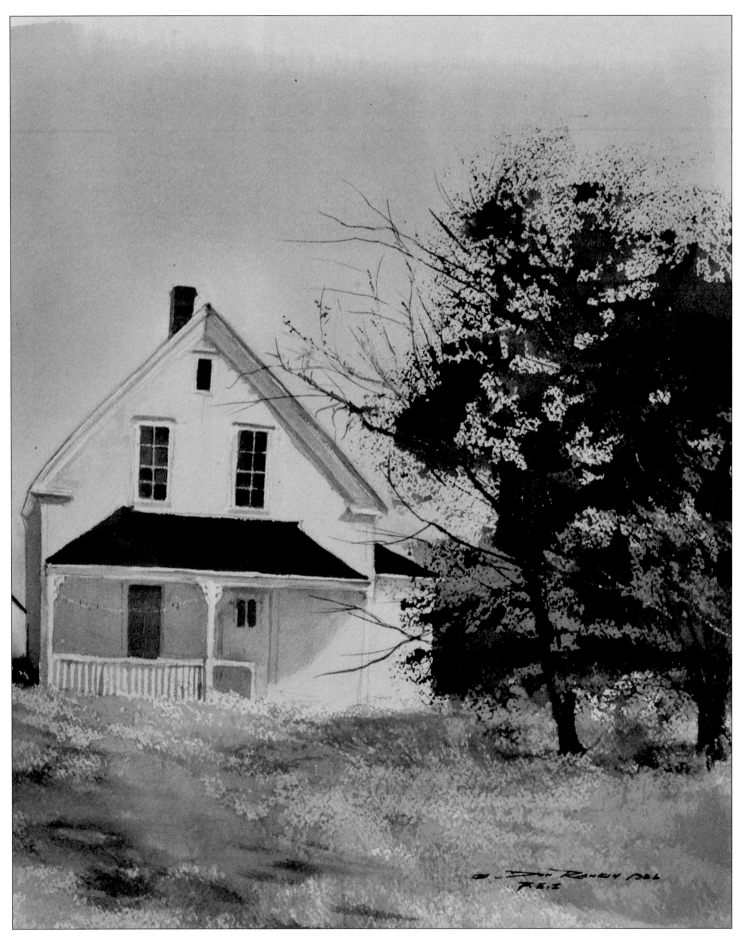

Prince Edward Island

Watercolor on paper, 15" x 28" (38.1 x 71.12 cm)

Private Collection.

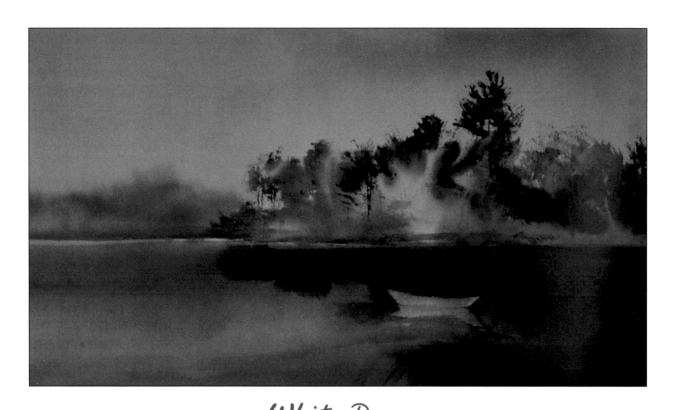

White Dory

Also known as *Blue Mist*, watercolor on paper, 42" x 26" (106.68 x 66.04 cm)
Collection of Saiko Shihan Y. Oyama.

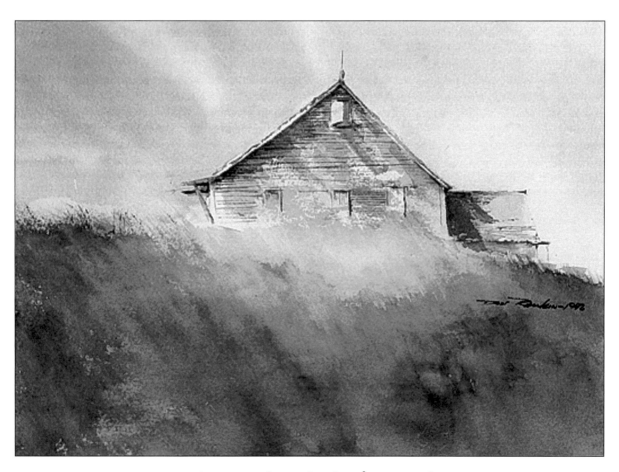

Near the Salt Marsh

Watercolor on paper, 12" x 9" (30.48 x 22.86 cm)
Corporate Collection (Originally purchased by SONAT, Inc.).

Kennebunkport

Watercolor on paper, 42" x 26" (107 x 66 cm)

Stolen, whereabouts unknown.

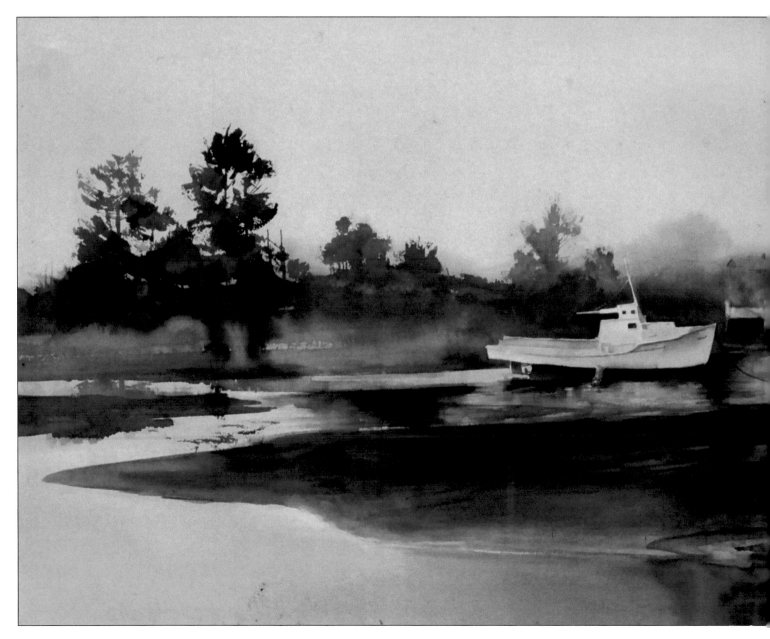

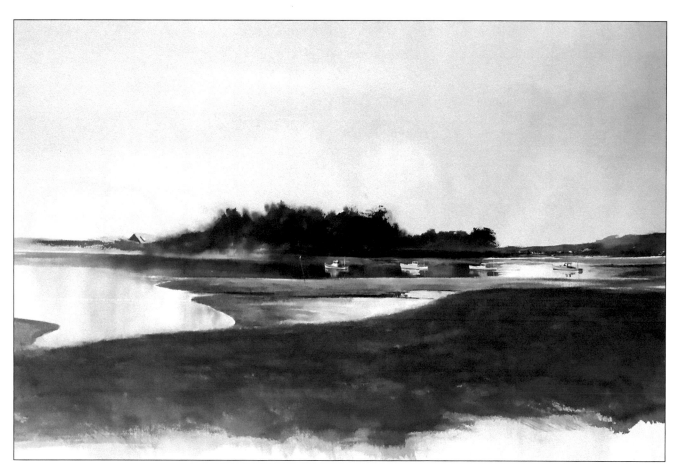

Near Kennebunkport
Watercolor on paper, 42" x 26" (107 x 66 cm)

Following spread:
Near Wellfleet
Watercolor on paper, 30" x 20" (76.20 x 50.80 cm)

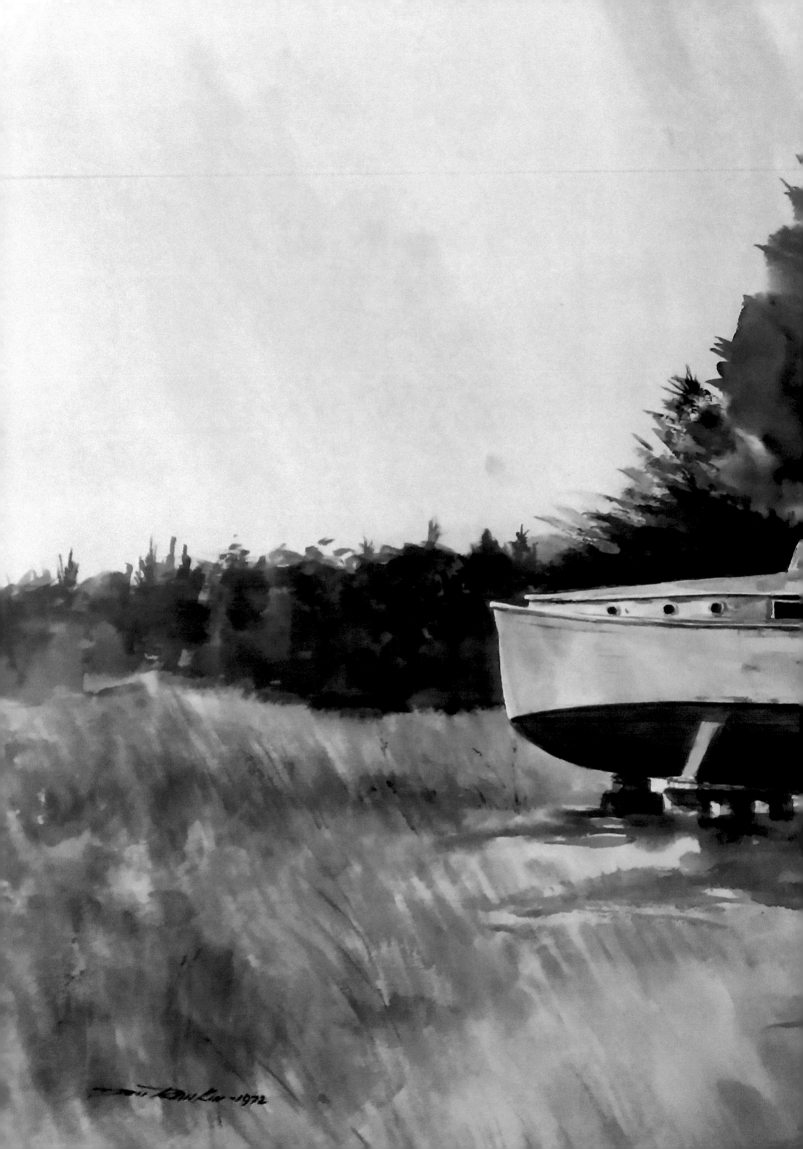

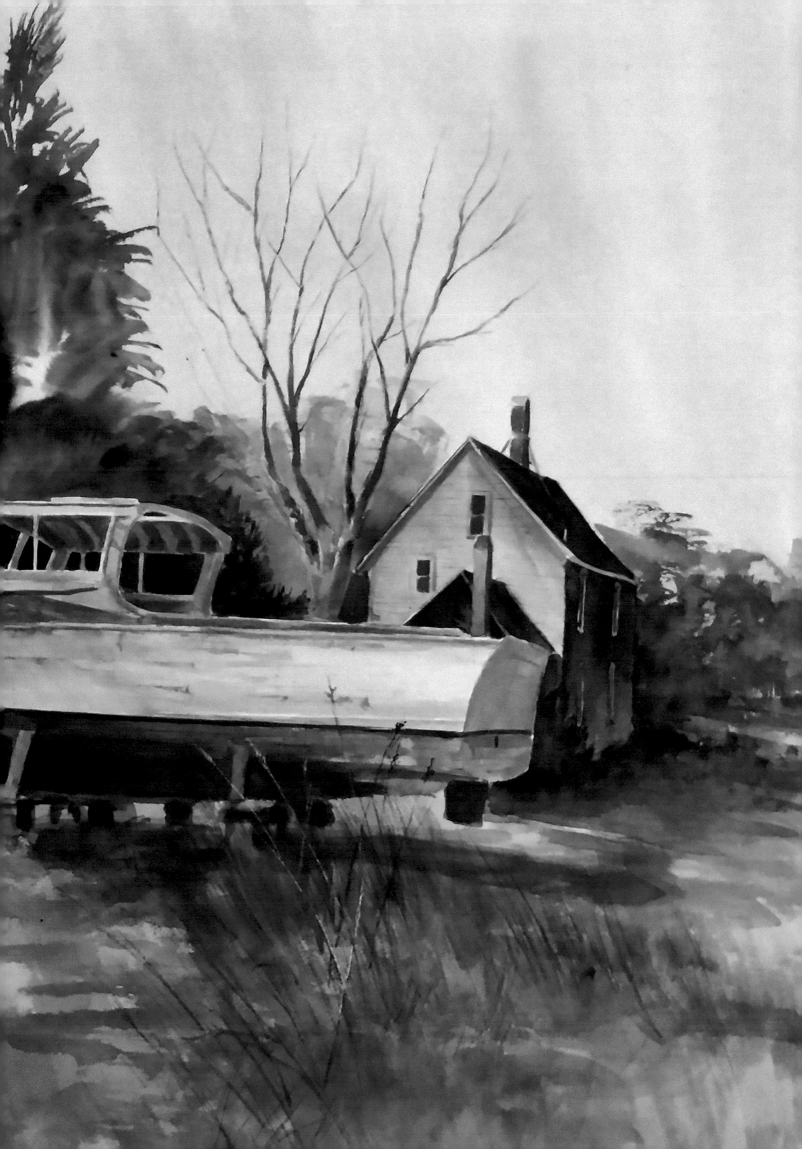

Quite Cove Sketch

9" x 6" (22.86 x 15.24 cm)

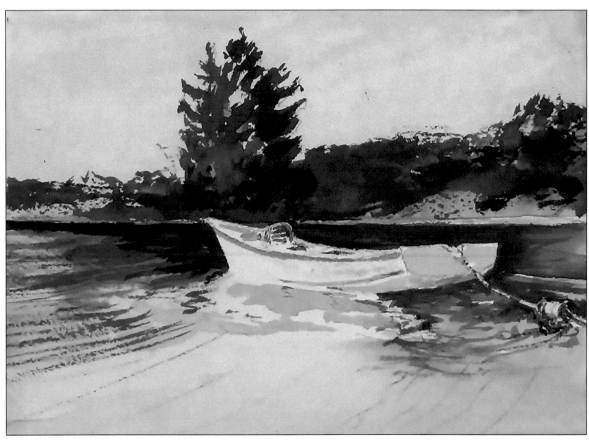

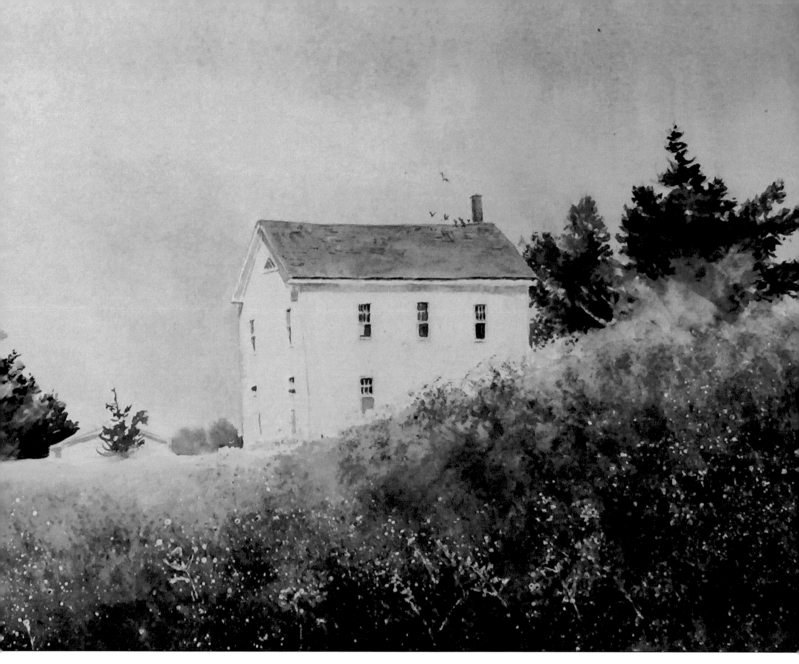

Nova Scotia

Watercolor on paper, 21.5" x 14" (54.61 x 35.56 cm)

A beautiful, quiet Sunday morning. The only sounds were the wind through the pines and off in the distance the muted clanking of a chain.

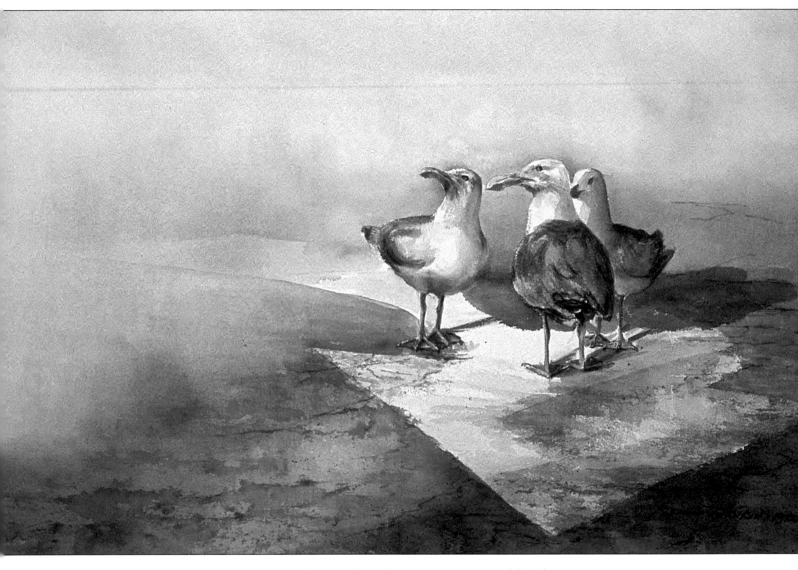

All Flights Cancelled

Watercolor on paper, 22" x 14" (55.88 x 35.56 cm)

The fog can come in quickly. On this day even the birds weren't flying.

Opposite page:

Harbor Mist

Fragment of original painting shown.

Original measures 30" x 18" (76.2 x 45.72 cm)

Private Collection.

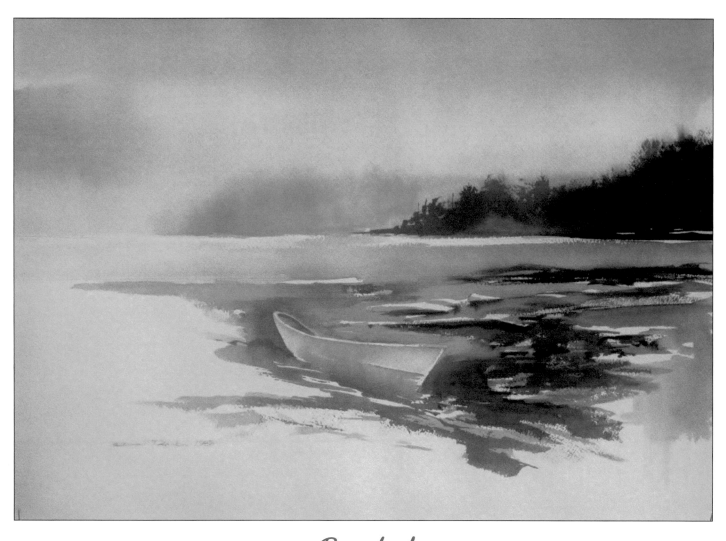

Beached

Watercolor on paper, 20" x 14" (50.80 x 35.56 cm)

Private Collection.

Bass Harbor Light

Watercolor on paper, 25.25 x 19.5" (50 x 65 cm)

This piece was a part of a traveling watercolor exhibition in Japan.
Once owned by a private collector, it has returned home to me.

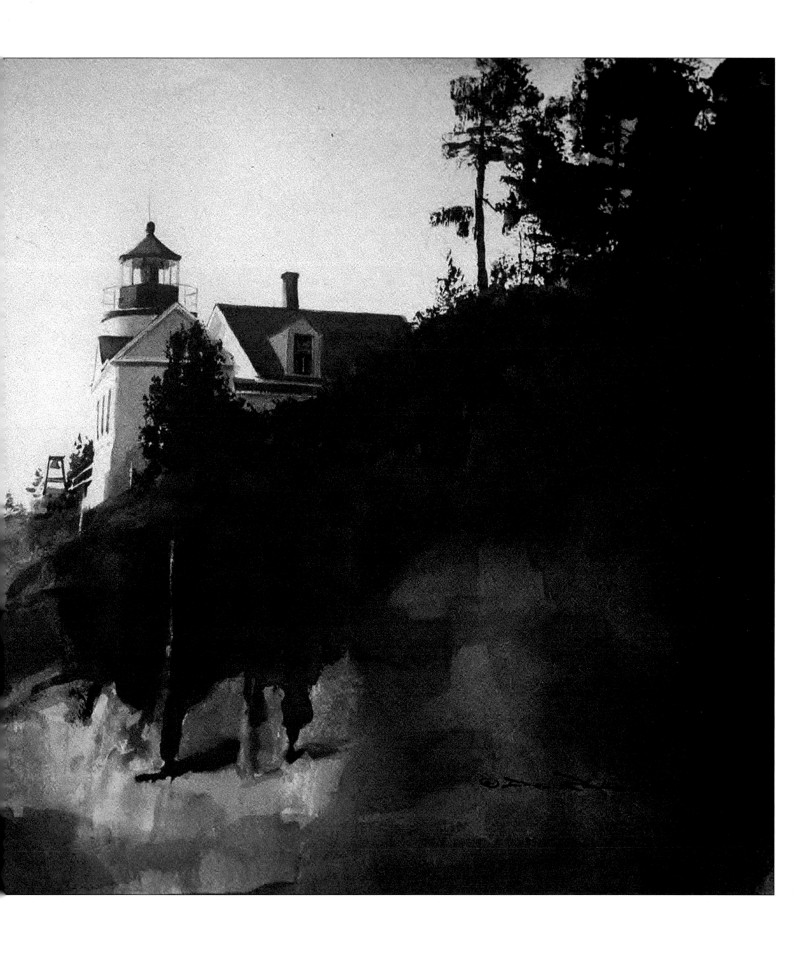

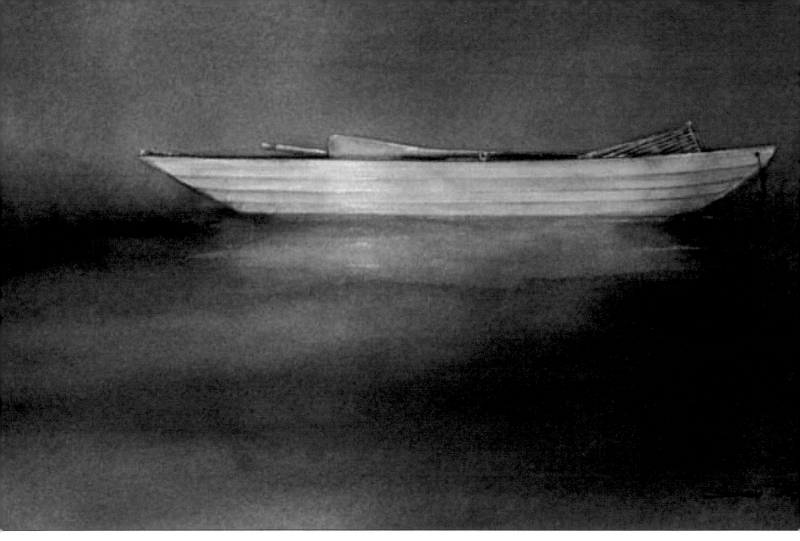

Ghost

Watercolor on paper, 24" x 10" (60.96 x 25.40 cm)

Robert Linthout Collection.

Following spread:

Near Seal Cove

Watercolor on paper, 30" x 20" (76.20 x 50.80 cm)

A quiet spot with fairly calm water and a well used boat.

Maine Washday

Watercolor on paper, 15" x 9.25" (38.1 x 23.50 cm)

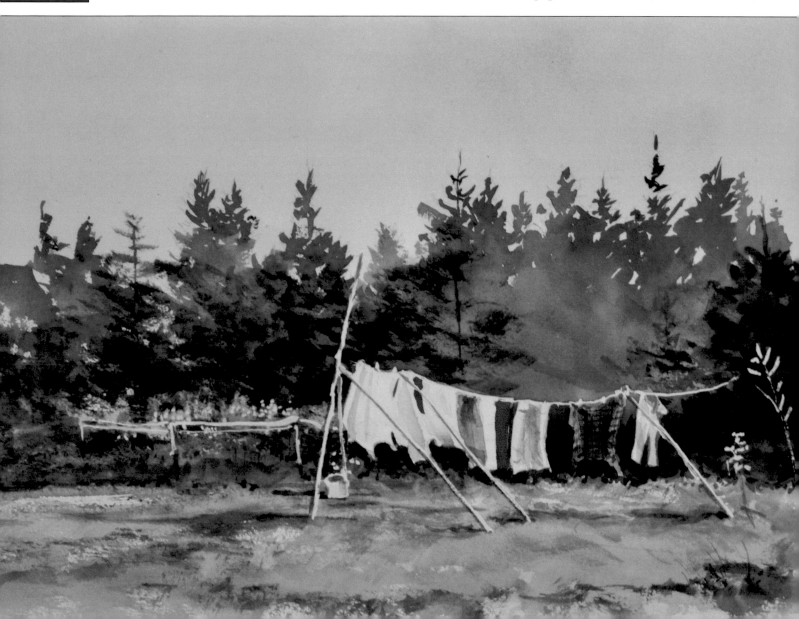

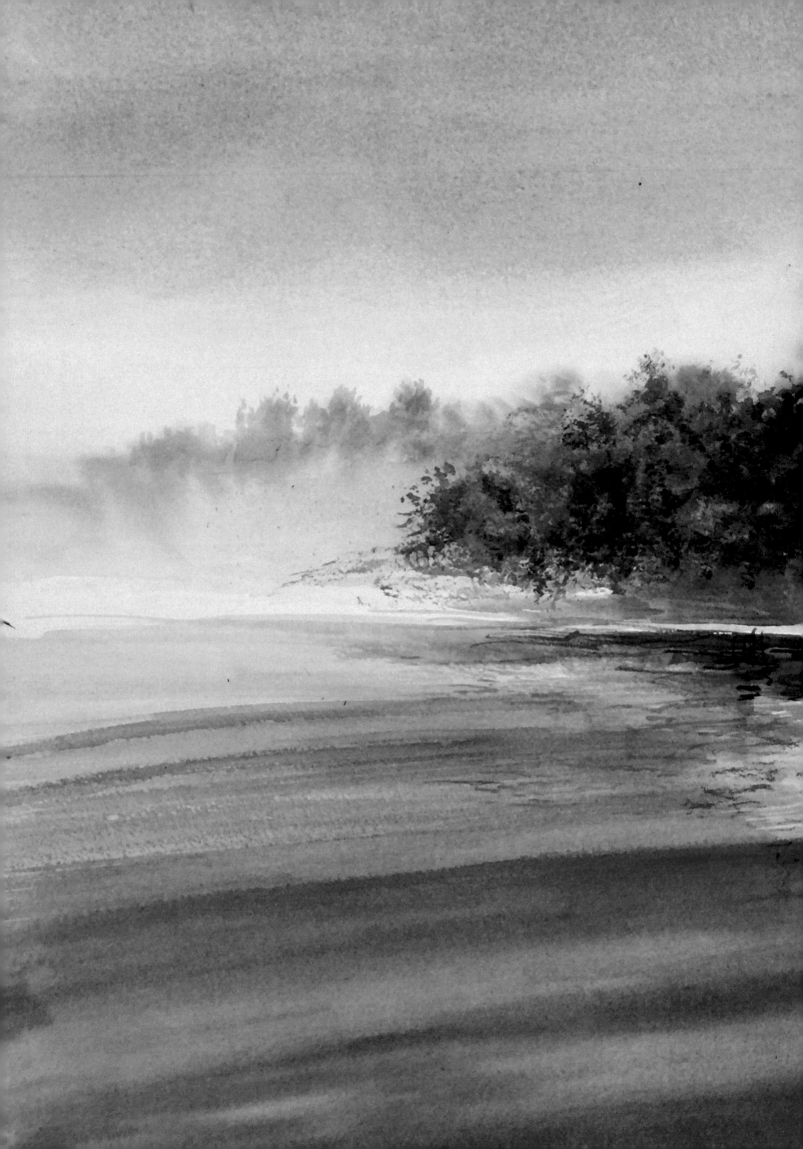

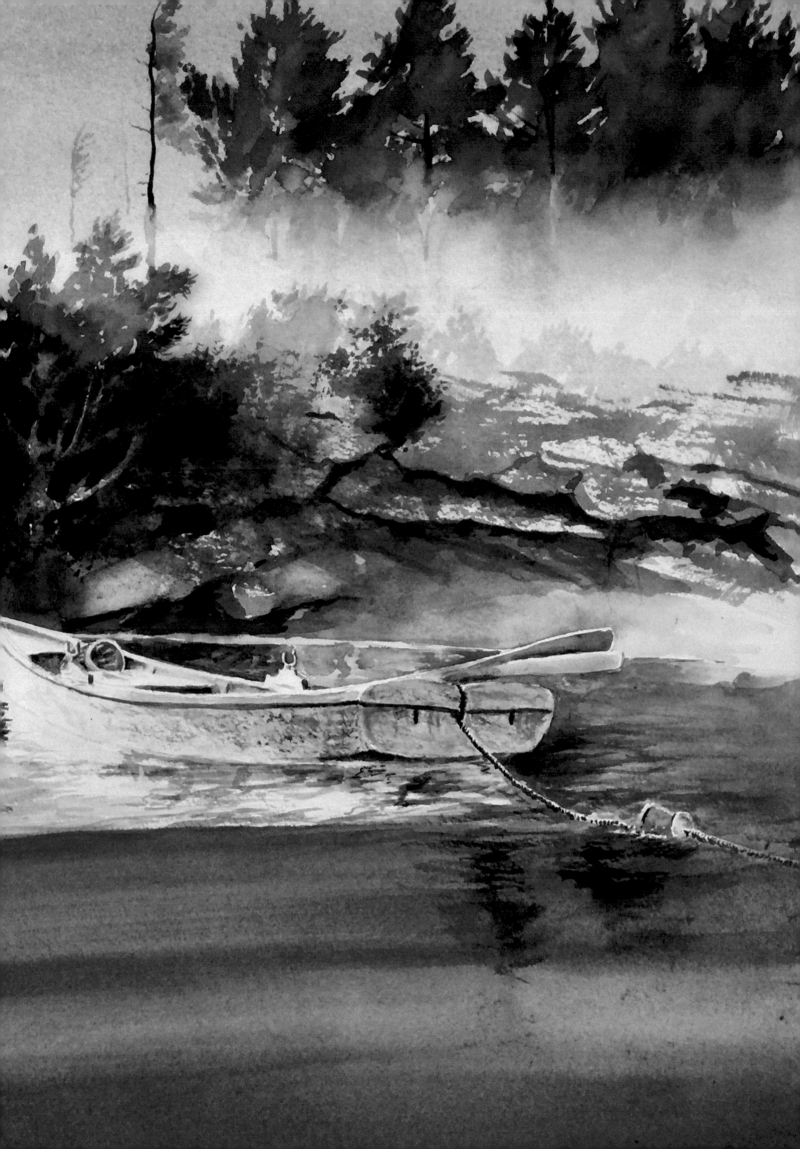

Egg Tempera

If you are going to make a mistake, make it DYNAMIC!

—Saiko Shihan Oyama, World Oyama Karate

Pyracantha
Egg tempera on basswood panel, 10" x 8" (25.40 x 20.32 cm)

Egg Tempera

I was inspired to try egg tempera by an Italian painter by the name of Pietro Annigoni. In 1968 I was in the Uffizi Gallery in Italy, and curators were busily restoring old masterpieces that had been damaged by the flooding of the Arno River. I had noticed that one of the restored pieces had begun to swell with a huge bubble forming under the painting's surface. I pointed this out to one of the museum workers.

In the course of the discussion I was carrying my sketchbook. An artist who was working on a piece nearby started a conversation and expressed interest in my sketchbook. It had to be a stroke of Divine Providence, for in hindsight my sketchbook wasn't anything to brag about! Regardless, the stranger was very encouraging and urged me to study egg tempera. I had a bit of knowledge about the medium but had not seriously considered attempting it. However, watching him work, my interest was aroused. At any rate the seed was planted and a book entitled *Libro dell' Arte* by Cennino d'Andrea Cennini was suggested. I found the book, in 15th century Italian, and began the process of deciphering the contents. Later when I got back to America I found that Dover Publications had a book by Daniel V. Thompson entitled *The Practice of Tempera Painting* that incorporated an updated view of Cennini's original book.

The proper technique of egg tempera is not something you are likely to casually acquire. You really need to work with someone who is accomplished in the medium. The process requires discipline and knowledge about several aspects.

Pennsylvania Blue
Egg tempera on panel, 11.5"x 9.5" (29.21 x 23.88 cm)

Preparation

The successful use of egg tempera requires certain things. Some would seem to make a religion out of the process, but with proper instruction one will find the medium to be very adaptable to more modern techniques. However, don't be fooled. This is a medium where one makes haste slowly after all of the necessary preliminaries have been addressed.

No doubt, every painter has his own recipes and procedures. First, the egg tempera paint must be painted on a rigid surface, for it will not flex like oils or acrylics. I see advertisements for all sorts of pre-prepared panels and paints. I prefer to make my own. Usually I work on untempered masonite or on properly prepared basswood panels. For a few years I have been purchasing wooden panels from Cheap Joe's Art Stuff in Boone, North Carolina. I take the raw wooden panel, which is cradled to prevent warping and coat it with hide glue, then unbleached, unsized muslin is stretched over the wet hide glue. After it dries several coats of gesso are applied. The gesso is the original version made of rabbit skin glue and precipitated chalk. I will apply at least 8-12 coats, with each coat at a diagonal to the previous coat. Once dry, the surface is smoothed with raw silk wrapped over a rectangular block of wood. The objective is to produce a silky smooth mirror surface. The so-called gesso that most art students know about is not really gesso but an acrylic coating. It will not work for egg tempera. The gesso coating for masonite panels is done in the same manner without the muslin.

I should add that the gesso is prepared over a few days of soaking and is then liquefied in a double boiler and applied while warm. Years ago my wife laid down the law that this would be done outdoors. So, as a general custom I prepare panels in the fall. I set aside a few days when the fall air has a crisp touch to it and I make enough panels to usually last all year.

Pigments

The pigments are dry powder in their raw state and require some preparation. These dry pigments are readily available. Unfortunately, one of my favorite suppliers went out of business requiring me to find alternate suppliers. In some cases I will source and grind my own colors from earth pigments that I find in various places. Once the dry pigment is obtained, it gets ground and refined. My method is to do it by hand using a glass muller on either a tempered glass sheet or granite or marble block. The pigment is ground into a paste using distilled water. Rubber gloves and a certified mask are a must while grinding, for some of the pigments can be toxic. Once I am happy with the grind, the paste is scooped up into an airtight clear glass container and covered with enough distilled water to keep it moist until it is time to prepare the paint.

A test panel. Since every egg is different in terms of moisture or viscosity, I use a gesso panel to test my egg mixture. The ideal mixture contains enough egg to create a strong matte finish without being too glossy. This can be tricky for the beginner since one has to learn, often by trial and error, to get the right mix. One saving grace for the beginner is that a little glossy is not a bad thing, but patience and practice will help perfect the technique.

The paint

If you read a lot of books, you will know that there are a number of recipes for egg tempera. This is where it gets personal. Some like to use an egg and oil emulsion. Others, like me, prefer to use nothing but the inside of the yolk of the egg. I use only local fresh organic eggs for my mixture. The organic eggs make a better paint. With a little practice it becomes easy to separate the yolk from the white and remove all traces of the white from the yolk. Once this

is done, the yolk is punctured over a clean glass bowl and the skin of the yolk sac is discarded. The result is the pure nectar of the egg. Depending upon my schedule, I will prepare 3-6 eggs for a day's work.

The critical part is to get the yolk mixture uniform, for egg yolks vary in their degree of moisture. The best way to determine the proper viscosity is by feel, which is hard to learn from a book. Often the yolk is too heavy or thick and requires diluting with distilled water. Distilled water is less likely to produce unexpected changes in the yolk. Tap water has all sorts of unknowns that can render the paint mixture suspect if not downright useless.

Once the egg mixture is prepared, it is time to add it to the pigment paste. The amount of egg to paste is critical. The paint needs to have enough egg to ensure adhesion to the panel but not so much as to be too thick. Test strokes are brushed across a small piece of gesso panel to get the proper mix. The tempera should dry almost instantly and ideally it should have a matte finish. This is where one of the dangers may be found— there needs to be enough egg mixture to make the paint adhere to the panel, while at the same time creating a matte surface. This takes practice.

Each color is mixed as a transparent paint. Then portions of it are separated into a slightly opaque mix by adding white and a darker value by often adding black or another color. This is done in a mathematical fashion to create a gradation of value for every color used. The paint dries so quickly that blending is not used except by the use of cross hatch, stippling and the weaving of color to produce an effect. In most cases I use a variety of brushes; many of them are riggers and a style known as lizard lick. The lizard lick has a large body of hair at the ferrule with a very slender tip. The mass of hair at the base holds more paint and allows for some extended use before needing to recharge. The brushes are used a lot like a pen or pencil would be used although no approach is set in stone. Large applications of paint with an intent to blend generally result in a terrible outcome. So one makes haste slowly.

The Actual Painting

As stated before, one can approach the medium from a very conservative rigid manner or in a more relaxed manner. Due to the nature of the paint, a well-planned and executed sketch is essential. For example, many early users would develop an extensive crosshatch ink drawing or a grey tone under painting on their panel. These days I use the under painting, often using complementary colors in the under painting process.

When I am painting I place my selected, mixed paints in small porcelain cups and the cups are arranged in a pan over a bed of ice since I do not "temper" my paint mixture with oil of cloves or wine. The adding of the oil or wine was called tempering to slow the spoiling of the egg. In fact, in the old days in Italy, an egg tempera studio was often referred to as "il putrificado." Many years ago I went on a trip and closed my studio door, forgetting that there was a jar of water in the studio that had been mixed with egg. When the door was opened a couple of weeks later I quickly learned why the Italian painters had named it so!

Once my under painting is on the panel, I begin the actual process of painting. This is a contemplative process of building passages of color. I often work for a quality called opalescence. This is a quality that incorporates both

A traditional egg tempera under painting

transparency and opacity to create an effect that cannot be produced in any other way. The effects are achieved by alternating mixtures of the more opaque mix with the transparent mix. Working with egg tempera helped me develop my approach in watercolor to some extent.

Very often I will spend years on a single painting. Consequently, my current inventory is not large. When I was teaching full time I did not paint in tempera due to the involvement; now I am free to explore it more thoroughly.

Why Go to the Trouble?

Once in a while I get that question. My answer is simple. Egg tempera has the ability to produce effects that cannot be achieved by any other medium. There is something exciting and fulfilling about preparing your own paint and getting lost in the millions of tiny strokes to produce a work that just can't be developed any other way.

Bald Eagle

Egg tempera on panel, 24" x 28" (60.96 x 71.12 cm)
Collection of Birmingham Zoo in memory of Bob Gordon.

Reflections

Egg tempera on panel, 46" x 21" (116.80 x 53.34 cm)

Corporate Collection of Jim Wilson and Associates.

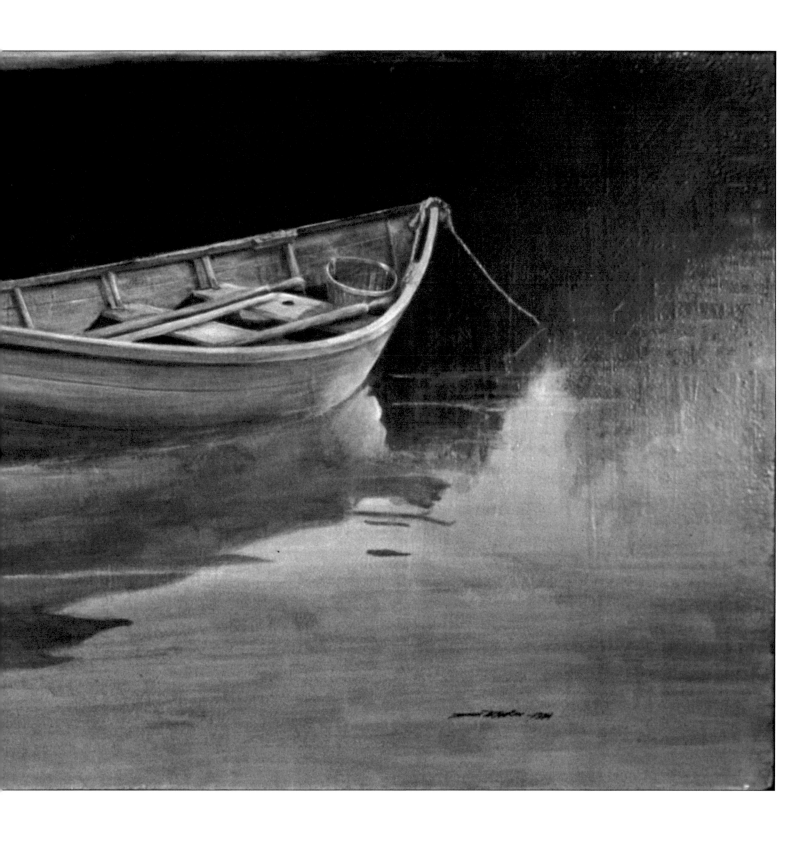

Geneal and Oscar, Best Buds Forever

Egg tempera on panel, 18.75" x 24" (47.63 x 60.96 cm)

This painting had its genesis on Christmas Eve of 2017, I think. Oscar and I rarely had disagreements but for some reason I verbally scolded him. He went to "momma." She gently called him over and he took refuge with her while she was watching a program. The lighting and the serenity of the moment compelled me to begin sketching while no one was looking. I think those are the best kind of moments. As Geneal grew weaker she commented that if Oscar died before her, she wanted his ashes put in her coffin. Geneal slipped away on the 24th of January. Oscar died on the 28th. A freak snow storm had delayed the funeral for a few days. Geneal got her last wish. We were able to place Oscar's boxed ashes with her.

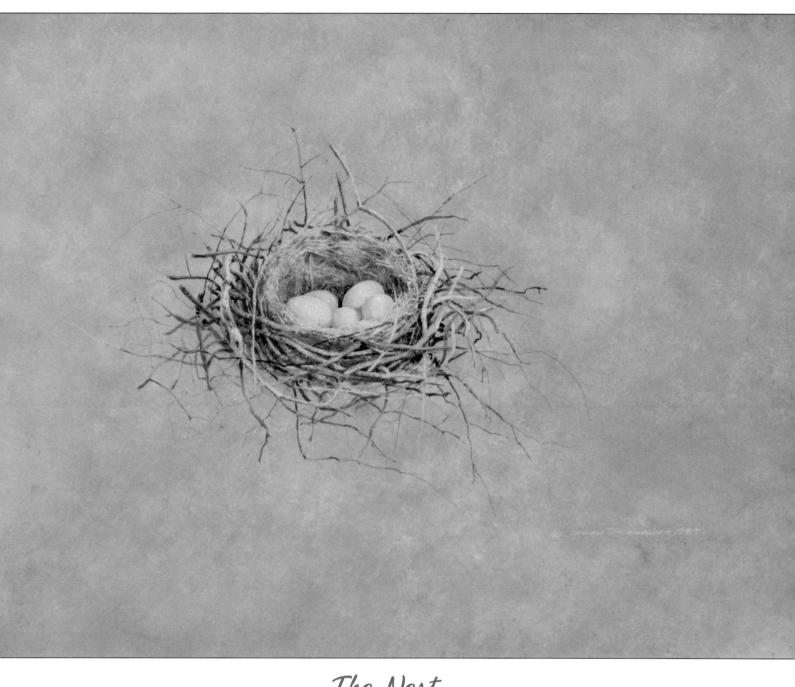

The Nest

Egg tempera on panel, 24" x 18" (60.96 x 45.72 cm)

Collection of Geneal Rankin.

The Door

Egg and acrylic tempera on panel, 28" x 48" (61.12 x 111.92 cm)

Corporate Collection Jim Wilson and Associates.

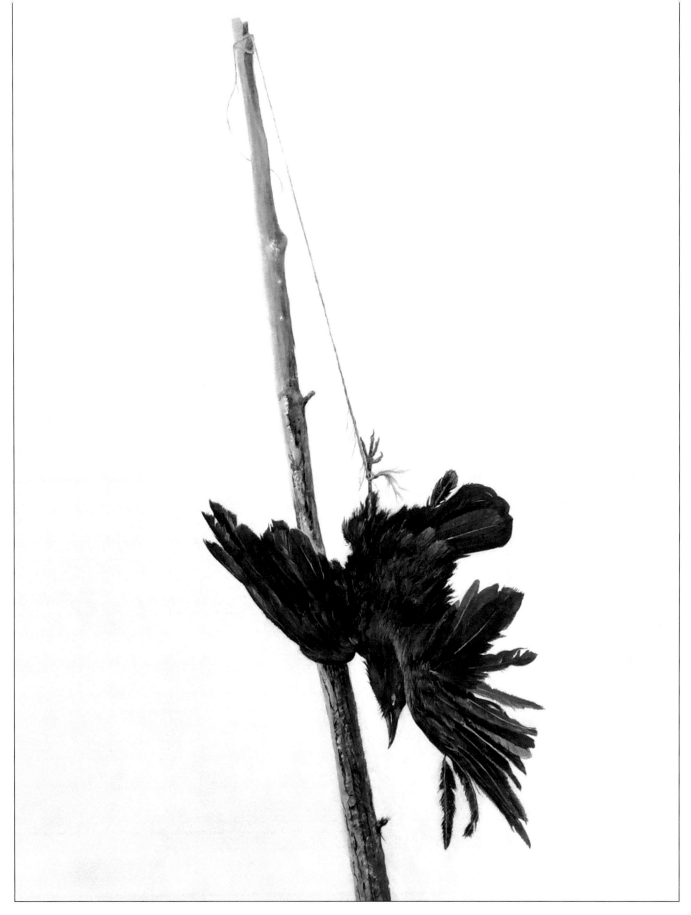

Scare Crow on Granny Squirrel Ridge

Egg tempera on panel, 36" x 48" (91.80 x 111.92 cm)

This is one of those special moments. I was returning home one Sunday morning after conducting a week long painting workshop near Tremont, Tennessee. I took the scenic route home that took me through Granny Squirrel near Andrews, North Carolina. The sky was cloudy but as I approached an open field the clouds parted and a beam of sunlight illuminated the poor bird hanging from the pole. The image burned into my memory. I began sketching. With the help of a live bird named "Jackie" who patiently sat in his cage while I sketched him I was able to recreate the finer details. Artist Collection.

Waiting for Work

Egg and acrylic tempera on panel, 40" x 30" (111.60 x 76.20 cm)

Waiting for Work

Watercolor on paper study for egg tempera,
24" x 18" (60.96 x 45.72 cm)

Private Collection.

Trail of Tears

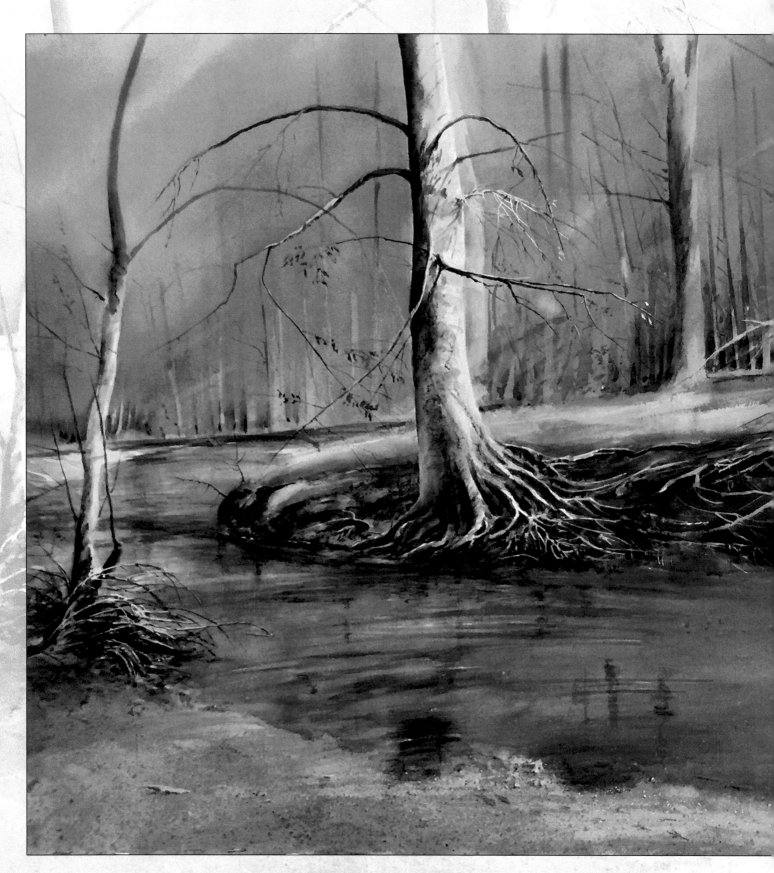

When the spirit does not work with the hand there is no art.

—Leonardo Da Vinci

❖ ❖ ❖ ❖ ❖ ❖ ❖

An artist is not one who is inspired, but one who inspires others.

—Salvador Dali

December Mist

Watercolor on paper, 40" x 25.5" (101.6 x 60.96 cm)

The rising mist is reminiscent of the cooking fires that used to warm the lodges that lined the bank above the shore.

Trail of Tears

Some paintings are so closely related that they compose a theme. A part of Alabama's history is what is known as the Trail of Tears. In spite of what some historians may say, a lot of evidence was left in Alabama and not all Indian people left the land they loved. A number of years ago I used to paint and sketch on an old abandoned farm not far from my studio. While wandering over the land I encountered what was once a thriving Indian village. A portion of the stream that meandered through the old site was lined with what appeared to be white clay tile. It was carefully lined by hand and was a great way to keep the water clear. The question arises, "Who fired the clay and who laid it in place?" I prefer to believe that the native inhabitants took the time and pains to do it in order to ensure clear water. In truth, I can only guess. One old resident in the general area confided that the clay tiles had lined the stream for as long as he could remember. He also added that his father thought them to be very old. There are still places like this that are currently hidden away. Unfortunately, some of those wonderful places are now a memory as the land has been developed.

Fire Light
Oil on canvas, 24' x 30"
(60.96 x 76.2 cm)

Opposite page:
Creek Village
Watercolor on paper, 22" x 30" (55.88 x 76.2 cm)
Silent birches bear witness to the people who once lived here

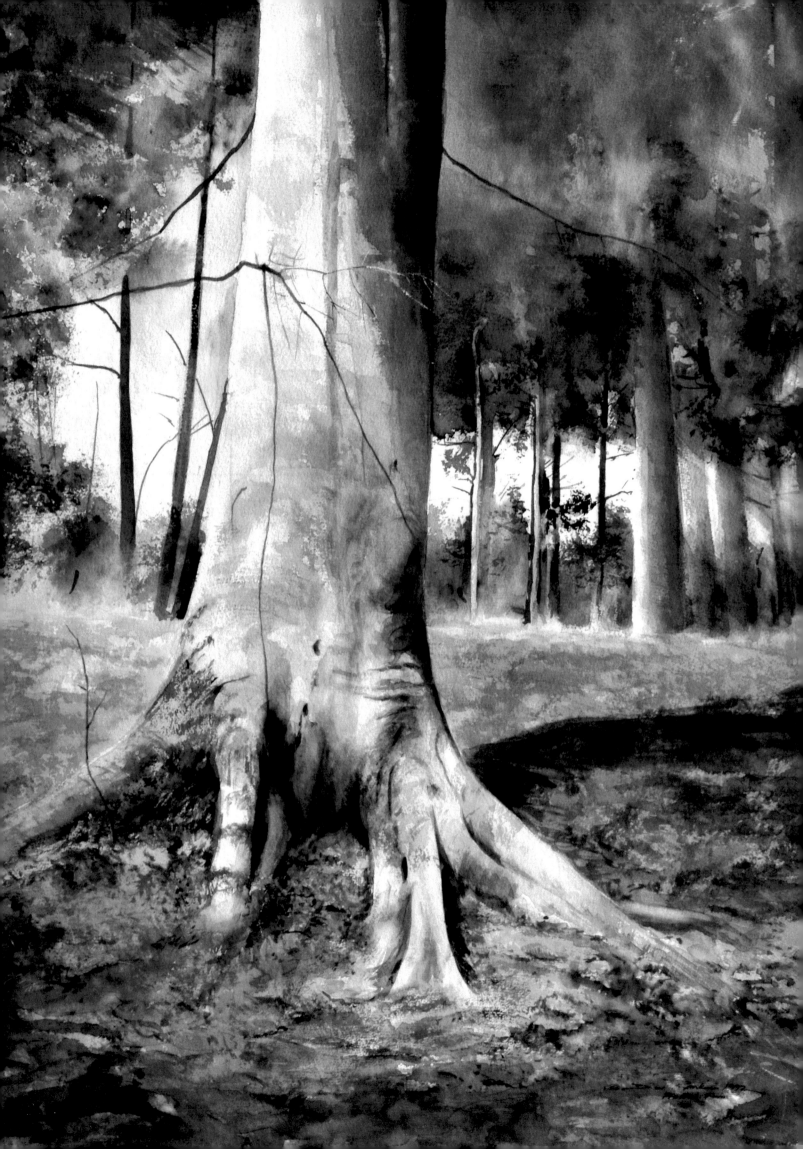

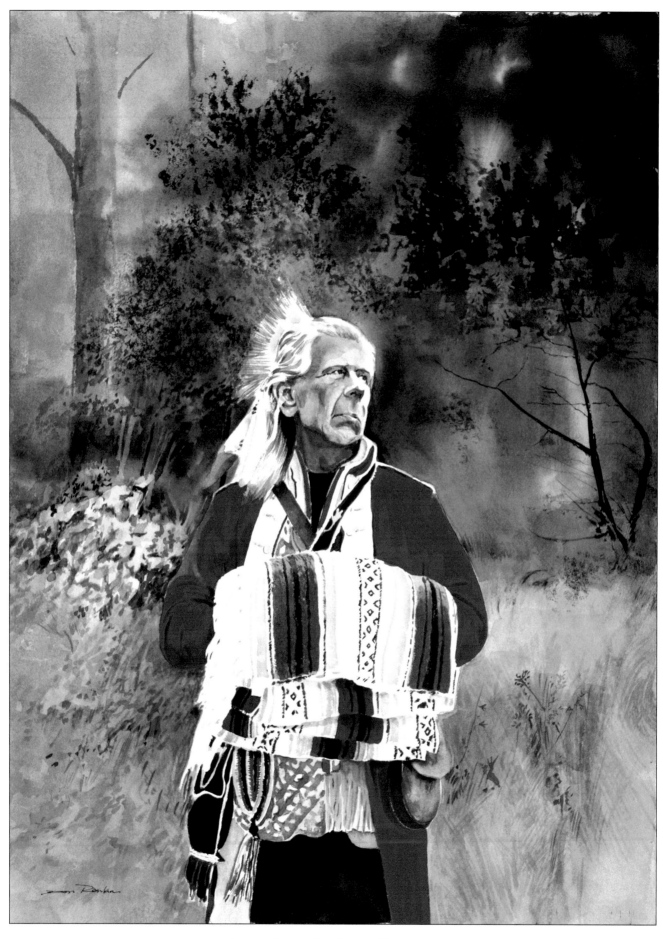

Looks Like Snow

Watercolor on paper, 22" x 30" (55.88 x 76.2 cm)

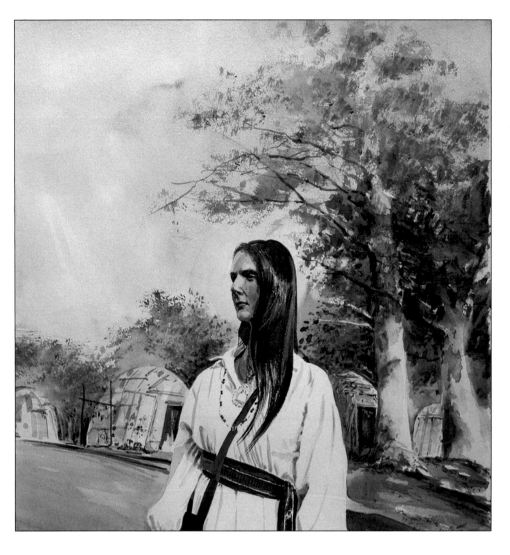

Turtle Mother

Watercolor on paper, 22" x 24"
(55.88 x 60.96 cm)

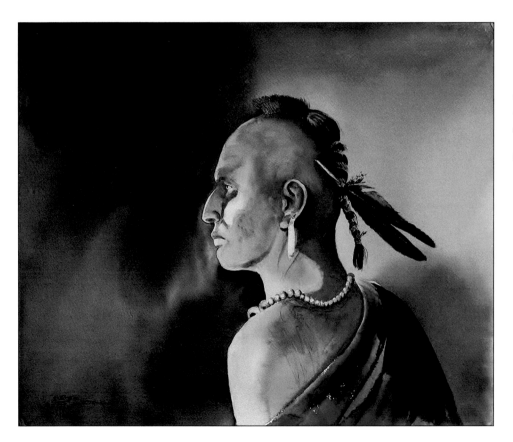

Dragging Canoe

Watercolor on paper, 22" x 18"
(55.88 x 45.72 cm)

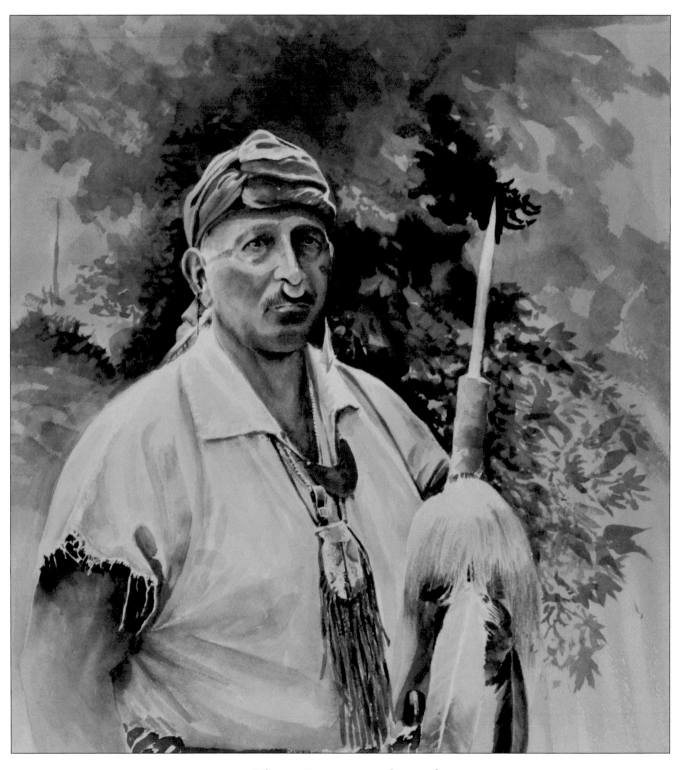

The Copperhead

Watercolor on paper, 18" x 22" (45.72 x 55.88 cm)

Last Leaves

Watercolor on paper, 22" x 30" (55.88 x 76.2 cm)

The remaining leaves are a reminder of the ones who did not leave the land during the Trail of Tears.

Themes Around
the Mountain

An artist is not paid for his labor but for his vision.

—James McNeill Whistler

When the pressure increases, what is engrained in you will come out.

—Nick Saban, Head Football Coach,
University of Alabama

Through the Trees
Watercolor on paper, 22" x 15" (56 x 38 cm)

Themes Around the Mountain

Many years ago my studio was up on Shades Mountain. Across the street behind my neighbor's place was a secluded, deep ravine with a beautiful stream, steep cliffs and huge boulders. Surveyors called it the Huckleberry Branch and had done some storm drainage construction in various locations. Due to its rugged nature, only the very healthy and young ever visited it. It was my perfect painting place all year long. In the winter the constant seeping of water enveloped a rock overhang known as Drip Rock with marvelous ice stalactites. Some were enormous in diameter and length, often reaching the ground floor. In the summer the constant dripping offered cool refreshing drops of water. Portions of the ravine offered all sorts of beautiful flowers and ferns.

White Ladies

Watercolor on paper, 24" x 14" (60.96 x 35.56 cm)

Private Collection.

Primitive Church at Oxmoor

Watercolor on hot press board, 40" x 24" (101.6 x 60.96 cm)

Another view of the old church before the land developer demolished a part of history. Artist Collection.

The Watcher

Watercolor on paper, 22" x 30" (55.88 x 76.2 cm)

Even now with all of the development we still have owls who often create lively banter during the night. Artist Collection.

Winter Orchard

13" x 20" (33.02 x 50.8 cm)

Robert Linthout Collection.

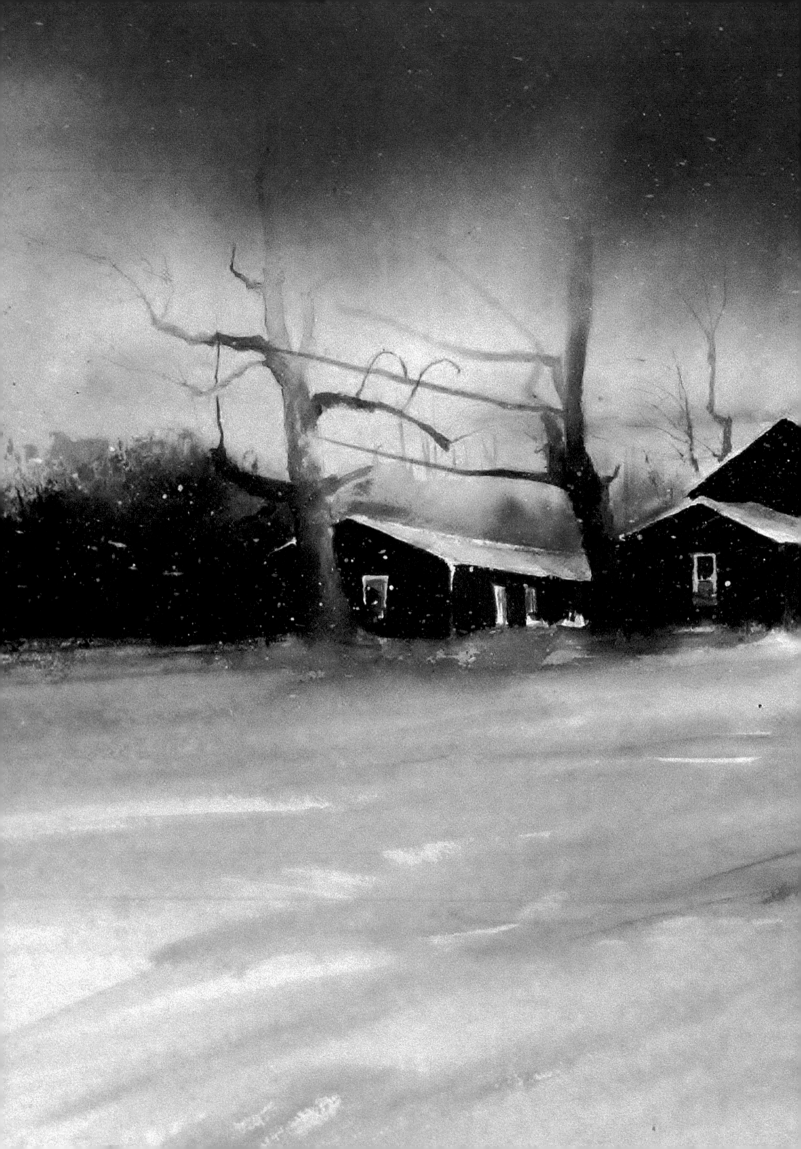

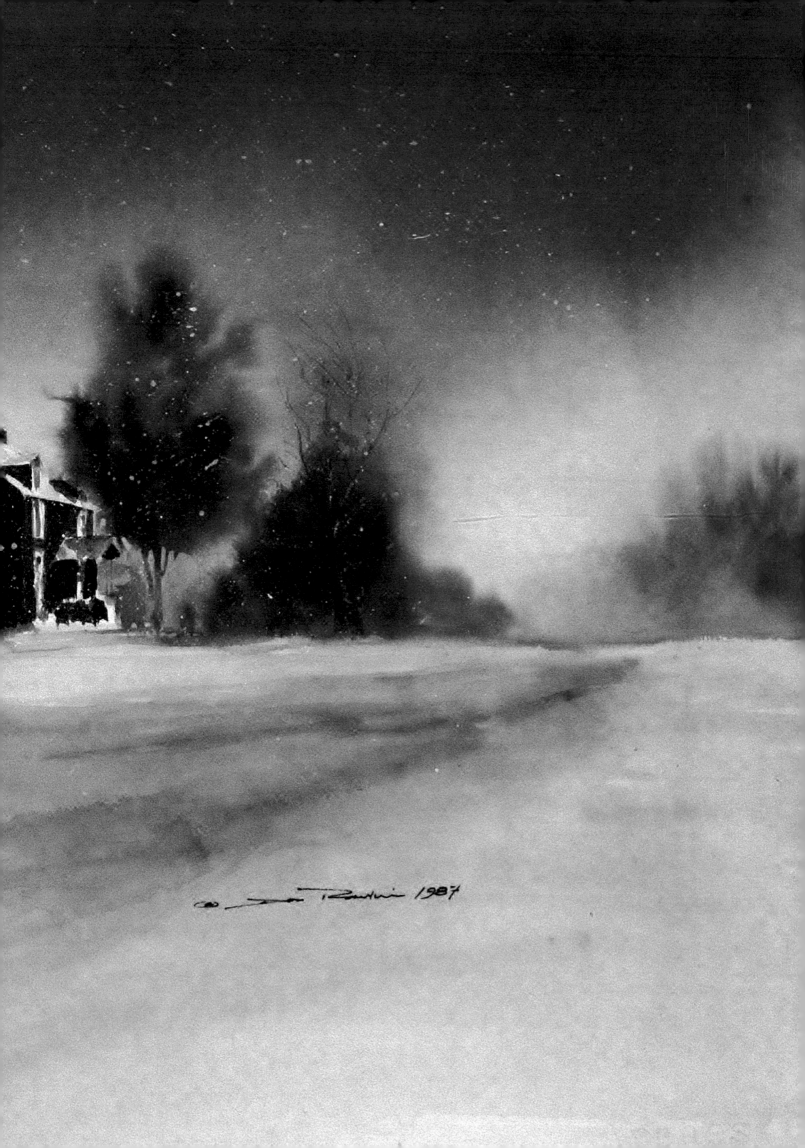

Previous spread:

Ice Storm II

Watercolor on paper, 22" x 14" (55.88 x 35.56 cm)

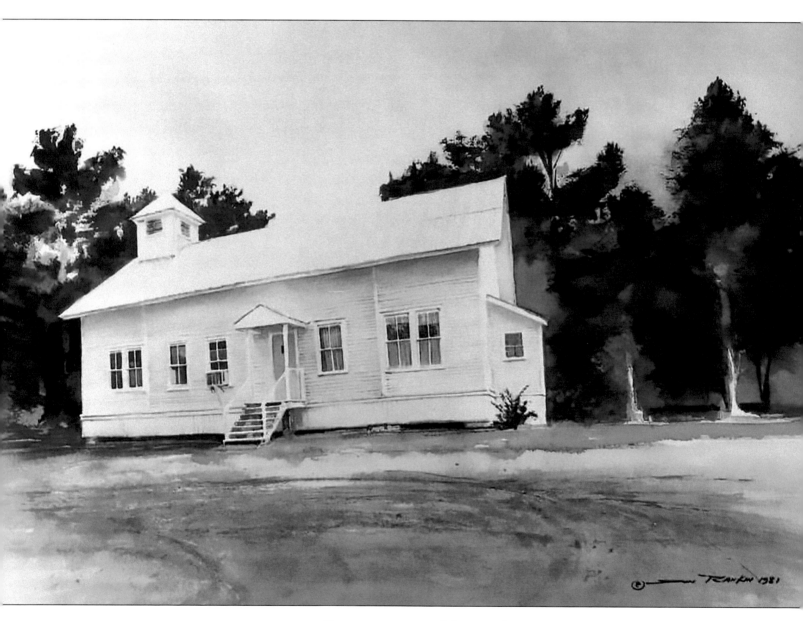

Oxmoor Church

Watercolor on paper, 24" x 16.5" (60.96 x 41.91 cm)

This antebellum church was demolished to make way for a putting range that never got built. It was said to be a mustering place for soldiers going off to fight in the Civil War. Federal Reserve Collection, Washington DC.

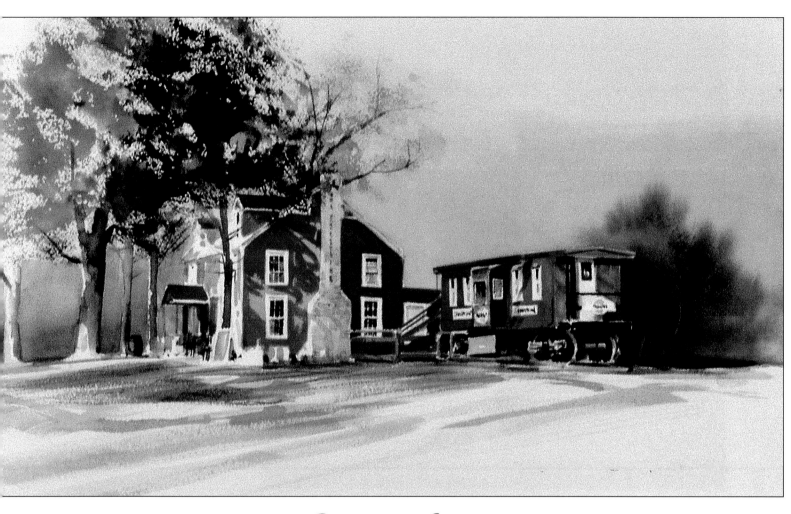

Evening Sun
Watercolor on paper, 22" x 14" (55.88 x 35.56 cm)

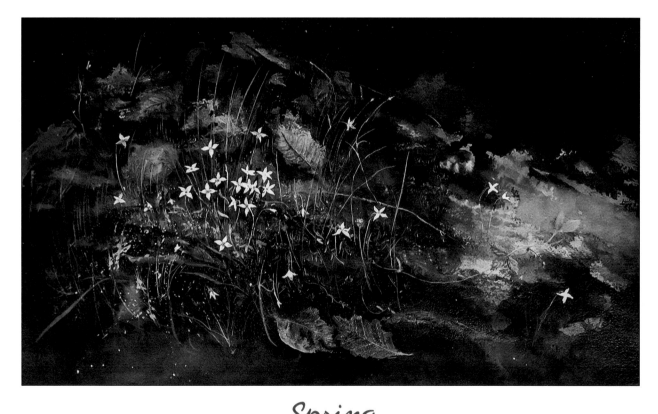

Spring
Watercolor on paper, 32" x 16" (81.28 x 40.64 cm)

The Energen Collection.

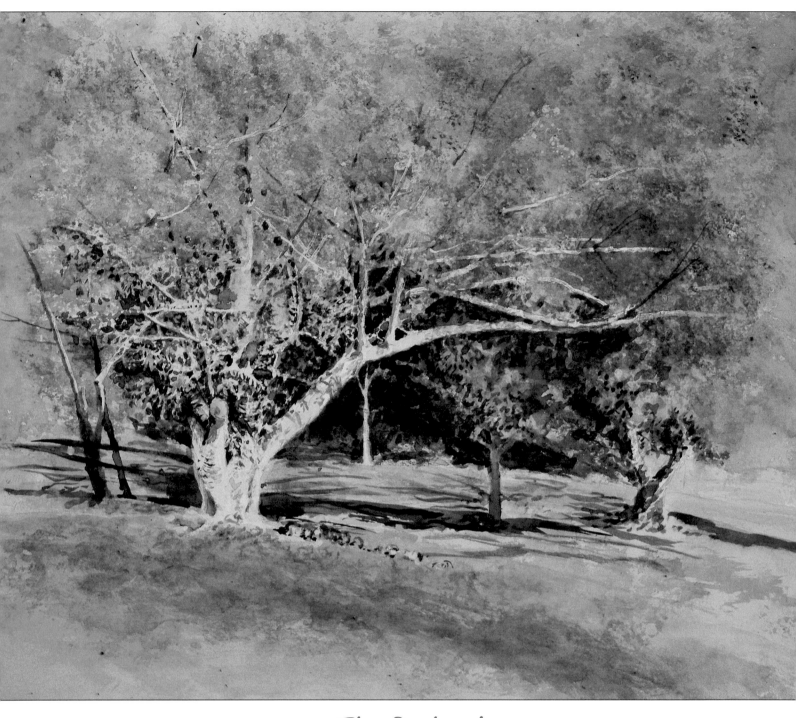

The Orchard

Watercolor on paper, 20" x 16" (50.8 x 40.64 cm)

My wife's great grandfather once owned a large portion of Shades Mountain. Much of it was fields and orchards.

Hornet's Nest

Watercolor on paper, 14" x 16" (35.56 x 40.64 cm)

The nest was gifted to me by a student. Very little
preliminary sketching was done as I painted from direct
observation. Artist Collection.

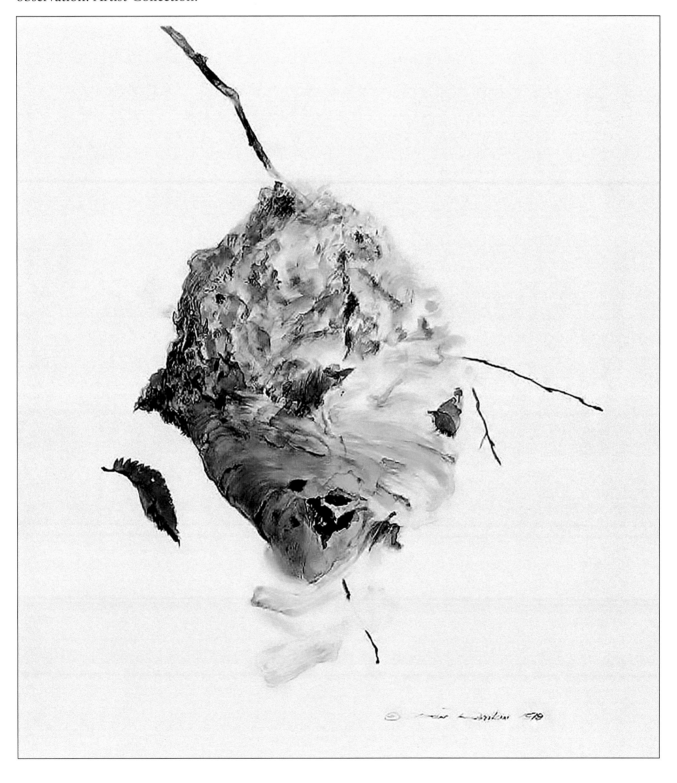

Down in the Hollow

Watercolor on paper, 20" X 24" (50.8 x 60.96 cm)

There is nothing like the calling of a hound who has treed his quarry on a cold winter morning.

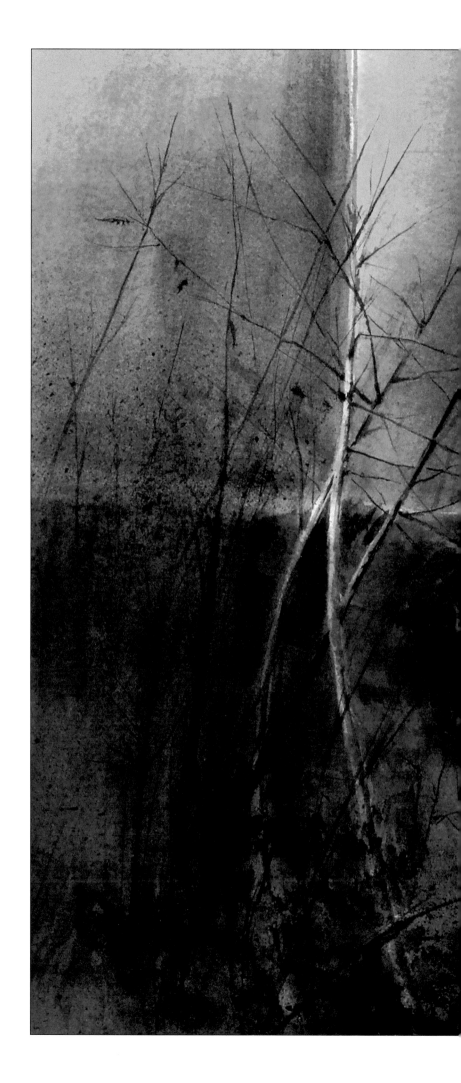

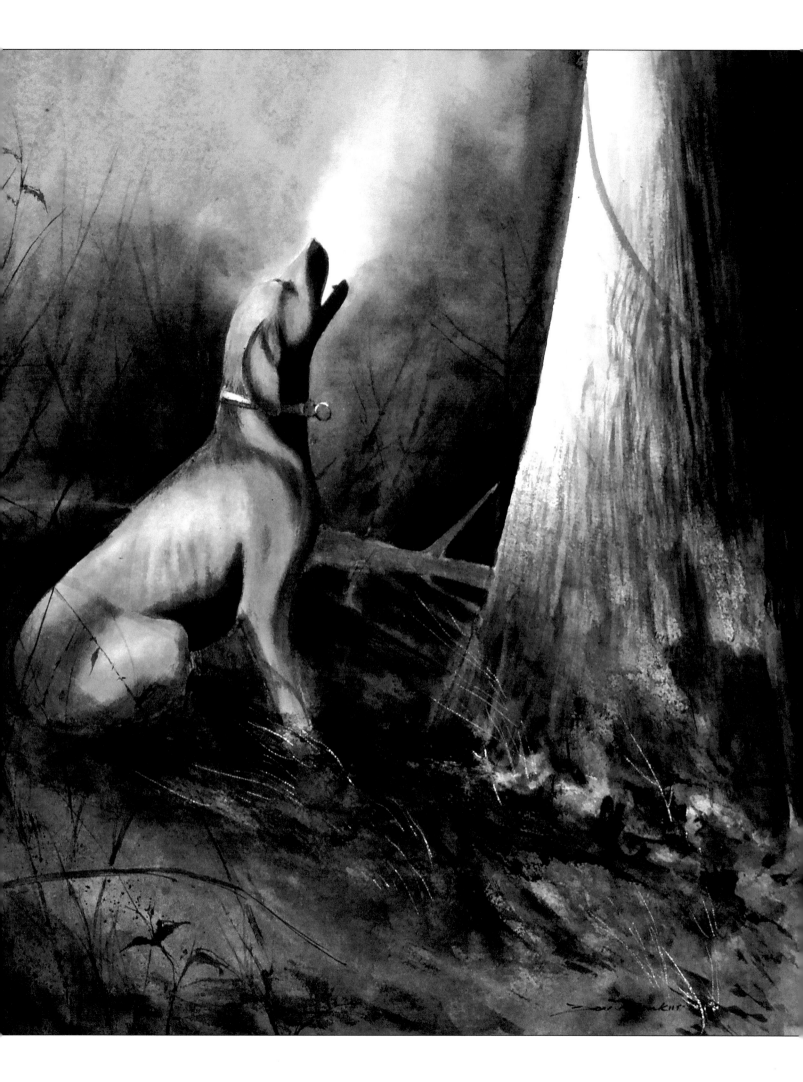

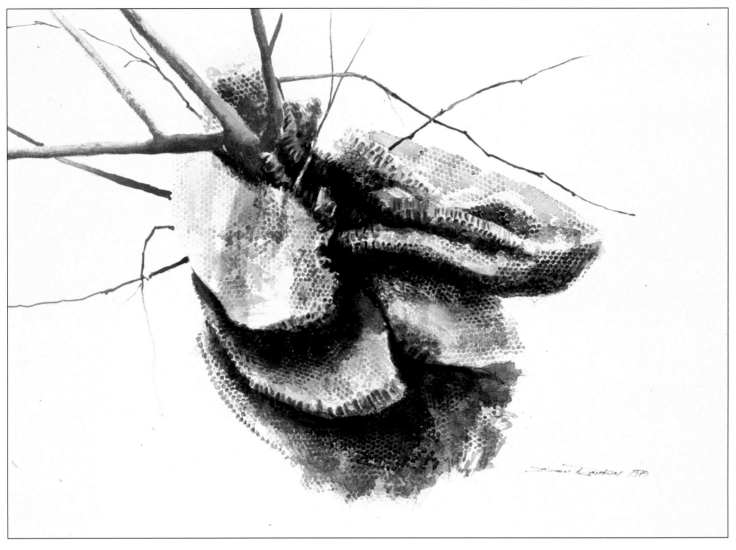

The City

Watercolor on paper, 13.5" x 19" (34.29 x 48.26 cm)

Many years ago an art student who was married to a tree surgeon came bounding into class proudly displaying this treasure. I had never been able to examine a hive like this up close. I've always been intrigued with nests, such complex architectural designs from such so-called uneducated creatures. The nest was an object of many sketches and conversation. Sadly, it eventually crumbled into fragments. Artist Collection.

White Flowers

Watercolor on paper, 24" x 9" (60.96 x 22.86 cm)

Corporate Collection.

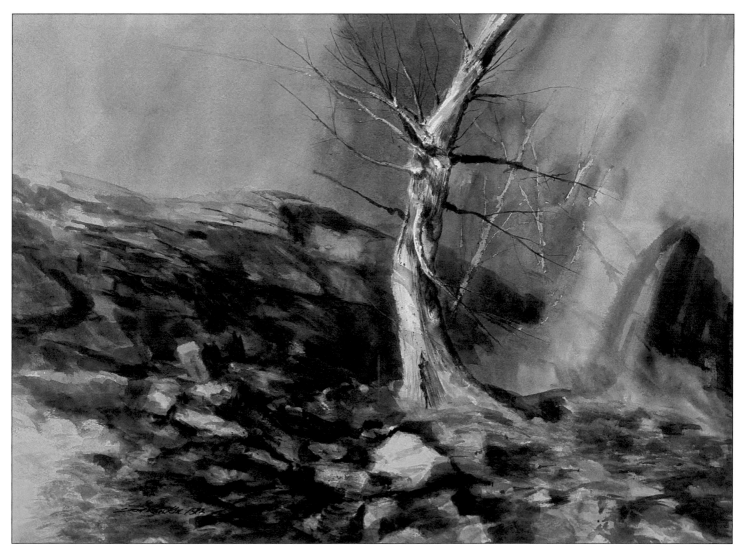

The Stream Bed

Watercolor on paper, 36" x 28" (91.44 x 71.12 cm)

A decaying remnant in a part of the broader stream bed that had long since dried up. Private Collection.

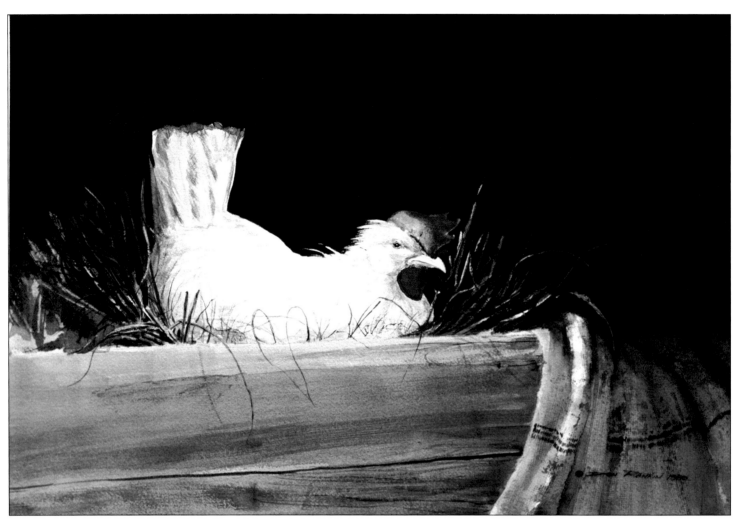

Settin' Hen

Watercolor on paper, 22" x 15" (56 x 38 cm)

Artist Collection.

Roosting Time

Watercolor, mixed media, 30" x 40" (76.2 x 101.6 cm)

Private Collection.

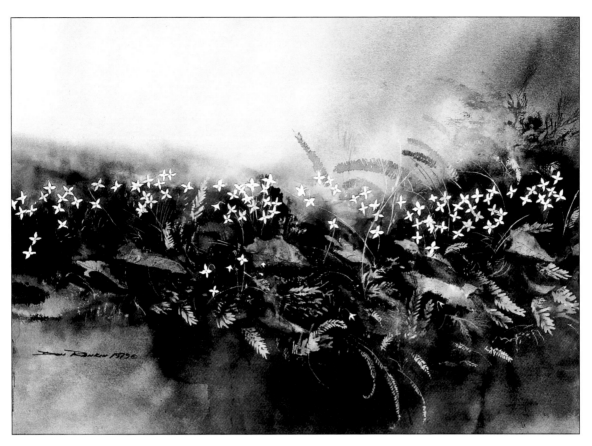

The Edge of the Cliff

Watercolor on paper, 20" x 28" (50.8 x 71.12 cm)

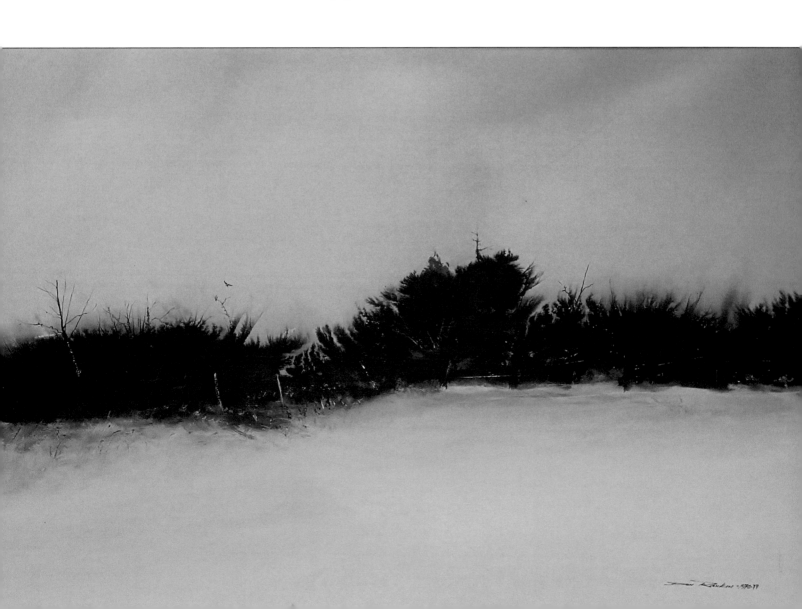

Abandoned

Watercolor on paper, 22" x 15" (55.88 x 38.1 cm)

I have only seen this type of nest in person three times in my life. This was the third time. This nest was near the banks of Paradise Creek that ran just a few hundred feet outside my old studio door. Unfortunately, the nests don't seem to last too long after they are abandoned. This one was already beginning to crumble. The afternoon light came through the leaves and cast powerful beams of light that seemed to make some of the comb transparent.

White Sentry

Watercolor on paper, 20" x 27" (50.80 x 66.04 cm)

This bird was sketched at the Alabama Wildlife Center. Sadly, she died during one of our rare blizzards. Artist Collection.

Down Where the Jacks Grow

Watercolor on hot press board, 20" x 26" (50.80 x 66.04 cm)

The moisture and filtered light encouraged the growth of many plants and flowers that had ceased to grow in other parts of the mountain.

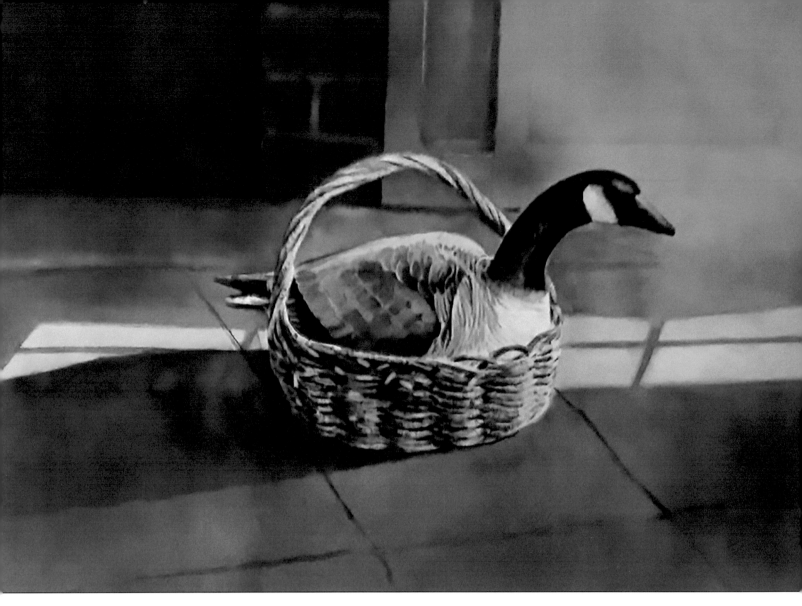

Early Morning

Watercolor on paper, 38" x 21" (96.52 x 53.34 cm)

I can recall when the first Canada geese started making their home in our neighborhood. I was one of the few who was excited to see them. Private Collection.

Early Morning sketch.

Through the Trees II
Watercolor on paper, 15" x 22" (38 x 56 cm)

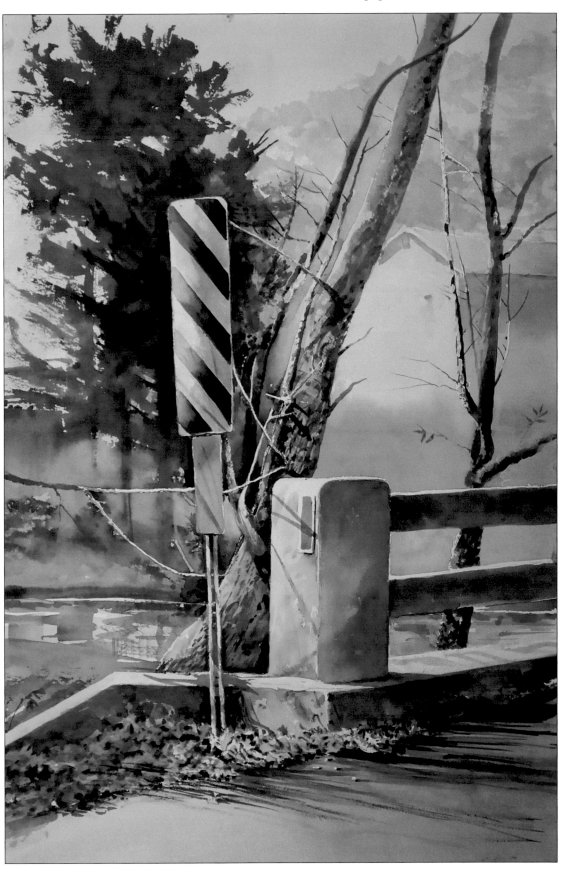

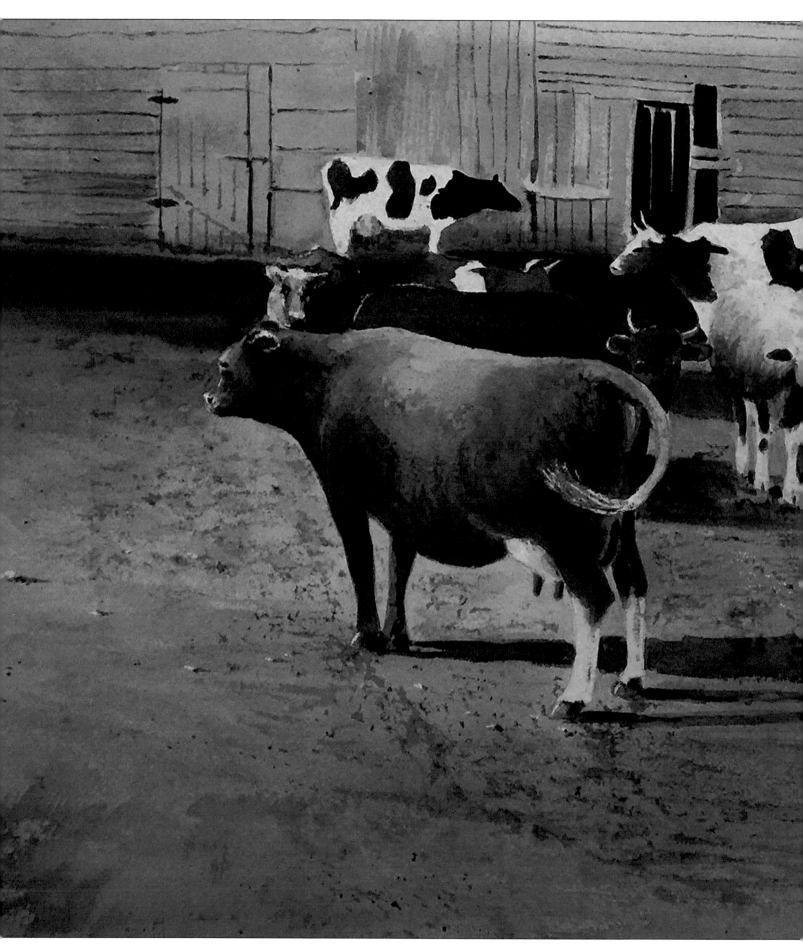

Milking Time

Watercolor on paper, 27" x 13.5" (68.58 x 34.29 cm)

This painting was a by product of one of the most interesting commissions I ever did. I was asked to paint a prize bull. I painted the bull and was present when the painting was presented and proudly hung over the mantle in the farm house. Unfortunately, no photo of the portrait is available but *Milking Time* evolved out of those painting sessions.

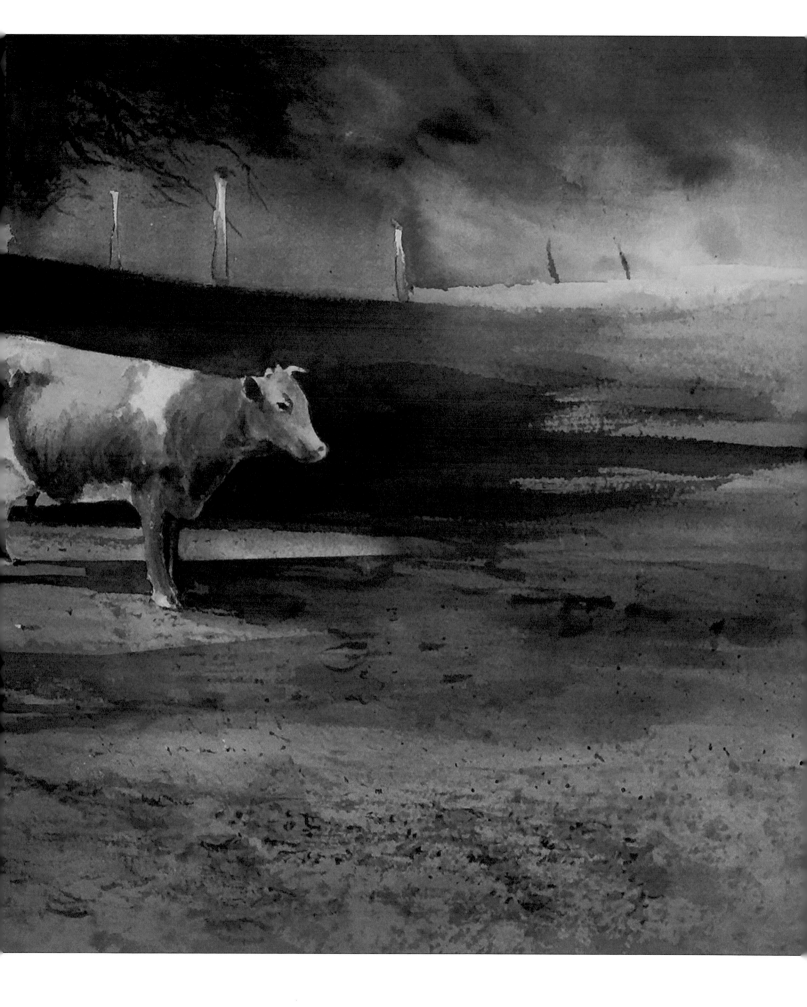

Miniatures

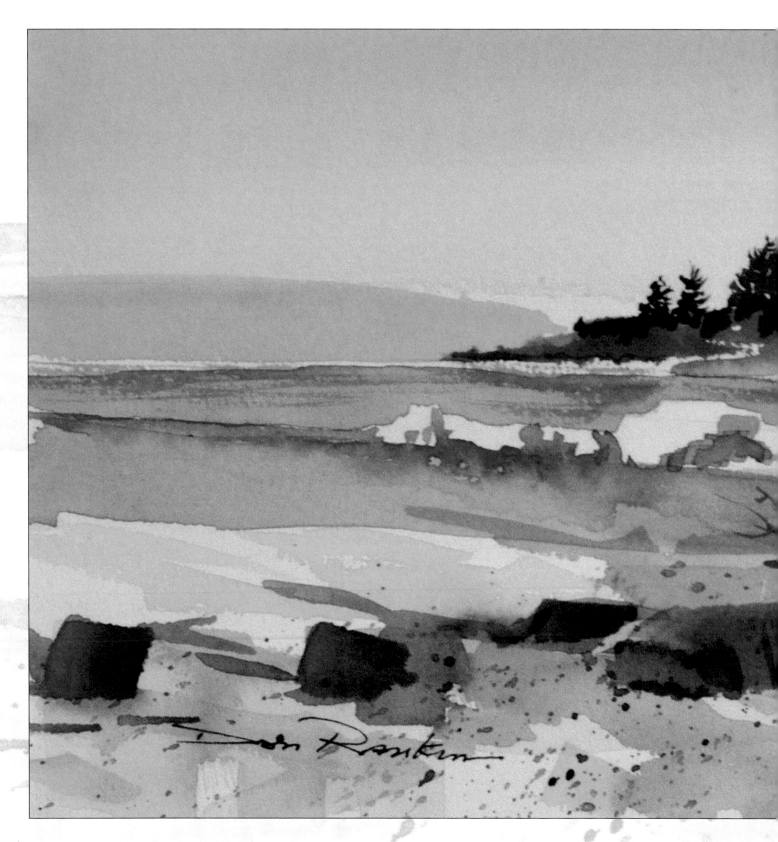

Start with a broom, finish with a needle.

—Eugene Delacroix

❖ ❖ ❖ ❖ ❖ ❖

Champions are losers who keep getting up!

—Ari Soko Ram

Maine

Watercolor on paper, 9" x 7" (22.86 x 17.78 cm)
One of many fleeting sketches while in Maine.

Miniatures

Around 1976, Barbara Moore got the idea to develop a Christmas in Miniature Exhibition. She invited her artists to paint miniature pieces for a special show. The idea was to allow potential collectors who were not accustomed to paying large sums to take the plunge and become art buyers of smaller pieces. She told me that her boss at the time thought she was crazy. Well, crazy or not, so far as we know she started a trend. Galleries all over the country picked up on the idea. The year 2019 marks the 37th year that Barbara has hosted a Christmas in miniature exhibition. Today she has her own gallery, Barbara Moore Fine Art in downtown Chadds Ford, Pennsylvania.

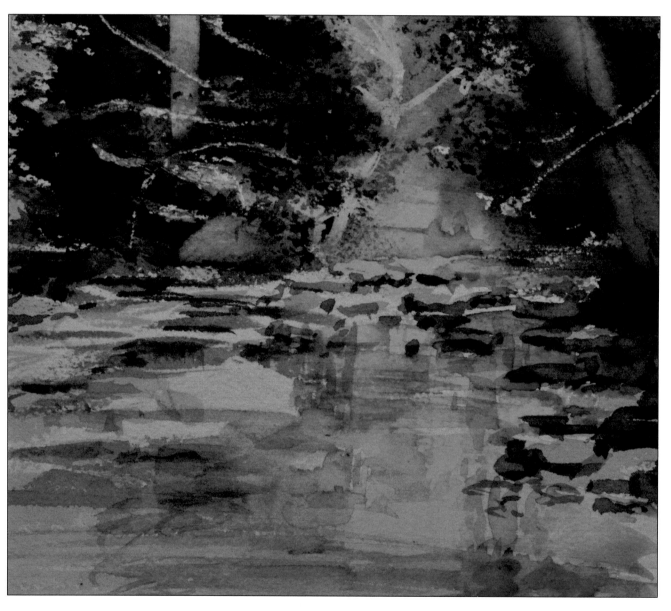

Shadows

Watercolor, 6" x 5" (15.24 x 12.70 cm)

A quiet spot not far from my old studio.

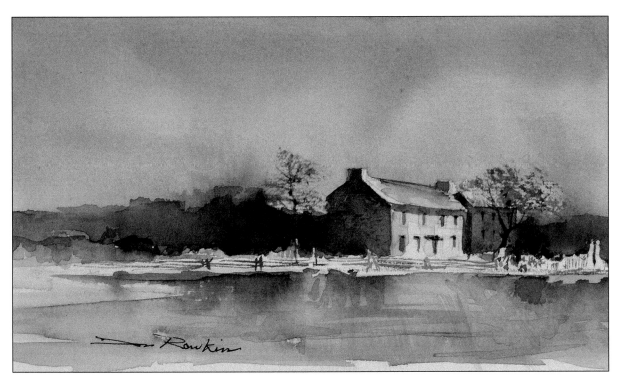

Winter Morning

Watercolor, 9.5" x 6" (24.13 x 15.24 cm)

It was bitterly cold near Chadds Ford; one of my bone chilling moments while capturing a moment of light.

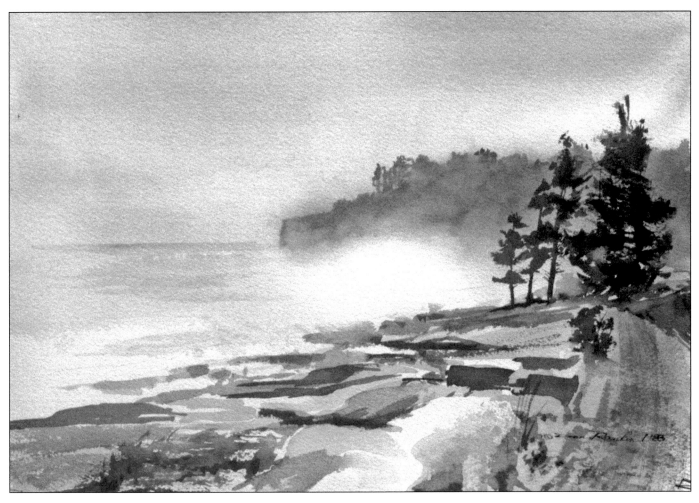

Acadia

Watercolor 9" x 6" (22.86 x 15.24 cm)

One of my favorite spots not far from Thunder Hole.

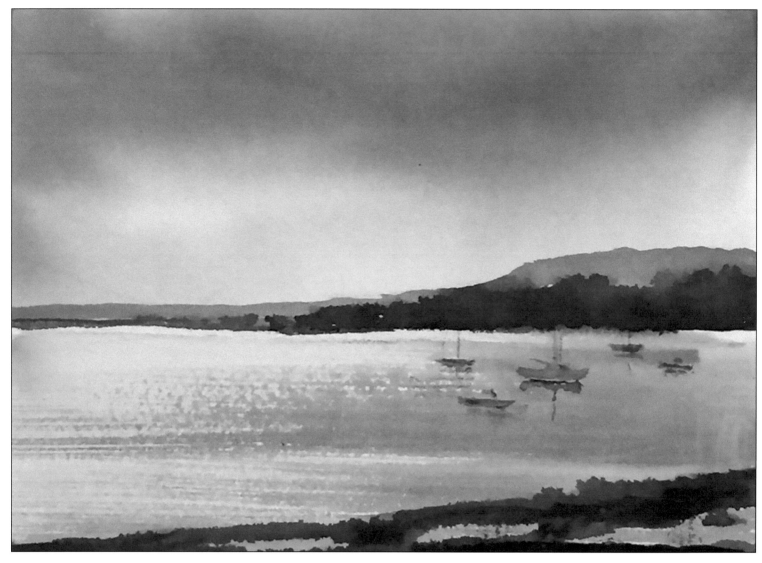

Northern Lights

Watercolor on paper, 7" x 5" (17.78 x 12.7 cm)

One of the most beautiful places I have ever seen. We arrived at Bras d'Or Lake a little late in the afternoon. The sun glinting off the water was like spun gold, hence the name "Arms of Gold." Later in the twilight the northern lights created another spectacular event.

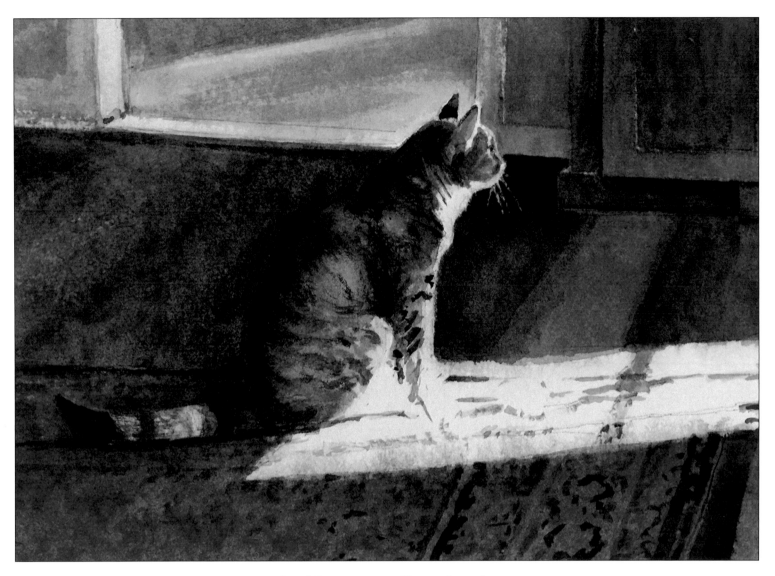

Callie in Sunlight

Watercolor on paper, 9" x 6.25" (22.86 x 15.87 cm)

Callie was our grand cat. Our daughter was not able to keep her and she came to live with us for about 16 years. Shortly before her death she was sitting in the den gazing out through the door to the deck. The sunlight enveloped her and gave her a glowing aura of light. Artist Collection.

Grape Tomatoes

Watercolor, 5.5" x 4.5" (13.97 x 11.43 cm)

At my old studio I had a deck that provided a great place for large planters.

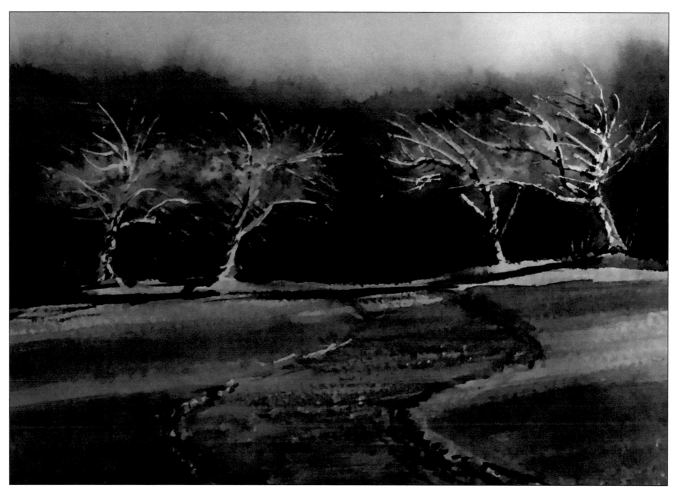

Old Hackberry

Watercolor, 9.5" x 6" (24.13 x 15.24 cm)

Many years ago, before I-65 came through, one access to Tyler Road on Shades Mountain, was a narrow, chert filled, switchback road that meandered up the mountain through an orchard. Today that portion only exists in memory.

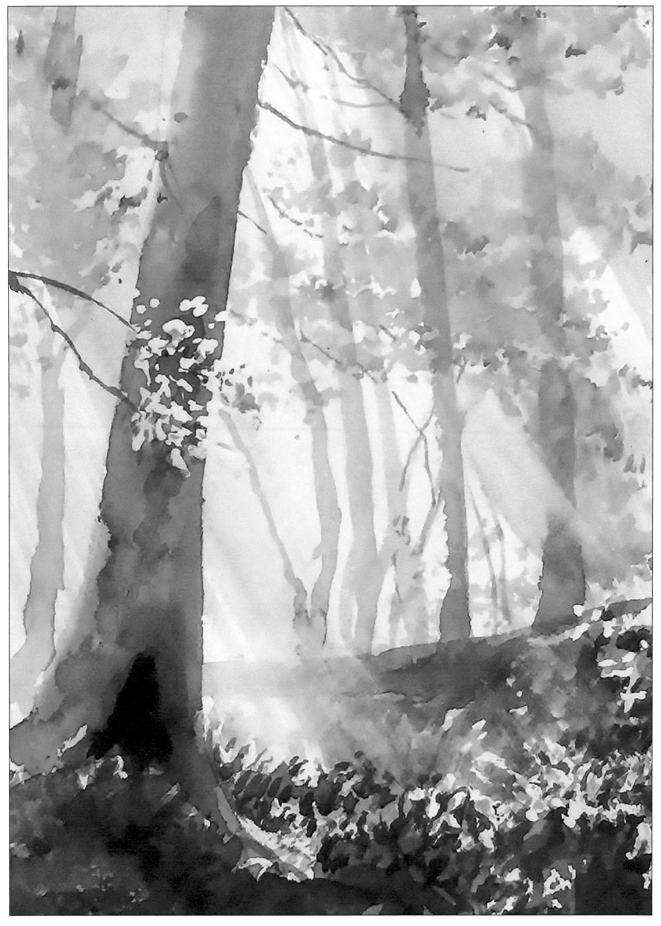

Near My Studio

Watercolor, 6" x 9" (15.24 x 22.86 cm)

Down below my old studio the light often filtered through the trees producing a peaceful dream land of color and shade.

Other Places

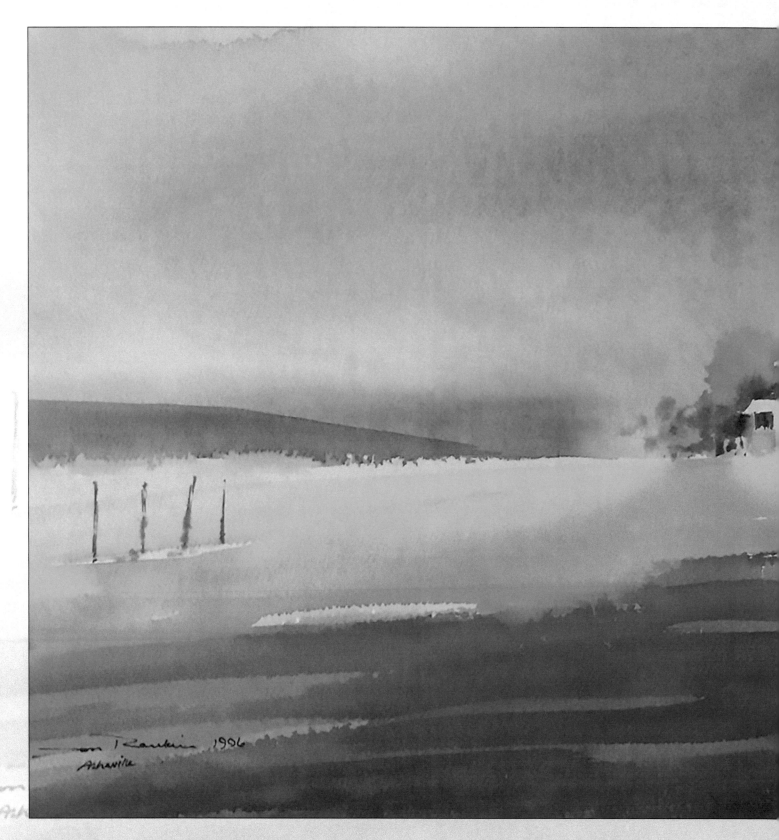

The difference between success and failure is not the will to win. Everybody has that. The difference is whether you have the will to prepare to win.

—Paul "Bear" Bryant, Former Head Coach, University of Alabama

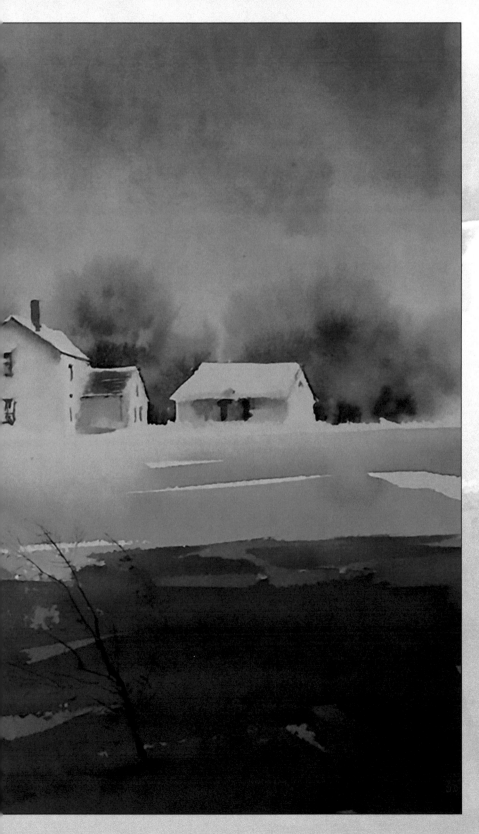

Asheville
Watercolor on paper, 22.5" x 13"
(57.15 x 33.02 cm)

Other Places

Not all of my paintings are produced on Shades Mountain. Surrounding areas often get my attention as well.

Smyer Road

Watercolor on paper, 22" x 14" (55.88 x 35.56 cm)

Private Collection.

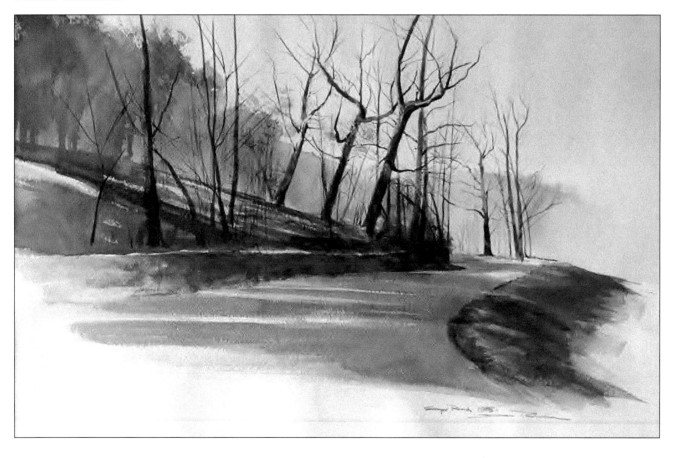

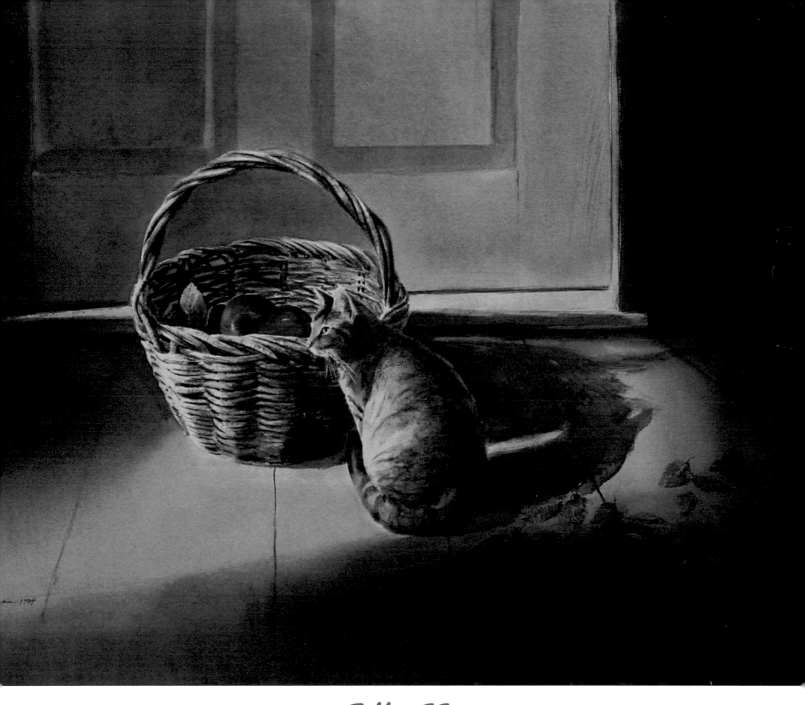

Taffy II
Watercolor on paper 35" x 25" (89 x 64 cm)
Artist Collection.

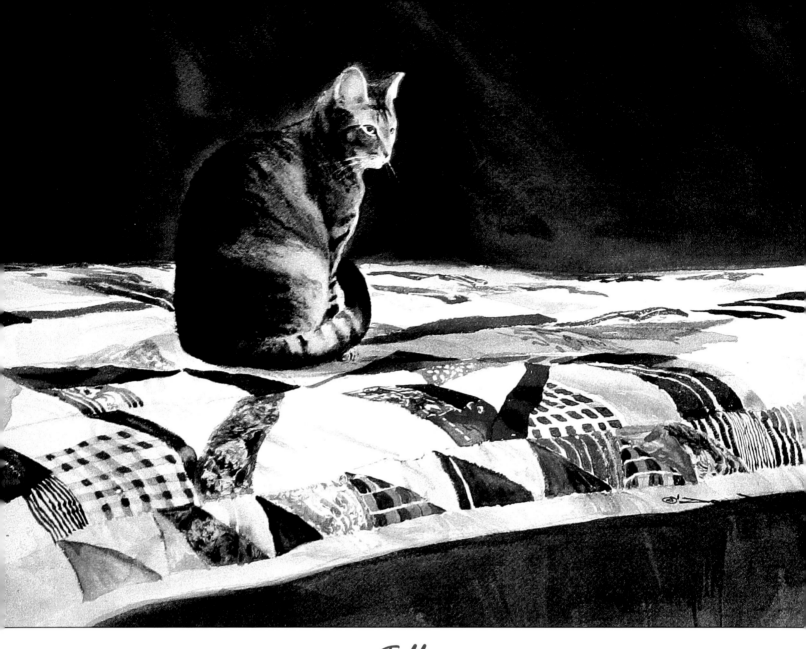

Taffy

Watercolor on paper, 28" x 15" (71.12 x 38.10)

Taffy was our daughter's first cat and the first cat in our household. The two were almost constant companions. Taffy set a trend that saw many other cats come into our lives. I painted her on one of my grandmother's quilts. Collection of Carol Findlay.

Opposite page:
Winter Watch

Watercolor on paper, 25" x 20" (63.50 x 50.80 cm)
Artist Collection.

Waterbird

Watercolor on paper, 20" x 14" (50.80 x 35.56 cm)

A quick impression of a moving target.

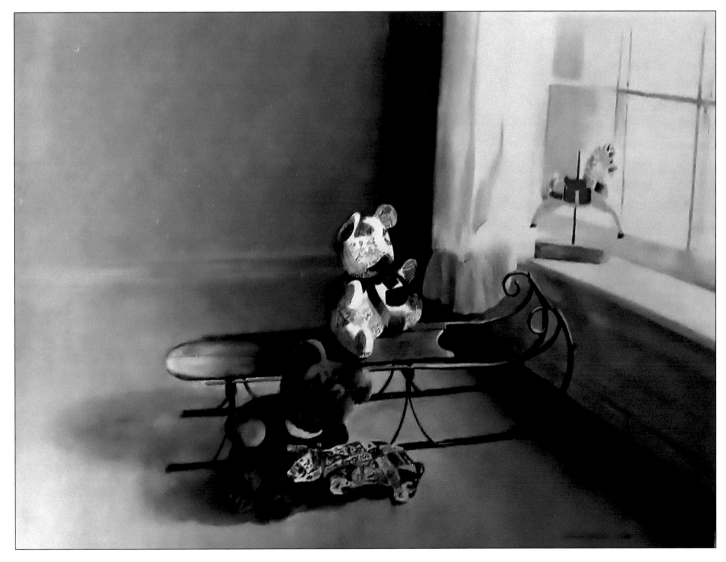

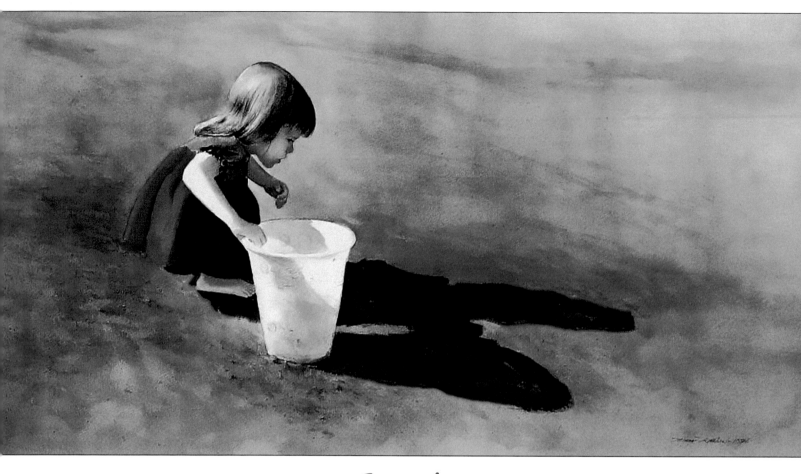

Jennifer

Watercolor on paper, 30" x 16" (76.2 x 40.64)

Little did we know she would one day earn a degree in Geology and Earth Sciences. Collection of Geneal Rankin.

The Cycle

Watercolor on paper, 36" x 14.5" (91.44 x 36.83 cm)

Artist Collection.

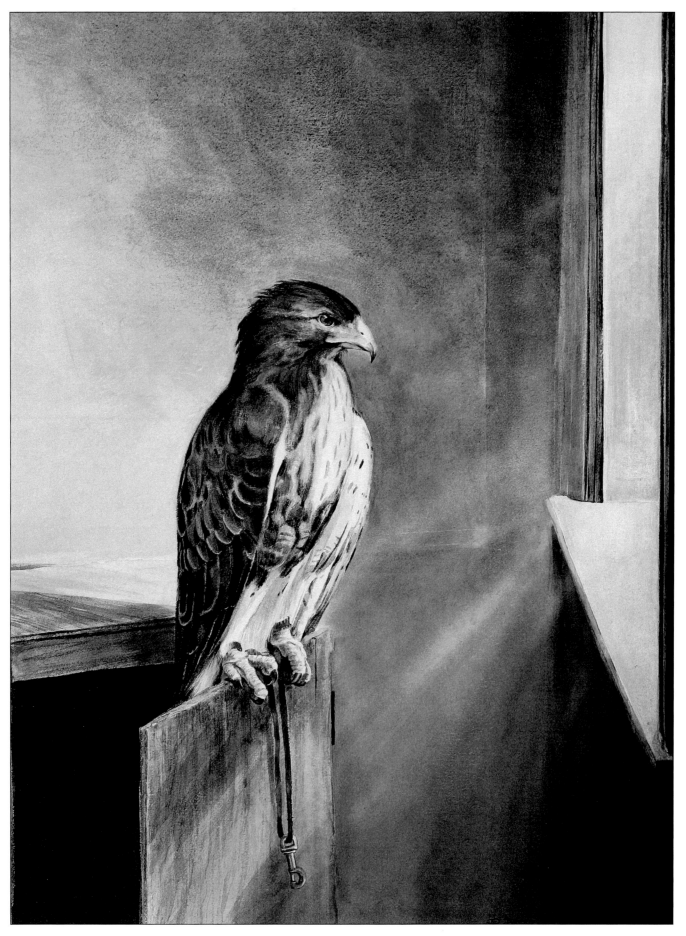

The Prisoner

Watercolor on paper, 22" x 28" (55.88 x 71.12 cm)

A young red-tailed hawk awaiting release after healing from a gunshot wound. Collection of the Frank Lewis Estate.

October

Watercolor on paper, 34" x 24" (86.36 x 60.96 cm)

I experienced this amazing light near the back door of a very old Mennonite church in the Saucon Valley, near Allentown, Pennsylvania. Collection of Geneal Rankin.

Opposite page:

Snow Near Wah-Wah Dairy

Watercolor on hot press board, 25" x 16" (63.50 x 40.64 cm)
Private Collection.

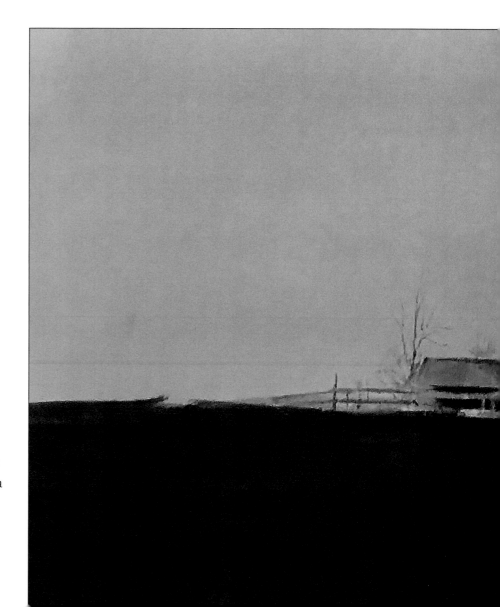

South of Harrisburg

Watercolor on paper 30" x 16"
(76.20 x 40.64 cm)

I painted this after a rainy afternoon just south of Harrisburg, Pennsylvania. I was one of the Alabama artists chosen to represent our state in the southeastern tour of Artrain. It was ironic that a Pennsylvania scene was chosen to represent Alabama. Private Collection.

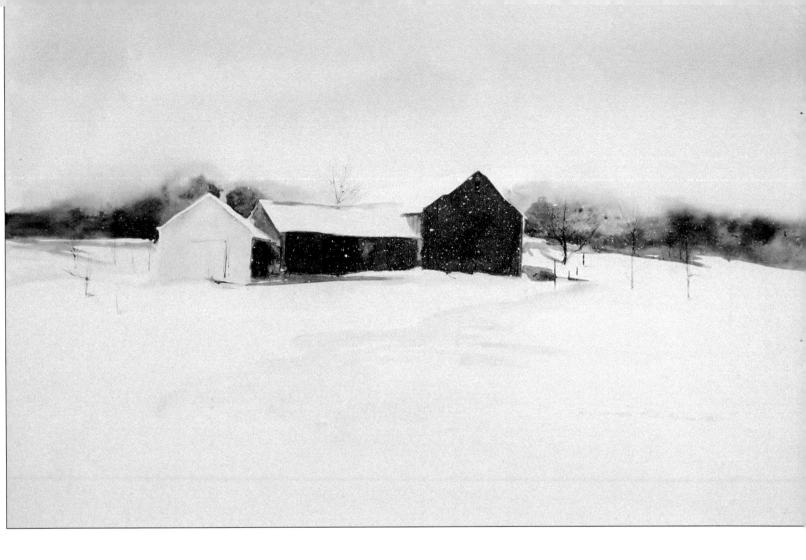

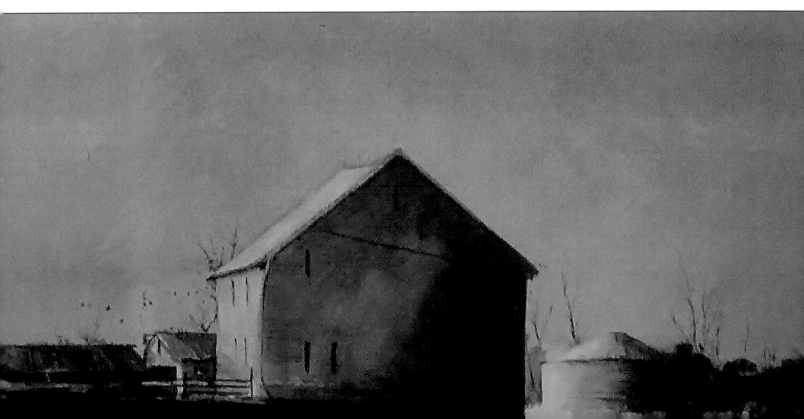

Pheasant

Watercolor on paper, 20" x 29" (50.80 x 73.66 cm)

Corporate Collection Alabama Power.

Williamsburg, Summer of '81

Watercolor on paper, 28.5" x 19" (72.39 x 48.26 cm)

It was lunch hour and the powder magazine was deserted when I went up to explore the light in the room. No visitors, or so I thought. This young man, one of the actors, was sitting bathed in the sunlight looking like a ghost. Private Collection.

Queen Bee

Watercolor on paper, 17" x 20" (43.18 x 50.80 cm)

I met this lady on a very hot day at a living history site in Georgia while she was running a very hot open hearth kitchen. She was cooking the old way. She said she preferred working here than taking a handout from the government. Seems she had several children and had been abandoned by her husband.

Opposite page:

Sunday Morning

Watercolor on paper, 19.75" x 25.5" (50.17 x 64.77 cm)
Artist Collection.

Opposite page:
Quiet Lagoon
Watercolor on paper, 16" x 22"
(40.64 x 55.88 cm)

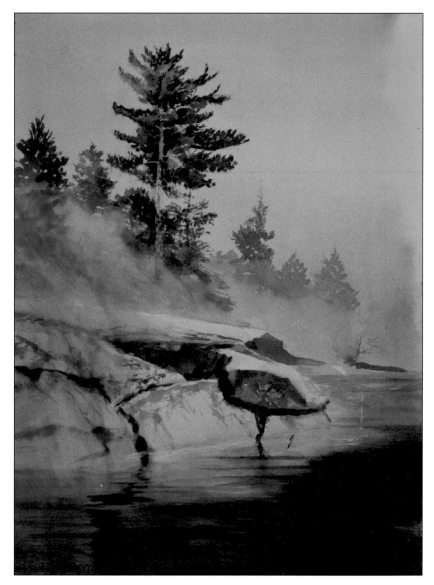

Misty Morning, Boundary Waters
Watercolor on paper, 22" x 30"
(55.88 x 76.20 cm)

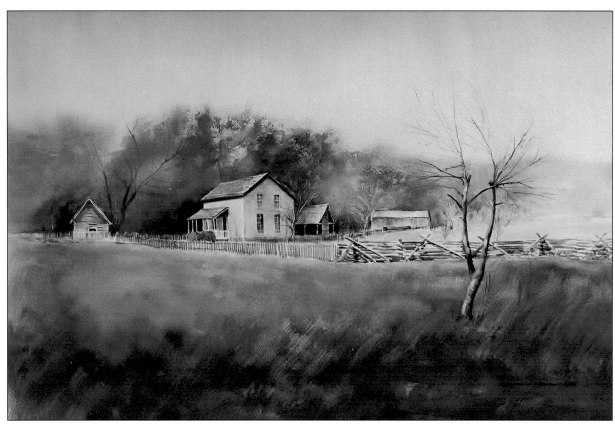

Mountain Farm (Becky Cable House)
Watercolor on paper, 22" x 14" (55.88 x 35.56 cm)

Collection of Geneal Rankin.

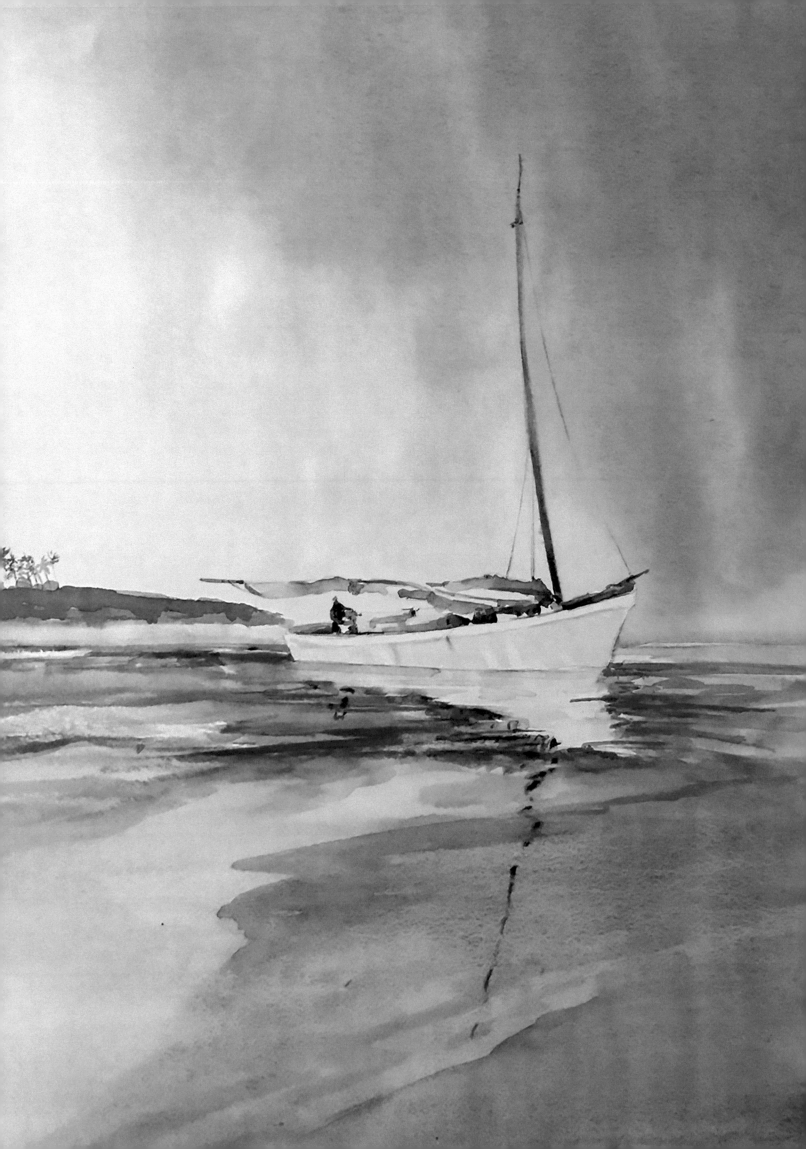

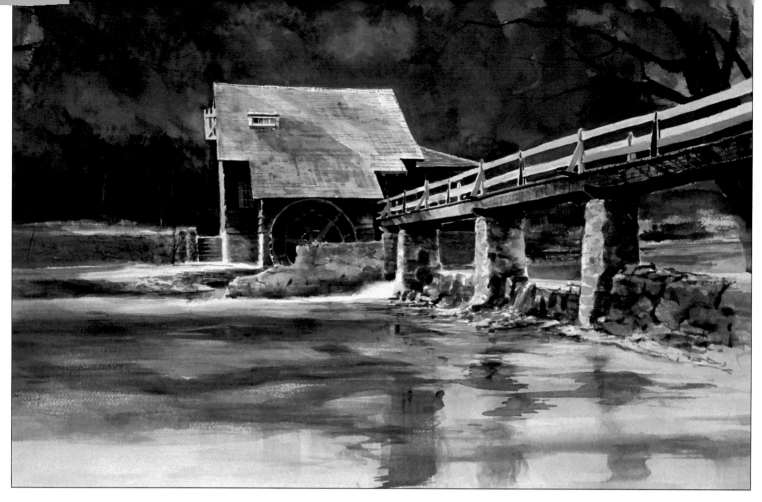

Early Summer

Watercolor on paper, 29" x 19" (73.66 x 48.26 cm)

Private Collection.

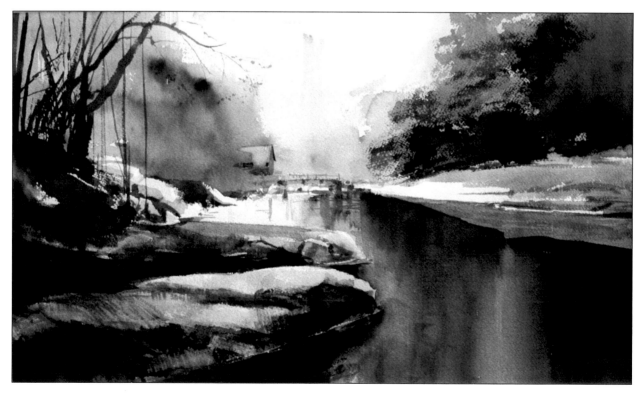

Mountain Mill

Watercolor on paper, 27.5" x 19.5" (70 x 50 cm)

Artist Collection.

Down in the Stream

Watercolor on paper, 9" x 17" (22.86 x 43.18 cm)

The smallest of the citizens of Paradise Creek make lively subjects. Artist Collection.

Huckleberries

Watercolor on paper, 16.5" x 20" (41.91 x 50.8 cm)

Following spread:

Franny's Basket

Watercolor on paper, 32" x 21" (81.28 x 53.34 cm)

Private Collection.

Meet the Artist

Don Rankin's work has captured the attention of many followers, and his online tutorials have instructed more than 500 students worldwide. While some label his work as "traditional" in approach, it carries the mark of the artist's personal views. He is not content to merely copy nature nor rely upon a safe formula for the creation of a painting. He feels that each painting should dictate its own method of solution, just as each subject has its own personality.

Rankin's work is unique in this present age of computer-enhanced imagery. His approach of development and execution recalls a less hurried time when artists polished their abilities and their work with loving care. His approach to watercolor and egg tempera reflects his patience, acquired over time, to endure the inconvenience of possible extra work in order to achieve his goal. Perhaps achieving the rank of Nidan, while training for more than 25 years with noted classical full contact Japanese karate master Saiko Shihan Y. Oyama of World Oyama, helped to nurture that sense of discipline. Additional years of training in Shinkendo, under the direction of Kaiso Toshishiro Obata and Hanshi Paul Couch, helped to instill patience and discipline. Now retired, the artist credits those years with helping him to see and react to his world with a keen point of view.

Don Rankin
Assistant Professor Emeritus, Samford University

Don's dedication and commitment to his work is evident in some of the national and international recognition he has received. In 1973, at the age of 26, he was one of the youngest artists to be included in *Who's Who in American Art.* In 1974 he was honored with a one-man show at the Birmingham Museum of Art. In the same year he was one of six Alabama artists selected to represent the state in a southeastern tour of Artrain. Five years later he was one of six American watercolor painters to be included in a Summer Festival Exhibition at the Chautaqua National Exhibition in New York. Some of his pieces have been included in international exhibitions in Japan and other parts of Asia.

In 1980 his work was featured on the Watercolor Page of *American Artist* magazine, one of the most prestigious art magazines in America at the time. His work also appeared in *Northlight* magazine and other art periodicals.

In 1984 he was one of twenty-three American artists included in *Painting the Landscape*. Author, art historian Elizabeth Leonard classified him as being as being an innovative landscape painter. She noted his concern with color and his ability to produce such subtle glowing effects with multiple layers of watercolor wash. She stated that he was one of three watercolorists she had chosen that build their landscapes using fresh techniques. She further stated that after much research, the artists she included, represented some of the finest landscape artists working in America. The Director of the Hunter Museum in Chattanooga, Mr. Cleve Scarbrough, ranked him among the top four or five realist painters working in the southeast, saying, "He is an exemplary technician who works with a creative flair. His landscapes reflect the mood of the region." Tom L. Freudenheim, the former Director of the Baltimore Museum of Art, had noted the unusual and utmost strength of Don's watercolors.

These observations were enforced in 1986 when Watson-Guptill Publications released Rankin's book entitled *Mastering Glazing Techniques in Watercolor*, referring to it as the first authoritative book on watercolor glazing technique. The book proved to be one of the most popular books in the history of the American Artist Book Club. In 1987 a new book was released entitled *Painting From Sketches, Photographs and the Imagination* also by Watson-Guptill Publications Inc. New York. In 1991, *Answers to Fifty of the Most Often Asked Questions About Watercolor Glazing Techniques*, another Watson-Guptill publication, was released. In 1992, *Everything You Ever Wanted to Know About Watercolor*, edited by Marian Appellof, was published by Watson-Guptill. That book included the work of 17 watercolor painters, including Don. Watson-Guptill was acquired by Random House, and the book continued in circulation for a time.

Some of Don's books were translated into foreign language editions, especially in Asia, while others were available through Phaidon Press, Oxford and via RotoVision, S.A. in Mies, Switzerland, who handled distribution in the Far East, Southeast and Central Asia and South America.

In 2007-2008 he received a *Who's Who in American Education* award from the Marquis Who's Who Publication Board for his contribution in the field of art education.

In 2011, due to popular demand, *Mastering Glazing Techniques in Watercolor, Vol 1, by Dr. Don Rankin* was revised with updates on pigments and paper with some new tutorials added. The revision has proved to be popular with a new generation of watercolor painters and has received international endorsements from students and instructors.

In 2017 Don received a *Lifetime Achievement Award* from the Publication Board of Marquis Who's Who Publication Board for his contribution in his field of art.

More recently, his painting entitled "Low Tide" was awarded the BoldBrush Regram Award. His work has appeared in various online magazines and websites. *Imagine Le Revue de Arte, Numero 43,* a French language publication, has featured his work. His work is also featured on Instagram and www.Donrankinfineart.com.

His work is represented by Ms. Barbara Moore of Barbara Moore Fine Art, 400A 1609 Baltimore Pike, Chadds Ford, Pennsylvania 19317.

Index of Art